THE BiG BOOK OF PACKAGING

HARPER DESIGN

An Imprint of HarperCollins Publishers

For information, address Harper Design, 10 East 53rd Street, New York, NY 10022.

HarperCollins books may be purchased for educational, business, or sales promotional use.
For information, please write: Special Markets Department, HarperCollins*Publishers*,
10 East 53rd Street, New York, NY 10022.

First published in 2011 by:
Harper Design
An Imprint of HarperCollins*Publishers*
10 East 53rd Street
New York, NY 10022
Tel: (212) 207-7000
Fax: (212) 207-7654
harperdesign@harpercollins.com
www.harpercollins.com

Distributed throughout the world by:
HarperCollins*Publishers*
10 East 53rd Street
New York, NY 10022
Fax: (212) 207-7654

Book design by Anderson Design Group, Nashville, TN.
www.AndersonDesignGroup.com

ISBN: 978-0-06-200989-0

Library of Congress Control Number: 2010928754

Produced by Crescent Hill Books, Louisville, KY
www.CrescentHillBooks.com

Printed in China

THE
BiG
BOOK OF
PACKAGING

WILL BURKE

WILL BURKE_ is the founder, CEO, and Chief Change Officer of Brand Engine. He draws on more than twenty years of experience in branding and packaging—uniquely bridging strategy and design—to solve complex issues with great insight and straightforward solutions. With a focus on consumer brands, his expertise is introducing new brands and repositioning existing brands to engage today's consumer.

Formerly with Landor Associates, Lister-Butler, and Axion Design, Will's background includes major branding and packaging programs for Citicorp, MasterCard, Shell Oil, Hewlett-Packard, Intel, Logitech, Palm, Foster's, Frontier Natural Products, Nestlé, and Tropicana. Under Will's direction, Brand Engine's work has been recognized in globally renowned competitions and books. In addition, Will's thought leadership has been featured in various trade and industry publications, and he is involved with several brand advisory boards, a speaker on branding and design, and a judge for design competitions.

Brand Engine, Founder and Chief Change Officer

As a ten-year-old, I knew what great design was, even though I couldn't articulate why the colors, imagery, shape, and feel of an object spoke to me. It was instinctual—I simply knew it was right, and I liked the emotions that beautifully designed objects evoked in me. Today, the feel of a well-crafted motorcycle conjures up that same excitement. It's not just the sound it makes; it's the way the tank effortlessly flows toward the seat and draws the eye out to the pipes. It's the unspoiled discovery of form and color that invigorates and inspires.

If I want to get from point A to point B, riding any motorcycle will do. But if I want to do it on a machine that responds intuitively to my every input—throttle, clutch, brakes, body position—and connects me to the road, it has to be my 2002 MV Agusta F4. The artistry in how its basic parts—the frame, the wheels, the engine, the four exhaust pipes—are designed and work together in harmony is what makes it an emotional experience.

A brand package should exhibit the same artistry, constructing a story about the brand and the product out of the basic parts of design: architecture, color, typography, and imagery. But to be truly successful, it should go further: excite, arouse curiosity, and elicit desire. In order to achieve this, I judge a design with three simple questions: Is it authentic? Is it meaningful? Is it compelling?

- **Authenticity** is about being true to the brand's values rather than following trends. It's about creating a personal experience in a way that becomes visceral and intuitive to your audience. Just as I knew what good design was when I was ten, customers sense authenticity and reward it with their attention and their loyalty.
 When the brand personality is conveyed with authenticity, it will be vibrant, alive, and fresh. At its weakest, a package is merely words and pictures—non-descript, unemotional, and bland. It may do the job, but it does so as duct tape seals a leaky fuel line—a temporary solution.
- Being **meaningful** is about delivering a shared value that transcends culture and boundaries. It's about offering solutions. We have to remember that we aren't merely artists, we are artisans—creators of industry. Our work changes how people live and view the world. We deliver meaning to their lives, making it easier, more fulfilling, and even exciting.
 Generating meaning can be utilitarian: this product meets a need. Or it can be desirable: I don't need it, but I can't live without it. A hybrid of the two—I need it and I want it—is the ultimate goal when creating a package.
- Finally, package design must be **compelling**. It must stand out in today's saturated market by offering a different choice or a new experience. And it must also fit into the consumer's lifestyle in a way that might not have been considered before. Good design makes us want to see what's next on the horizon because we've become attached to the brand's personality and the idea of ourselves with the brand. As the brand evolves, we're there with it, eager to see where it's going because we like where it's been.

I keep a 1968 Ducati 350 Single Café Racer in my garage as a reminder of how great design can transcend generations. Parked next to my current ride, the familiar curves and interplay of silver and red are difficult to miss. While the older bike might not be as powerful, the experience is pure Ducati and makes me look forward to its next iteration.

That kind of forward thinking is what makes the package designs in the following pages truly exceptional. They represent the best of our craft. The common thread among this elite group is their ability to tell a brand story that is authentic, meaningful, and compelling. These designs deliver on many levels by transcending the merely obvious and offering us the possible. The shape, material, color, and graphics combine to arouse our interest and influence our decisions. And the ten-year-old in me thinks they just feel right.

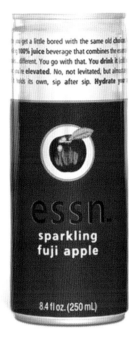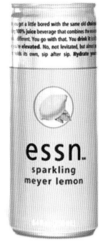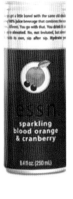

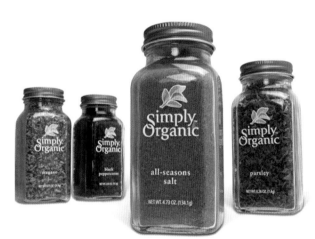

Will Burke's all-time favorite packages

Thinking about my top seven package designs of all time is a really daunting challenge. I've been a student of package design since childhood. The package has always been more than a vessel to me. Starting at a young age, I studied every nuance—the shape, weight, color, graphics, copy, typography, photography, illustration, and texture—to understand why each package was able to evoke one or more emotions in me. To come up with a list of my all-time favorites, I had to step back into my childhood, before I knew about my profession, and recall which specific designs spoke to me.

1. Budweiser Beer Tin Can from the 1970s
When I was ten years old, I found this empty can while fishing in a reservoir about a 90 minute drive from where I lived in Layton, Utah. I've kept it all these years. The design is both simple and complex. The copy tells the story behind the brand. It's bold yet delicate at the same time and is a great example of contrasting languages that work in harmony.

 This can now has a second life as a pen and pencil holder on my desk.

2. Coca-Cola Bottle
This shape of the Coca-Cola glass bottle was refined by Raymond Lowey (a hero of mine.) It's a simple shape and has fancy script and nothing else. It's a timeless icon.

3. Peko Candy Tin (Japan)
I'm big fan of Manga and this design has not changed since I was a kid. Now my kids love it. I don't buy into the reimaging of characters to appeal to a new generation. Would you do that to the *Mona Lisa*?

4. Band-Aid Tin, Johnson & Johnson
It's all about function. When you held this metal container in your hands, it felt confident, protective, solid. The snap of the lid, the heft in your hand. Can't you just hear and feel that even now?

5. Apple Computer iPod Box
This is a beautiful mix of wonder and logic all bundled into a joyful experience. The anticipation, the unveiling of each layer—it took some time to remove the iPod from its container, and I'll bet 99% of consumers savored every moment.

 This product represents the moment when tech people finally began to appreciate and rethink package design.

6. Orangina Bottle
You can't help but smile when you see the bottle. And you can't wait to crack it open and have a sip.

7. Adidas Shoe Box
So simple—three white stripes on a blue background. As a kid, I was always an Adidas fan and looked forward every year to my one pair the "Americana" with red and blue stripes over a white nylon mesh body with suede toe, which they don't make anymore. (Deep sigh.)

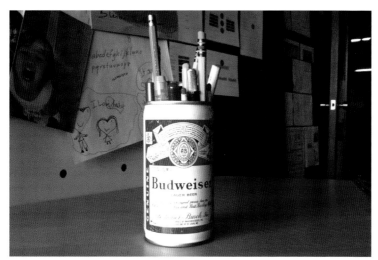

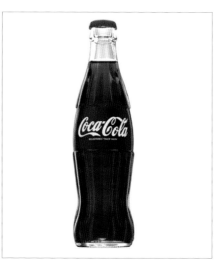

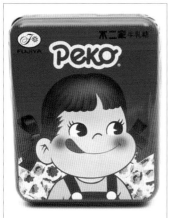

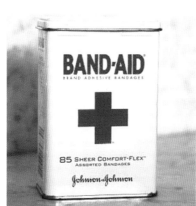

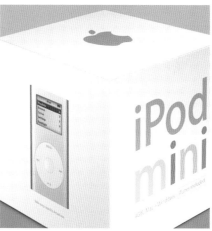

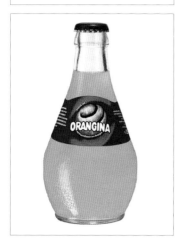

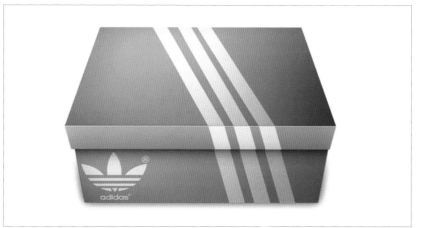

JAMES PIETRUSZYNSKI

JAMES PIETRUSZYNSKI_ James has over fifteen years of experience in brand and packaging design. He has led projects for clients such as Kraft Foods, Pepperidge Farm, General Mills, Coca-Cola, MillerCoors, Unilever, Jim Beam, and Dole Foods.

James's work has been recognized by Graphis, How, Print, Communication Arts, Mobius, London International Awards, International Brand Packaging, Creativity Annual Awards, and Creativity 35.

James is currently a member of AIGA, and AMA Chicago chapters.

He was also a judge for the 2009 Creativity Annual Awards. In his personal time, he loves digging in the dirt and watching the garden grow.

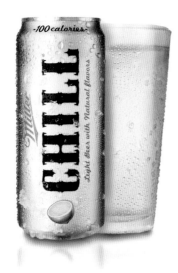

Soulsight, Partner/Creative Director

My mom has told me that before I could read, I could draw. Some of my very first drawings were of Tony the Tiger from the Kellogg's Frosted Flakes™ cereal box and Fred Flintstone from the Fruity Pebbles™ cereal box. Sitting at my grandfather's table on Saturday mornings, I would watch him taking the boxes apart and putting them back together to explain how the graphics fit together. My grandpa was not a trained structural designer, but he did work in a box factory. His lessons about packaging and the three dimensions of a structure encouraged me to appreciate the power of good design and packaging at a young age.

Great packaging can create a lasting memory in our minds, perhaps more so than a great ad campaign or promotion. Great packaging, either structurally or graphically, connects a person to a product on an emotional level. The package is the bridge that links a person and product. Through great packaging, this link makes an imprint and becomes almost part of who we choose to be. We surround ourselves with objects and people who define us as individuals, and when packaging has done its job, it becomes one of those objects that reflects our identity.

I've often wondered about becoming a packaging designer and the process of developing package design—is it influenced more by nature or nurture? Working on both iconic global brands and emerging new brands has made me realize it's always a little of both. I've realized that to create a great package you have to begin to explore and view the world not only as a designer but as an artist, an engineer, a research scientist, a psychologist, an anthropologist, and a little bit as a private investigator.

How do we begin to understand the nature of a product to create a great package design? One of my mentors once said, "In order to create a package that has a lasting impression, you must become the product. Think like the product, feel it, smell it, taste it, stare at it, and become one with it." Being able to connect to a product through our human senses helps us understand it from all vantage points. I've often joked with our colleagues that a little piece of our spirit goes into the development of a brand or package design. When we work in new product development, innovation, or brand revitalization, we are almost bringing an inanimate object to life, giving it a personality and soul. The exciting part of this process is watching something we've nurtured grow into something that connects to consumers and their culture. Once a package design or brand has connected to a consumer, it creates a relationship opportunity for that brand to become a reflection of the consumer's personal brand identity.

The packaging that we create not only tells a story about who and what we are individually, but it also reflects who we are as a society. It explains our basic human need, states our ambitions, and reveals our aspirations as a person or a people. Our individual culture and world culture have become closely connected. This connection has made it become increasingly important to see and understand brands and packaging from around the world. *The Big Book of Packaging* allows us just a glimpse of how package design helps define and create influence on different cultures. The nature of a globally connected world begins to reaffirm that the packaging that we create become the artifacts that describe our cultures. The packaging evolves as we evolve as a people.

As we have become more culturally connected, we have also become more design-centric. The power of good design is often the strategic insight that makes a brand or package successful. As consumers become more savvy, cultured, and sophisticated, it makes design and strategy more important.

A package must engage a consumer in three to five seconds, connect to them emotionally, help them understand what they are purchasing, seem authentic, and even make them feel good about the purchase.

Sometimes in order to truly connect to consumers, bold, brave moves need to be made. It's OK to be different than the rest—a little taller, a little shorter, a little brighter, or a little softer. Letting a brand's true personality shine through packaging is never fake, and if a brand can't truly be itself, it will never stand the chance of being great. This is the amazing thing about being a packaging designer. We are given the opportunity to understand the true nature of a product and then nurture it, creating and then building brands so that they become the artifacts that reflect who we are as a culture.

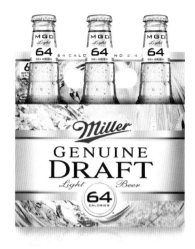

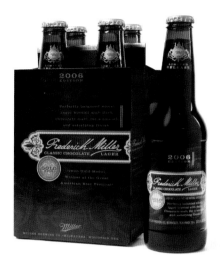

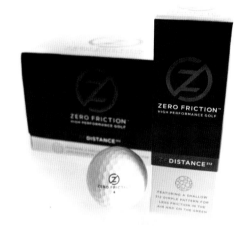

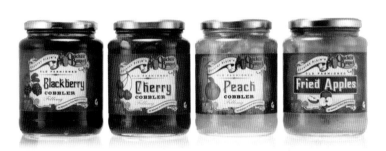

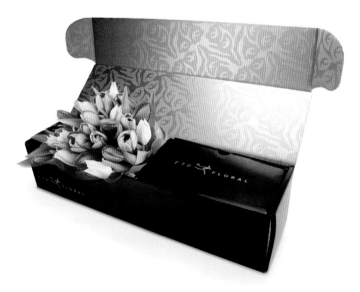

JAMES PIETRUSZYNSKI

James Pietruszynski's all-time favorite packages

1. Tootsie Roll Wrapper

As a kid, I believed that if you found a Tootsie Roll wrapper with a Native American shooting a star printed on it, you could mail it to the company and win a free Tootsie Pop in return. We probably paid more for the postage stamps than the actual Tootsie Pops themselves were worth. Now proven to be an urban legend, this word-of-mouth promotional tactic provided a great sense of mystery and marvel for the brand. Although Tootsie Roll Industries has never held any promotion involving the collection or redemption of their wrappers, it was an inspiring way to give meaning to the packaging graphics and a memorable way to engage consumers with a brand.

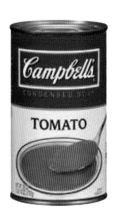

2. Push-Ups

I have always loved the packaging of the Frozen Push-Up. The interactive quality of the package becomes the ritual of the consumption experience. The innovative structure keeps the product from melting on your hands, making it truly enjoyable. The Push-Up brand will always feel simple, nostalgic, and happy. It's the classic summer treat that will never go out of style and will always "put a smile in your taste."

3. Campbell's Soup

The iconic American package of the Campbell's soup can will always be a symbol of love in my life. As a child, we would pass a Campbell's soup factory en route to my grandparents' home. I knew that when the water tower painted like an extremely large Campbell's soup can was in sight, I was minutes from seeing my grandparents. To this day, the simplicity and timelessness of this package provides the sense of comfort and joy that I felt as a child. What a great reflection of true American family values when a simple can has the ability to be that powerful.

4. Lik-M-Aid

The Lick-M-Aid package is another structural inspiration that not only provides an amazing, innovative consumption ritual but also allows the consumer to customize the sweet experience to his liking. Mixing the vanilla dipping stick into the blue raspberry, cherry, and grape sugars was like making art for your mouth with a different result in each dip. This revolutionary packaging was the young artist's palette with unlimited tasteful possibilities.

5. Drakkar Noir

The Guy Laroche Drakkar Noir cologne packaging launched a powerful masculine style and brand attitude that every man desired. The clean, simple typographic approach along with the confident masculine structure made it easy for all men to identify with. This classic simplicity and desirable attitude made it a popular choice for young men, and it remains one of the best-selling fragrances today.

6. Rubik's Cube

One particular innovative package immediately transports me back to my youth: the Rubik's Cube. I would save the outer box it came packaged in because once the cube was solved, the package served as a display box for my masterpiece. The shadow box allowed you to see and touch the final product but also tempted you to take a chance and attempt to solve it time after time. It is inspirational when great packaging can complement a great product.

7. Crayola Crayon Box

As a young artist and designer, who could not be inspired by the Crayola Crayon box with the built-in crayon sharpener? The smart functionality of the package made it possible to always have crayons just as sharp and crisp as when the box was first opened. This brilliant packaging structure provided the creative tools for any aspiring artist and was a huge catalyst for my own path as a designer.

8. Barnum's Animals Crackers

Barnum's Animals Crackers packaging will always be an inspirational brand vehicle and a pioneer in innovative package design. I love the notion that these boxes can be carried using its clever handle so you can take your favorite snack with you anywhere. The playfulness of the circus graphics allows imaginary interaction for a child, and today, my own children enjoy creating the circus train with multiple packs more than eating the product itself. It is inspiring when a package can have a secondary purpose and even more inspiring when that purpose creates joy for the young mind.

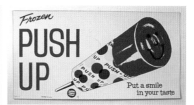

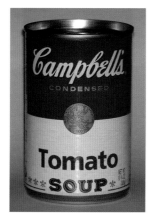
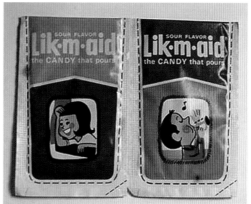

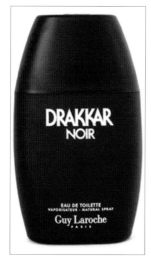
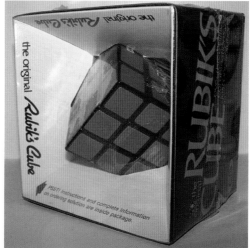

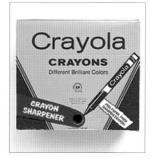
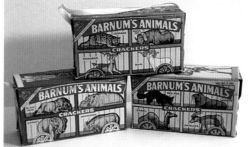

LISA BAER

LISA BAER_ Lisa Baer is the president of Baer Design Group in Evanston, IL. She is a former president of the Chicago Chapter of Women in Packaging (WIP) and actively speaks and consults with organizations about the creation, care and use of their brands. Her extensive knowledge about sustainability in packaging has led her to host a series of Green Packaging Summits, as well as blog on the topic for WIP.

Baer Design Group, President

What moves someone to buy a package? Theories change as often as the wind changes direction, but I think there is a terrific thrill in creating consumer packaging that invites, engages, and then gets put into that shopping cart. For consumer products, packaging is the primary focus of the retail environment. Muhtar Kent, CEO of Coca-Cola, recently stated, "Packaging is the single biggest driver of sales increases in the world." When the packaging connects the consumer to the product, that sweet spot delivers sales.

That's why it is so important to be able to take stock of global design trends as well as advances in the sustainability and functionality of packaging. Packaging is the first important visual interaction a product has with its customers, and *The Big Book of Packaging* is an important tool. As someone who works on creating packaging for that sweet spot, I am honored to be a part of this book and thrilled to share it with you. This book will benefit anyone involved in consumer packaged goods (CPG). Designers, marketing professionals, entrepreneurs, and students will be inspired by some of today's best consumer packaging.

What to Expect

This book provides instant access to current trends and micro-trends in packaging. Included are myriad examples of packaging as a true strategic marketing tool. The high quality of packaging design submissions for this book made choosing among them difficult. Packaging is the final result of multiple critiques, focus groups, legal reviews and approvals, manufacturing limitations, and approvals from retail buyers before the product finally lands on the retail shelf. Each package is in this book not only because it is unique and visually interesting, but because it significantly leverages the product's marketing positioning. *The Big Book of Packaging* will help you understand why some design choices work better in the marketplace.

The Unexpected

The Big Book of Packaging is one of the first books of its kind to include sustainable packaging. Nearly every segment of CPG now offers some kind of green product. This new green-packaging focus was launched back in 2006 when Walmart created the Sustainable Packaging Scorecard with the idea that it would reduce packaging and conserve resources. By utilizing smarter structural design, reducing the weight of packaging materials, and using new compostable and recyclable materials, cost savings soared and the rest of the packaging-to-retail process responded accordingly. What started out as a way to meet environmental goals became a cost-saving benefit that extended beyond packaging throughout the supply chain.

And Walmart is not alone in supporting the green packaging movement; in a recent green living report from Mintel, more than 35% of American consumers said they would pay more for environmentally friendly products. In order to support those products, packaging must be good to the earth.

I became involved in learning more about green packaging in 2006. At that time, I was president of a packaging association and created Green Packaging Summits where we explained the Walmart Sustainable Packaging Scorecard and helped the packaging industry understand green philosophies and options. As a recent judge for the Greener Package awards, I have watched brands make long-term commitments to developing new green materials and creating sustainable packaging. And, while green packaging can be most visibly about the latest materials, such as the 100% compostable PLA (polylactic acid) bags for Frito-Lay Sun Chips, for most companies it is a philosophy of green choices that reaches far beyond the package.

LISA BAER

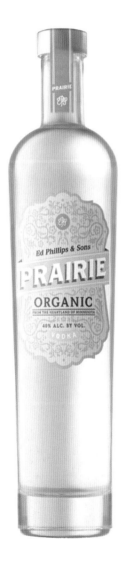

Lisa Baer's all-time favorite packages

1. iPhone Box

The initial impact of your new iPhone was not something Apple left to chance. It's obvious they wanted each consumer to feel the sensation of opening a very special present—and they wanted this sensation to last a while, hence all the neatly placed elements.

The box itself is stunning with its silver foil stamping and spot gloss lamination on a satin finish. The phone, covered with a gray cloth, is nestled within a deep, well-constructed box and cradled in a crystal-clear insert. All the cords, manuals, and other necessities are neatly hidden.

All this ink, foil, and finishes could have been tacky, but this somehow manages to be a wonderfully understated design.

All Apple packaging is impressive, but this box was small enough to keep for inspiration.

2. Archer Farms (for Target)

This package design for the grocery category fits nicely with Target's private-label program. It's traditional-yet-contemporary design transforms common food items into special treats.

Designing a unified packaging system for a brand with a large number of SKUs isn't easy, especially when you consider that new products are continually added.

3. Knob Creek

A typography-only design on a premium spirit label without a script face? This was a brave and rare thing for the designer to do. (But then, isn't all good design brave and rare?)

At the time of its introduction, this label set a new tone for packaging with its collage of Gothic type and aged-paper colors. A breakthrough design like this combines strategy and craftsmanship.

4. Nike Golf Balls

This is power design to the extreme. You can see this box from across the store and read the stacks on display from all sides. Different performance characteristics, such as control or distance, are conveyed without breaking from the line.

I don't golf much, but this package design had me dreaming of using these balls to lower my score. Now that's good packaging.

5. Praire vodka bottle label

An unexpected look sets this vodka apart by selling its organic benefits. Due to the great design and the subtle color palette, the appeal of a crafted liquor is not lost.

6. Tide

The product and the packaging are one; this is a true classic. By no means is the design an artistic statement—it's simply about bold, graphic colors and shapes, and it works.

7. Tiffany Bags, Boxes, and Satchel

One glance at Tiffany blue is all you need—you know where it came from. A large color field with a one-word logo set in an elegant, thick-and-thin serif font is a design exercise in restraint—but the brand is all about luxury. And restraint combined with luxury is a wickedly smart combination.

There's something about having a big, open canvas and putting a small mark right in the middle. To me, it says, "Oh, we've got it, but we don't have to flaunt it." That's a confident brand identity.

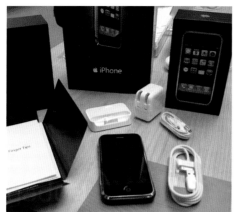

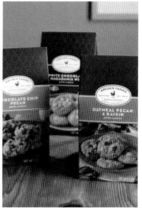

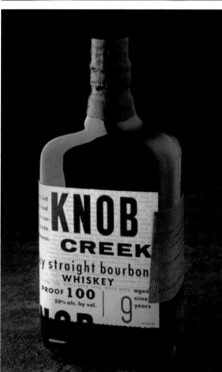

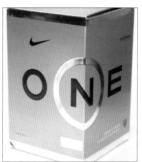

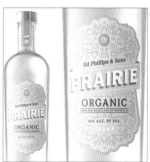

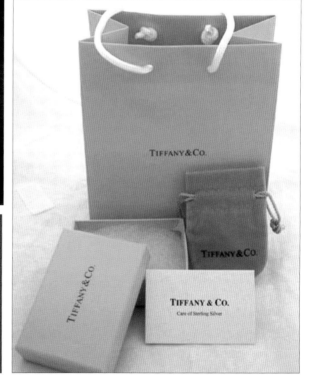

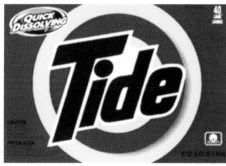

LOOKIN' GOOD:
HEALTH & BEAUTY

1. cut along solid lines
2. fold along dotted lines
3. fold the center of each corner inward
4. fold tab inward to make top

A = Front / B = Side / C = Back / D = Side / E = Bottom / F = Top

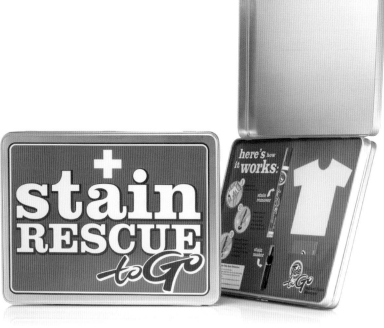

BORSAWALLACE_ NEW YORK, NY, UNITED STATES
CREATIVE TEAM: Jeffrey Wallace, Jason Davis
CLIENT: DeVries Public Relations

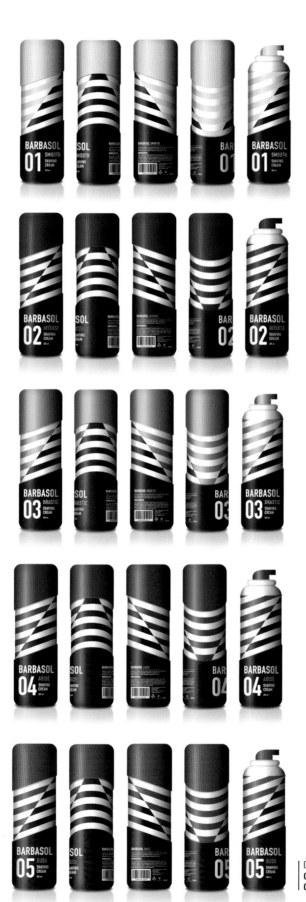

GWORKSHOP_ BARCELONA, SPAIN
CREATIVE TEAM: Jose' Luis Garcia Eguiguren
CLIENT: Student Work

21

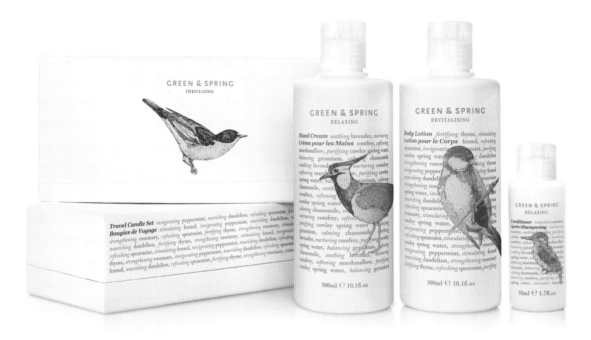

PEARLFISHER_ LONDON, UNITED KINGDOM
CREATIVE TEAM: Jonathan Ford, Natalie Chung, Sarah Butler
CLIENT: Green & Spring

GEYRHALTER DESIGN_ SANTA MONICA, CA, UNITED STATES
CREATIVE TEAM: Fabian Geyrhalter, Julia Hou
CLIENT: Quintessential Healing

AVANTGARDE DESIGN_ LODZ, POLAND
CREATIVE TEAM: Agnieszka Ziemiszewska
CLIENT: Biogened

23

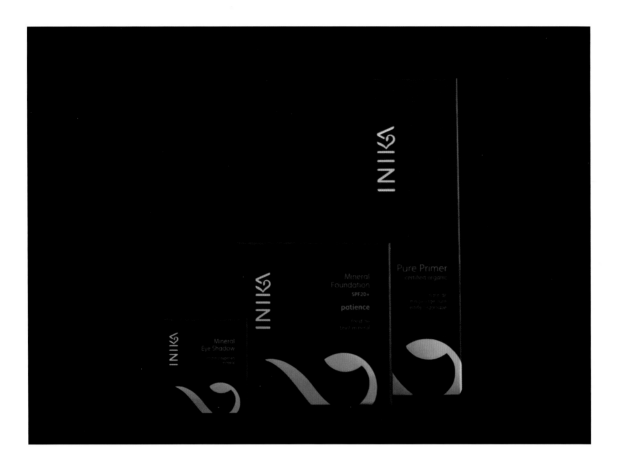

An In-Depth Look

Inika Beauty Products

"I told them exactly what I thought," said John Valastro of his first meeting with natural beauty products innovator Inika.

Valastro, Founding Partner and Creative Director of Australia's Studio Cream Design, had stumbled across Inika in the course of his own research and found them intriguing. Studio Cream Design, he said, "had never worked with a client who required so much packaging work."

So he sent them some work samples by way of introduction and presently found himself across a table from "about 12 people in a meeting room and learnt they were in the process of relaunching their packaging." They were happy with some existing aspects of their packaging but not so much with others. They asked him what he thought.

"I didn't share their enthusiasm for any of the design work they had shown me," Valastro admits. "Internally, our clients were in a state of confusion, and that confusion showed in the old designs. Their visual language was 'thrown together.' The brand image needed to be re-focused, re-defined and re-designed. The revamp of Inika packaging needed to be presented clearly for the first time, with greater visual clarity, simplicity, and focus.

"Later," he says, "I learned it was this honest, straight-to-the-point discussion I had with Inika that got us the job!"

Inika is a beauty- and personal-care products company with impressively high standards. The products contain no harsh or unsafe chemicals and come in recycled and recyclable packaging. According to their website, Inika is the only cosmetics company in the world to be 100% Certified Organic, Vegan, Cruelty Free, and Halal certified.

Valastro was suitably impressed. He wanted to give the whole line better design execution "to lift the brand up to where it deserved to be."

A beauty product first, Inika promises performance and colour that rivals traditional makeup brands, but with the added benefit of being nearly all natural. Inika is targeting a more mature and sophisticated female market (25-50) who are looking for better makeup products that replace chemicals with natural alternatives but don't compromise performance. They are sold in retail and online environments in 13 countries, including Australia, New Zealand, the UK, USA, and across Europe and Asia.

From the start, Inika was looking for a more sophisticated, modern, beauty-focused image. While they enjoyed a loyal following of environmentally conscious consumers, they didn't want the "natural" message to alienate consumers who valued beauty, glamour, and fashion.

"This project was about shifting perceptions and broadening market appeal. It needed to feel familiar to consumers as a beauty product, while introducing its added value as a natural product. Strategically, we proposed a design that visually communicated 'beauty' but, through language and iconography, introduced the 'natural' aspect as well."

From the moment they were commissioned by Inika, they had four weeks before the first product was to go into production with its new brand image

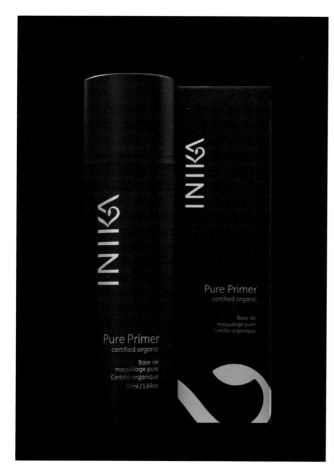

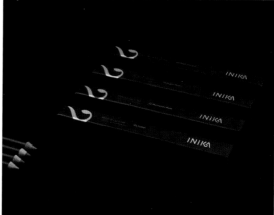

STUDIO CREAM DESIGN_ SYDNEY, AUSTRALIA
CREATIVE TEAM: John Valastro, Luisa Franco
CLIENT: Inika Pty Ltd

and packaging design. Within that four-week period, they explored multiple concepts, refined the direction of the designs, and finalized the new brand look, ready for rollout.

From there it was a staged rollout, preparing artwork for each container and box packaging, applying the new look in a consistent manner across a wide range of different shapes and sizes. The main obstacle was time. But Valastro feels the quick turn-around time forced everyone to stay focused, which is why they were able to meet their deadlines.

In the beginning there were few limitations, but eventually, creative limitations did emerge. "Limitations are a part of the design process. The major guideline was that our new designs still needed to resemble the old look." In the end, they designed a simple but strong visual DNA, a new visual language for the brand that still maintained a familiar connection with the old. Using the iconic swirl of the original branding, they arrived at a solution that was "even more Inika—clarified, focused, but still familiar." Once the new Inika look began to get out there, it was clear that the change had matured the brand, opening more doors for them than ever before.

"As a studio we are very small and very few, but we are very passionate about doing what needs to be done to create work of the highest caliber. At the end of the day, design should function as an introduction to the product and leave an indelible impression on consumers. Good design is a good investment."

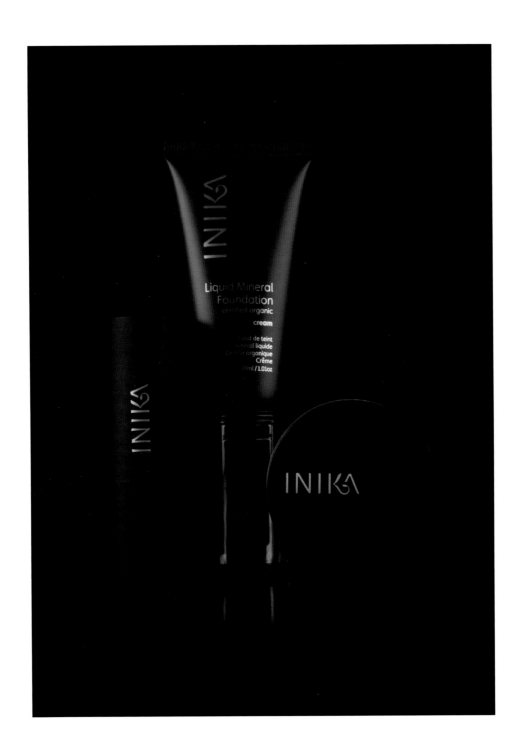

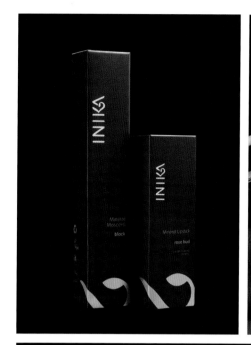

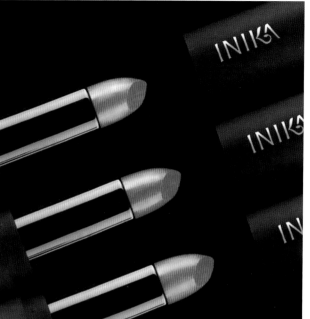

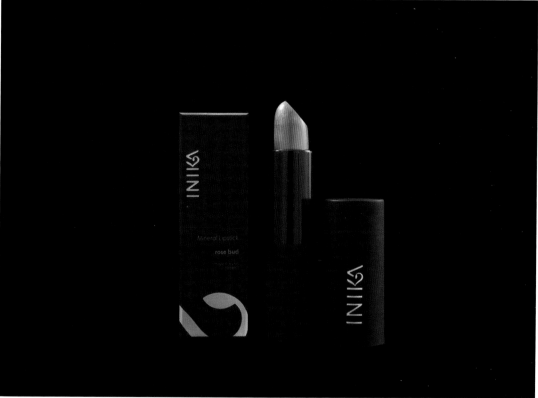

STUDIO CREAM DESIGN_ SYDNEY, AUSTRALIA
CREATIVE TEAM: John Valastro, Luisa Franco
CLIENT: Inika Pty Ltd

28

| STUDIO ONE ELEVEN - A DIVISION OF BERLIN PACKAGING_ CHICAGO, IL, UNITED STATES
CREATIVE TEAM: Studio One Eleven - A division of Berlin Packaging
CLIENT: Chattem

| CASA REX_ SÃO PAULO, BRAZIL
CREATIVE TEAM: Gustavo Piqueira, Danilo Helvadjian, Lilian Meireles, Luiz Sanches
CLIENT: Unilever Brazil

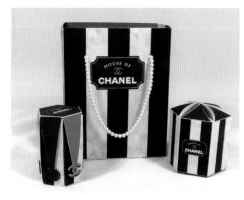

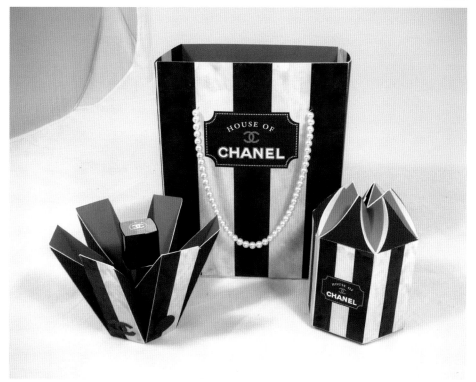

DREXEL UNIVERSITY, ANTOINETTE WESTPHAL COLLEGE OF MEDIA ARTS & DESIGN_
PHILADELPHIA, PA, UNITED STATES
CREATIVE TEAM: Cariese Bartholomew, Jody Graff
CLIENT: Student Work

29

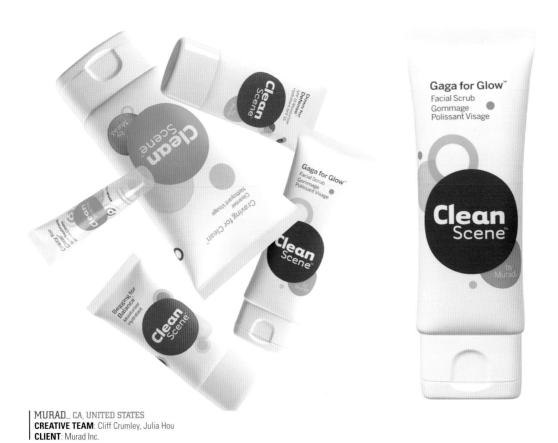

MURAD_ CA, UNITED STATES
CREATIVE TEAM: Cliff Crumley, Julia Hou
CLIENT: Murad Inc.

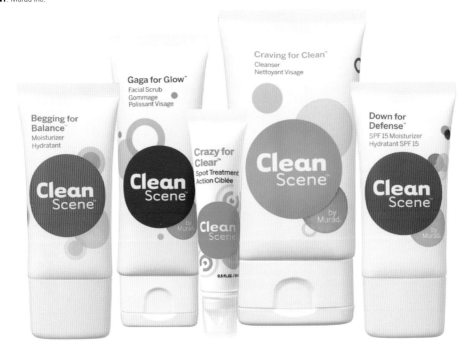

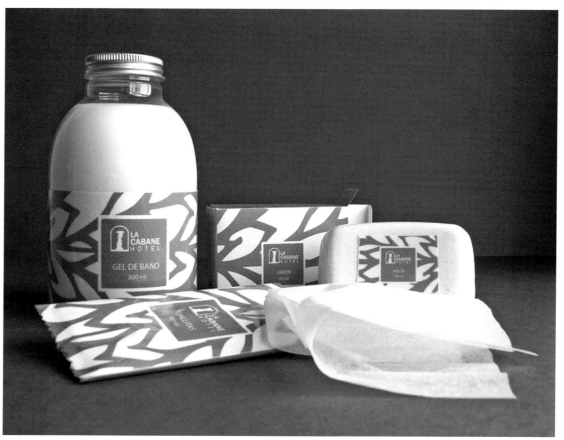

SALVARTES DISEÑO Y ESTRATEGIAS DE COMUNICACIÓN_ CÁDIZ, SPAIN
CREATIVE TEAM: Salva Garcia-Ripoll Toledano, Manu Vazquez
CLIENT: Hotel La Cabane

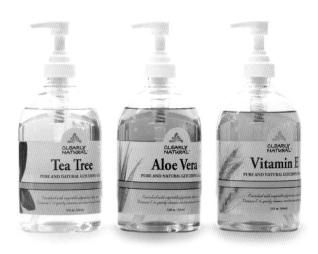

ENFORME INTERACTIVE_ FREDERICK, MD, UNITED STATES
CREATIVE TEAM: Sue Hough
CLIENT: Beaumont Products, Inc.

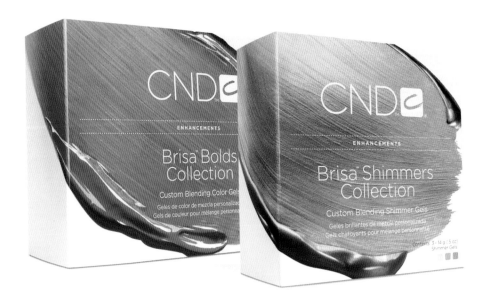

MIRESBALL_ SAN DIEGO, CA, UNITED STATES
CREATIVE TEAM: John Ball, Jenny Goddard, Kristi Jones
CLIENT: CND

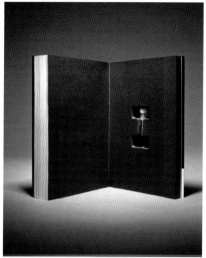

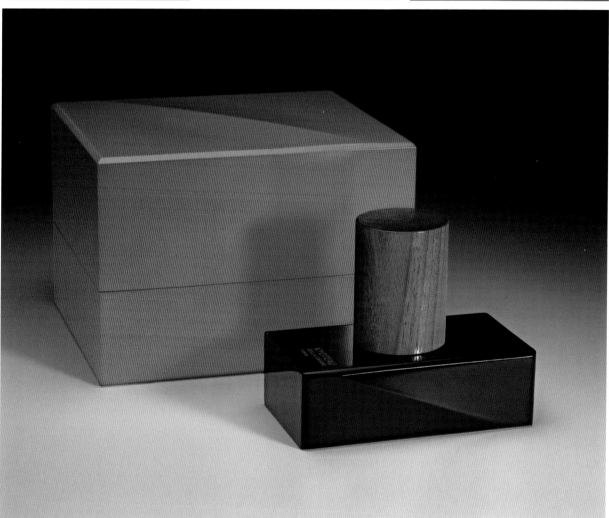

DELLA CHUANG STUDIO_ NEW YORK, NY, UNITED STATES
CREATIVE TEAM: Della Chuang, Ying-Ling Lee
CLIENT: Garden City Publishers

LITTLE BIG BRANDS_ NYACK, NY, UNITED STATES
CREATIVE TEAM: Karen Murabito, John Nunziato,
CLIENT: Lornamead, Inc.

TFI ENVISION, INC._ NORWALK, CT, UNITED STATES
CREATIVE TEAM: Elizabeth P. Ball, Chris Plaisted
CLIENT: Unilever Home & Personal Care USA

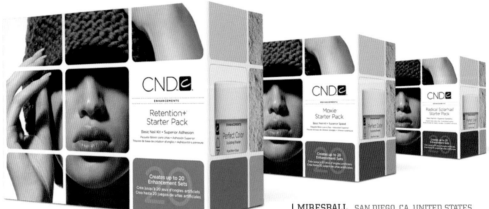

MIRESBALL_ SAN DIEGO, CA, UNITED STATES
CREATIVE TEAM: John Ball, Jenny Goddard, Ashley Kerns, Kristi Jones
CLIENT: CND

34

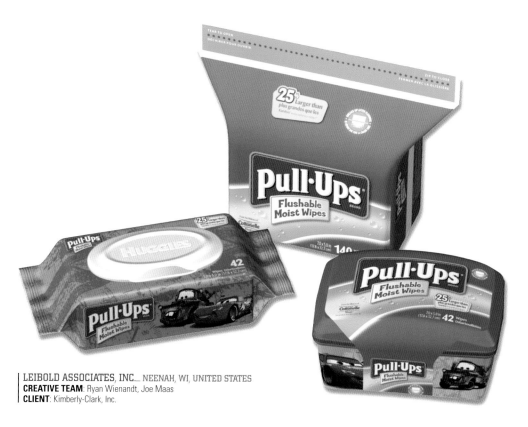

LEIBOLD ASSOCIATES, INC.__ NEENAH, WI, UNITED STATES
CREATIVE TEAM: Ryan Wienandt, Joe Maas
CLIENT: Kimberly-Clark, Inc.

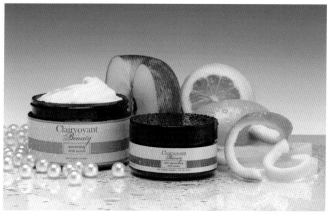

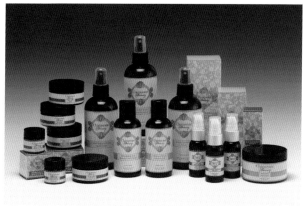

HYPELIFE BRANDS__ KANSAS CITY, MO, UNITED STATES
CREATIVE TEAM: Curt Cuscino, Thomas Stock for stockstudiosphotography.com
CLIENT: Clairvoyant Beauty

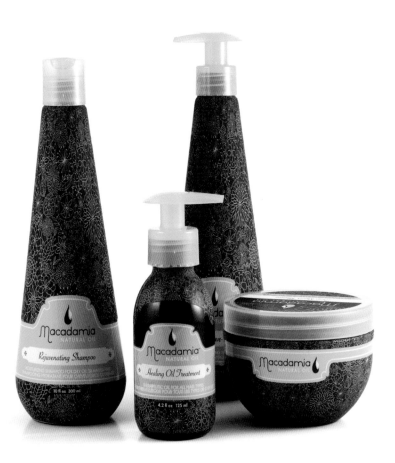

An In-Depth Look

Macadamia Nut Oil hair care products

"We wanted to do something that was really different for the professional beauty industry," says Chris Fasan, Creative Director of Version-X Design Corp., of the from-the-ground-up design they created for the Macadamia Natural Oil line of professional beauty products. "We wanted it to come across as a modern twist on 'natural.'"

"The main ingredient in the line is macadamia nut seed oil. But there's also a secondary ingredient called argan oil, and the two have widely different histories; each ingredient has a story of its own. Macadamia oil has a tropical connection with Hawaii, a South Pacific influence. But argan oil is from the North African Berber region, in the Southwest of Morocco, and it has a sort of Middle-Eastern, desert story. We didn't want the design to come across as either of those exactly, but as something that evoked both. And that was the challenge."

Version-X Design Corp met that challenge with a Maui-meets-Marrakesh design that suits the high-end locations where Macadamia Natural Oil products can be found. In order to achieve a design that was different enough to truly stand out, they wanted to go beyond a simple screened bottle; what they really wanted to try was a shrink sleeve. But there were certain pitfalls they wanted to avoid.

"These are expensive products that are sold in exclusive salons, and we couldn't have the bottles looking like an energy drink or a vitamin water from the supermarket. We had to explore ways to make the shrink process look more high-end. The main thing we wanted was to get rid of the awful

shininess. We wanted a matte finish, but not a total matte finish. In the end, we left some of the gloss showing through so that the green area would have that glossy sheen, but the rest would be matte. It worked out really well."

"From a design standpoint, where the sky's the limit as far as what you can do with a shrink sleeve, we could have gone crazy with photography or gradients, but we chose to go simple, and that kept the elegance," says Senior Designer Adam Stoddard. "We had spot varnish and six spot colors going on, all at 100%, and we didn't really do any four-color printing. We extracted the color palettes directly from the macadamia." A macadamia nut has several layers—a bright, vibrant green outer shell, an inner, hard, dark brown shell, and the actual meat of the nut was the inspiration for the pale beige in the delicate patterns on the bottles.

"Due to the nature of the oil itself, there were a few limitations we had to live with," says Fasan. "We knew we had to use a tinted glass bottle, but otherwise, the client left the designs to our discretion, creatively." They chose the larger, 10-ounce bottle shape because it alluded to a drop of oil. "We just couldn't see putting these distinctive products into standard-shaped bottles. They needed a Middle Eastern vibe; the shape of the masque jar has those strong connotations.

"The only bottle that is fairly standard, with more sloped shoulders, is the oil bottle. We initially played around with having a label on the glass bottle, but that didn't work. So we included a little clear window that kind of

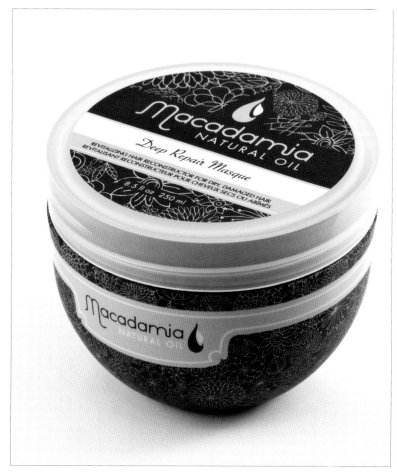

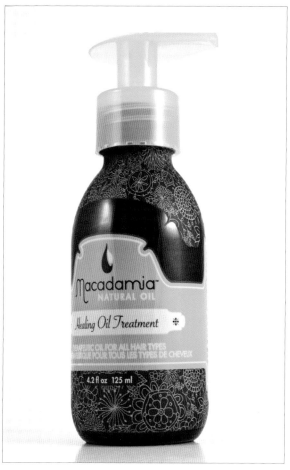

VERSION-X DESIGN CORP_ BURBANK, CA, UNITED STATES
CREATIVE TEAM: Chris Fasan, Adam Stoddard
CLIENT: Macadamia Natural Oil

flows with the shape of the green, because when you had the full sleeve on the glass bottle, you couldn't see the product at all. That last, finishing touch really made that product stand out."

They had a relatively short timeline—roughly March to June to design all the packaging, do the logo, make the prototypes, write the copy—in order to have everything ready in time for the July trade show. They were worried about how the shrink sleeve would come out, but even it exceeded their hopes. "There was a lot of back-and-forth with vendors to make sure it was on straight, and shrunk tight, and looking as good as possible, because—especially on the teardrop bottle—there's a lot of room for sleeves to be applied inaccurately, and when those things are on crooked…" But in the end, everything really worked. And it's been incredibly well-received.

"The client debuted the brand in July 2009, it was in salons that September, and now the line is flying off of shelves pretty much all over the world. It's really amazing how quickly it's taken off."

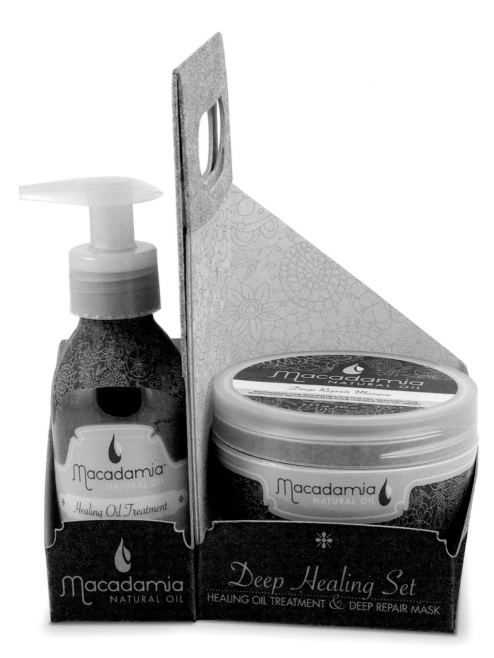

VERSION-X DESIGN CORP_ BURBANK, CA, UNITED STATES
CREATIVE TEAM: Chris Fasan, Adam Stoddard
CLIENT: Macadamia Natural Oil

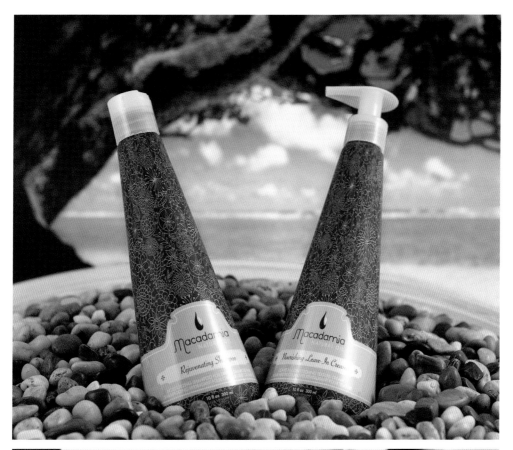

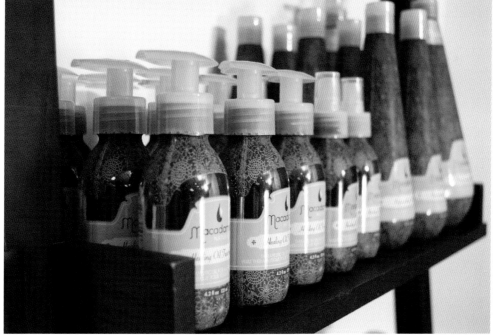

LIDIA VARESCO DESIGN_ CHICAGO, IL, UNITED STATES
CREATIVE TEAM: Lidia Varesco, Justin Blair, Rick Daitchman
CLIENT: Justin Blair & Company

LCDA_ SAN DIEGO, CA, UNITED STATES
CREATIVE TEAM: Laura Coe Wright, Tracy Castle
CLIENT: Oasis Medical

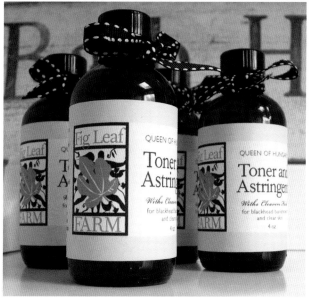

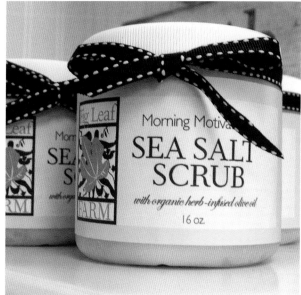

FARM STRATEGIC GRAPHIC DESIGN _ SANTA ROSA, CA, UNITED STATES
CREATIVE TEAM: Alana Jelinek
CLIENT: FIG LEAF FARM

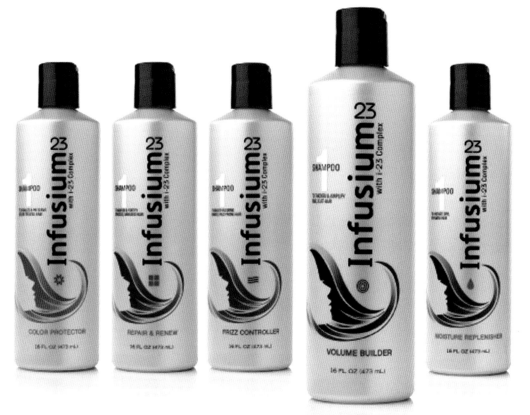

SPRING DESIGN PARTNERS, INC. _ NEW YORK, NY, UNITED STATES
CREATIVE TEAM: Ron Wong
CLIENT: Idelle Labs, Inc.

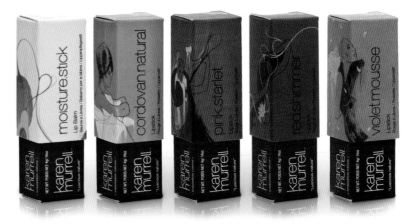

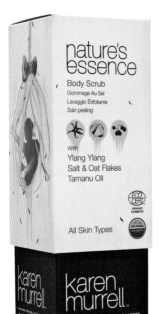

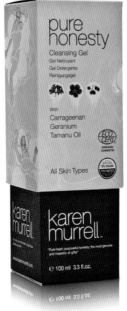

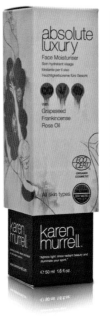

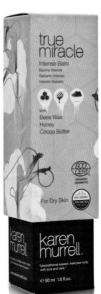

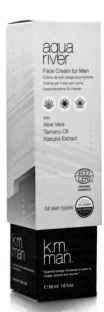

42

MATA LIMITED_ AUCKLAND, NEW ZEALAND
CREATIVE TEAM: Matthew Allen, Andrew Archer
CLIENT: Karen Murrell

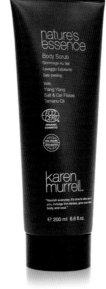

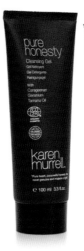

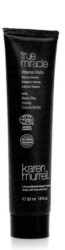

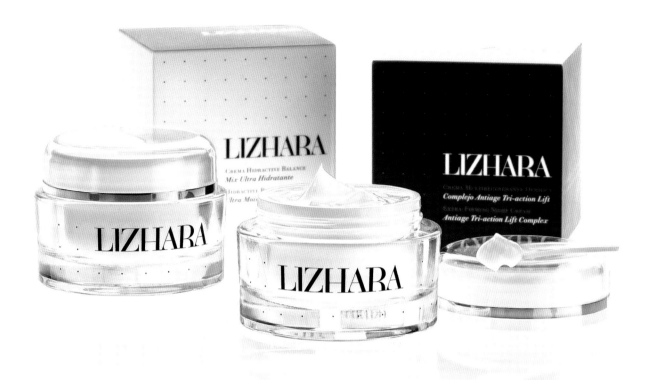

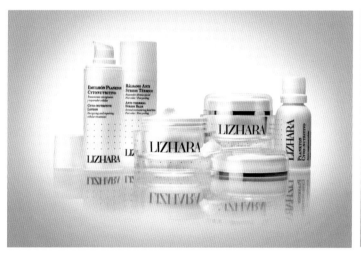

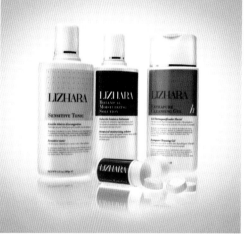

43

| TRIDIMAGE _ BUENOS AIRES, ARGENTINA
| **CREATIVE TEAM**: Adriana Cortese, Hernán Braberman, Virginia Gines
| **CLIENT**: Laboratorios Firenze

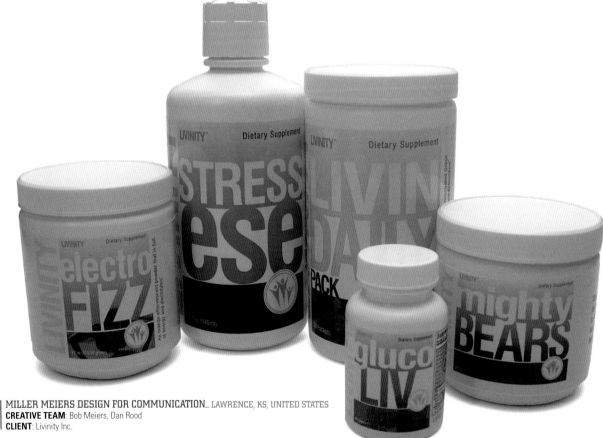

MILLER MEIERS DESIGN FOR COMMUNICATION_ LAWRENCE, KS, UNITED STATES
CREATIVE TEAM: Bob Meiers, Dan Rood
CLIENT: Livinity Inc.

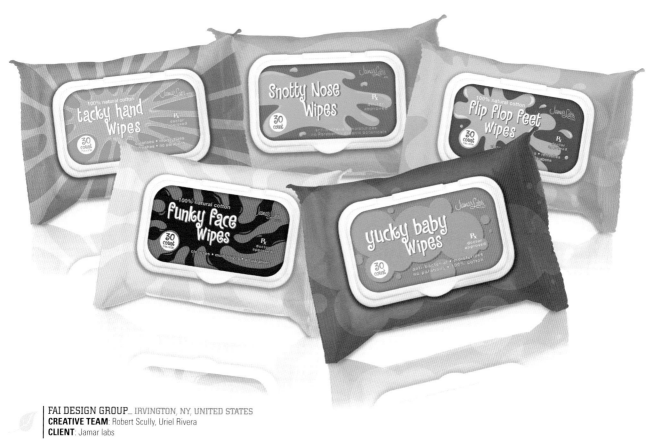

FAI DESIGN GROUP_ IRVINGTON, NY, UNITED STATES
CREATIVE TEAM: Robert Scully, Uriel Rivera
CLIENT: Jamar labs

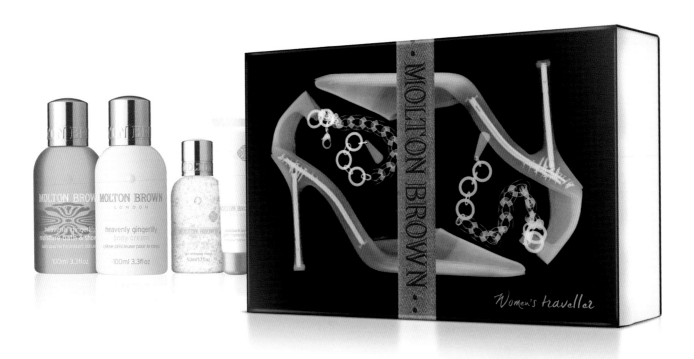

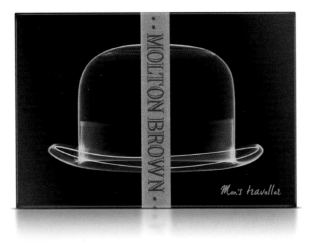

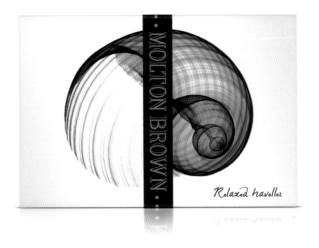

BRANDHOUSE_ LONDON, UNITED KINGDOM
CREATIVE TEAM: David Beard, Bronwen Edwards, Keely Jackman
CLIENT: Molton Brown

CORNERSTONE STRATEGIC BRANDING_ NEW YORK, NY, UNITED STATES
CREATIVE TEAM: Cornerstone Creative Staff
CLIENT: Bertin-Mcleny Distributors

BORSAWALLACE_ NEW YORK, NY, UNITED STATES
CREATIVE TEAM: Jason Davis, Cecilia Molina, Tae Kim, Cristina Ortega
CLIENT: DeVries Public Relations

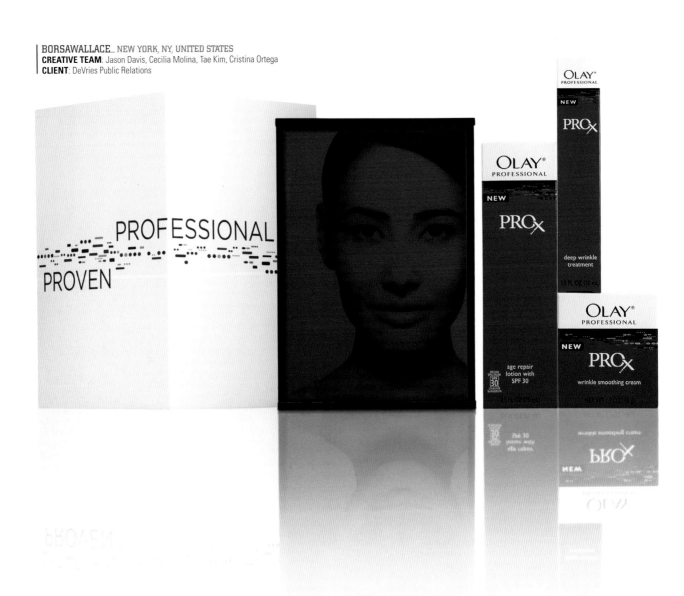

SHIKATANI LACROIX_ TORONTO, ON, CANADA
CREATIVE TEAM: Richard Dirstein, Kim Yokota, Murtuza Kitabi
CLIENT: Purity Life

49

AVANTGARDE DESIGN_ LODZ, POLAND
CREATIVE TEAM: Agnieszka Ziemiszewska
CLIENT: Glancos

50

REGGS_ AMSTERDAM, NETHERLANDS
CREATIVE TEAM: Leonie van Dorssen
CLIENT: Kruidvat

SELLIER DESIGN_ MARIETTA, GA, UNITED STATES
CREATIVE TEAM: Pauline Pellicer
CLIENT: Bodifresh

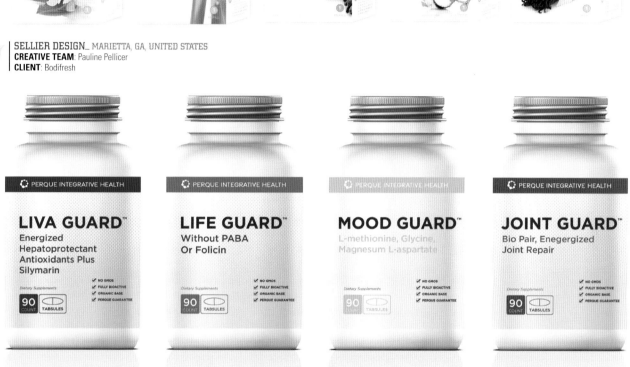

MOTTO AGENCY_ MYRTLE BEACH, SC, UNITED STATES
CREATIVE TEAM: Sunny Bonnell, Ashleigh Hansberger
CLIENT: PERQUE Integrative Healthcare

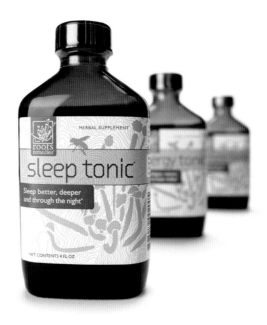

52

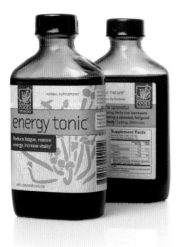

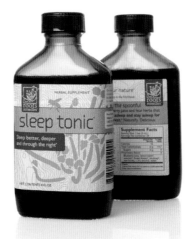

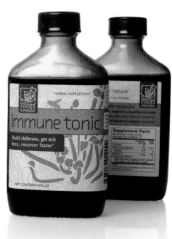

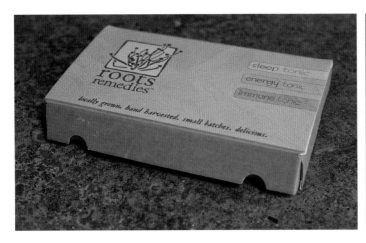

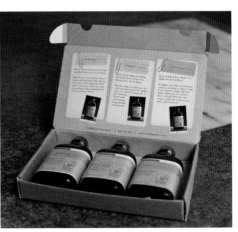

YAM BRAND_ SEATTLE, WA, UNITED STATES
CREATIVE TEAM: Angela Mack, Michael Young
CLIENT: Roots Remedies

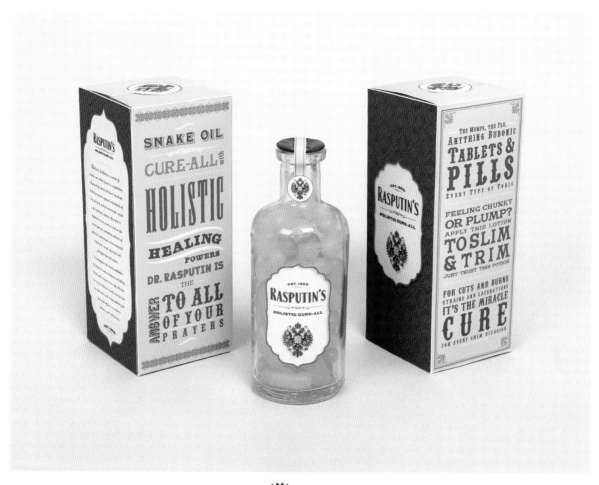

TYLER SCHOOL OF ART_ WARRINGTON, PA, UNITED STATES
CREATIVE TEAM: Jamielynn Miller
CLIENT: Tyler School of Art, Temple University

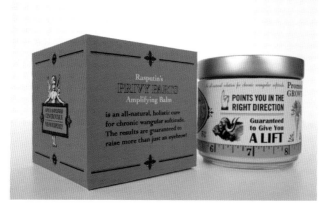

DESIGN BLISS_ PHILADELPHIA, PA, UNITED STATES
CREATIVE TEAM: Christine Fajardo, Paul Sherif
CLIENT: Tyler School of Art, Temple University

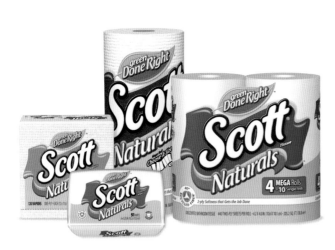

LEIBOLD ASSOCIATES, INC._ NEENAH, WI, UNITED STATES
CREATIVE TEAM: Ryan Wienandt, Joe Maas
CLIENT: Kimberly-Clark, Inc.

STUDIO ONE ELEVEN - A DIVISION OF BERLIN PACKAGING_
CHICAGO, IL, UNITED STATES
CREATIVE TEAM: Studio One Eleven A Division of Berlin Packaging
CLIENT: Colgate Palmolive

54

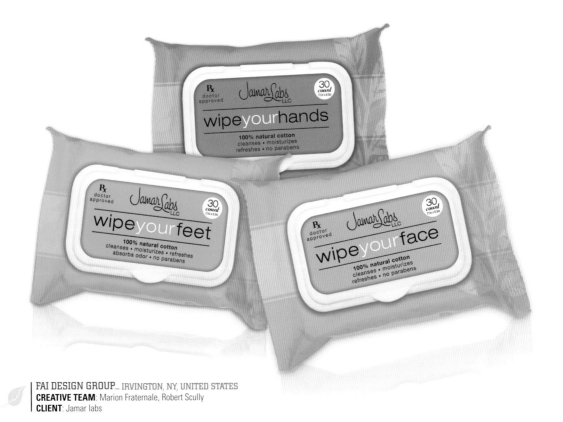

FAI DESIGN GROUP_ IRVINGTON, NY, UNITED STATES
CREATIVE TEAM: Marion Fraternale, Robert Scully
CLIENT: Jamar labs

GREY GROUP/WING_ NY, UNITED STATES
CREATIVE TEAM: Mengwen Xiang
CLIENT: AKL

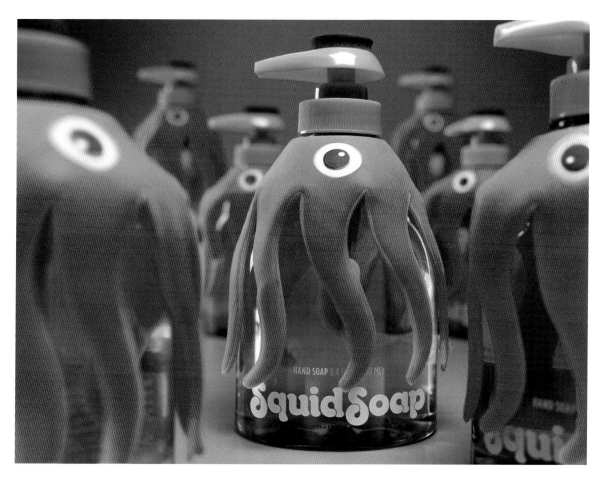

PENTAGRAM DESIGN_ AUSTIN, TX, UNITED STATES
CREATIVE TEAM: DJ Stout, Julie Savasky
CLIENT: Squid Soap

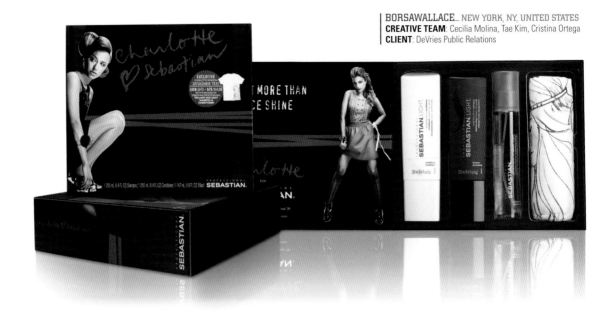

BORSAWALLACE_ NEW YORK, NY, UNITED STATES
CREATIVE TEAM: Cecilia Molina, Tae Kim, Cristina Ortega
CLIENT: DeVries Public Relations

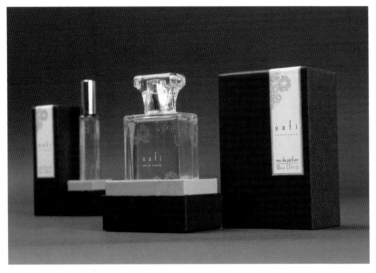

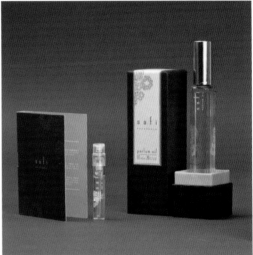

DARLING DESIGN, INC._ NEW YORK, NY, UNITED STATES
CREATIVE TEAM: Sarah Skapik, Courtney Darling
CLIENT: Safi Fragrance

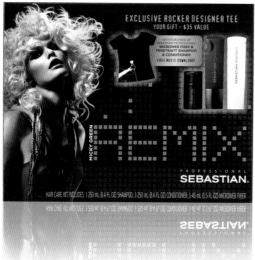

BORSAWALLACE_ NEW YORK, NY, UNITED STATES
CREATIVE TEAM: Cecilia Molina, Tae Kim, Cristina Ortega
CLIENT: DeVries Public Relations

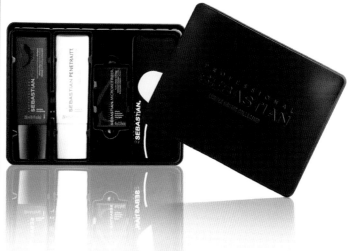

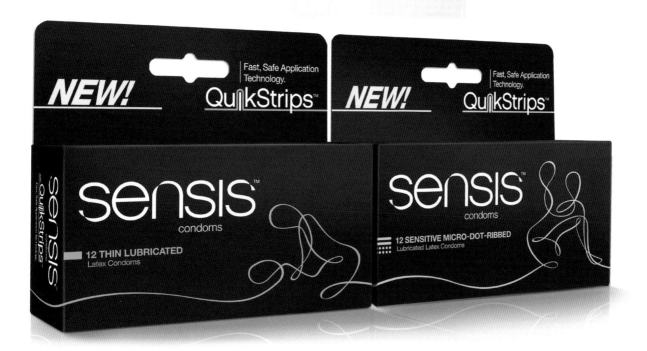

SPRING DESIGN PARTNERS, INC_ NEW YORK, NY, UNITED STATES
CREATIVE TEAM: Ron Wong
CLIENT: Grove Medical

57

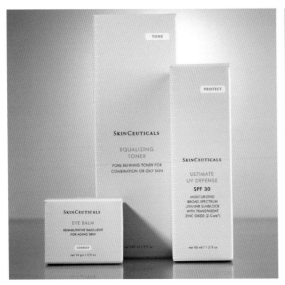

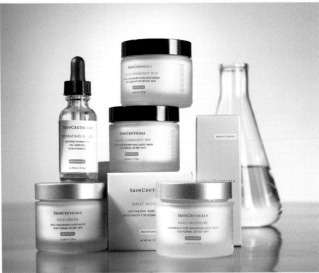

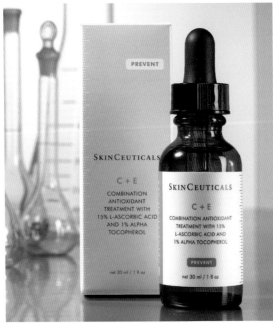

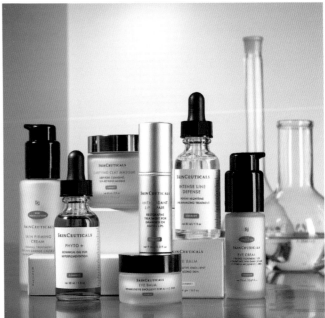

| **PENTAGRAM DESIGN_** AUSTIN, TX, UNITED STATES
CREATIVE TEAM: DJ Stout, Julie Savasky
CLIENT: Skinceuticals

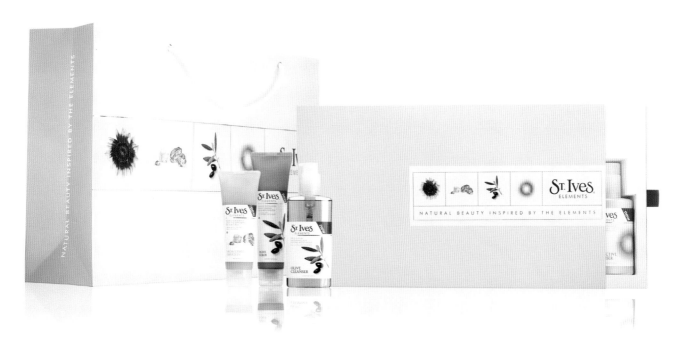

BORSAWALLACE_ NEW YORK, NY, UNITED STATES
CREATIVE TEAM: Cecilia Molina, Tae Kim, Cristina Ortega
CLIENT: Kaplow Communications

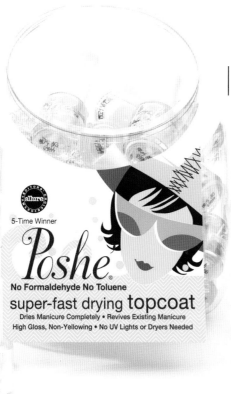

INKY LIPS LETTERPRESS_ MCKINNEY, TX, UNITED STATES
CREATIVE TEAM:Casey McGarr
CLIENT: Poshé

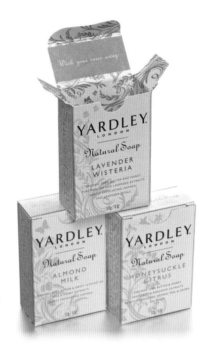

LITTLE BIG BRANDS_ NYACK, NY, UNITED STATES
CREATIVE TEAM: Deidre Williams, John Nunziato, Stephen Shirak
CLIENT: Lornamead, Inc.

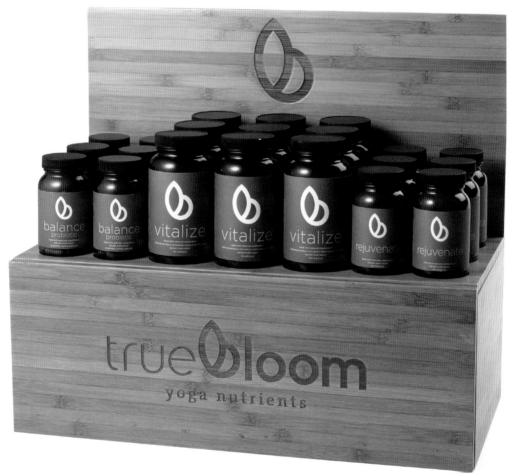

SW!TCH STUDIO_ TEMPE, AZ, UNITED STATES
CREATIVE TEAM: Jim Nissen, Kris Olmon, Erin Loukili, Chaidi Lobato
CLIENT: True Bloom

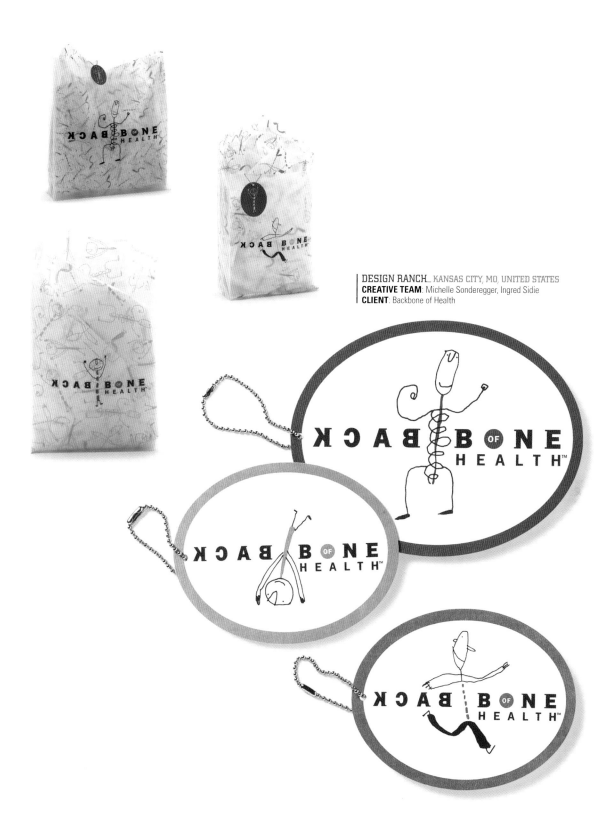

DESIGN RANCH_ KANSAS CITY, MO, UNITED STATES
CREATIVE TEAM: Michelle Sonderegger, Ingred Sidie
CLIENT: Backbone of Health

61

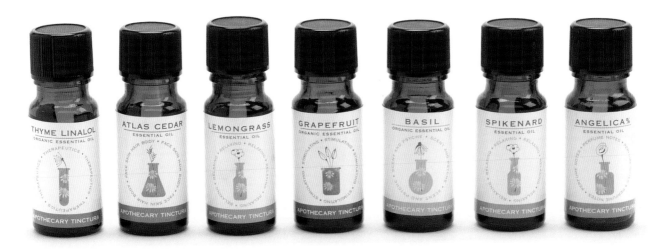

DESIGN RANCH_ KANSAS CITY, MO, UNITED STATES
CREATIVE TEAM: Michelle Sonderegger, Ingred Sidie
CLIENT: Apothecary Tinctura

62

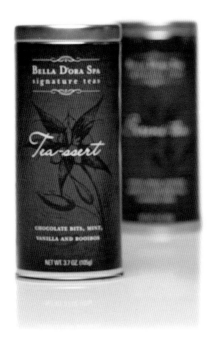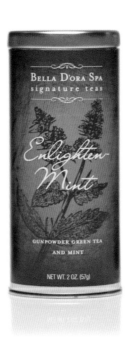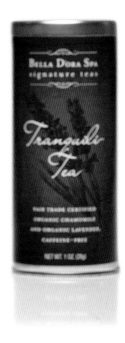

JENN DAVID DESIGN_ SAN DIEGO, CA, UNITED STATES
CREATIVE TEAM: Jenn David Connolly
CLIENT: Bella D'ora Spa

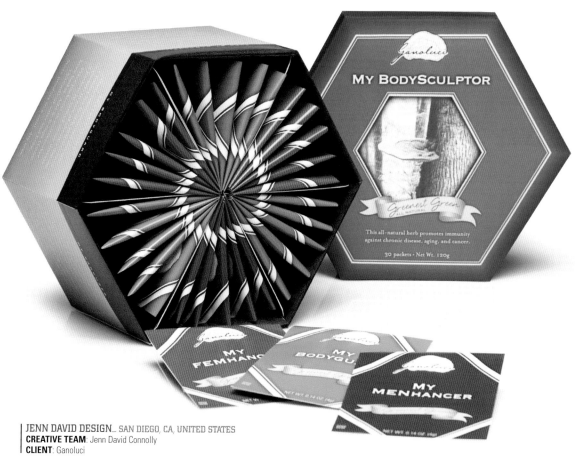

JENN DAVID DESIGN_ SAN DIEGO, CA, UNITED STATES
CREATIVE TEAM: Jenn David Connolly
CLIENT: Ganoluci

THE O GROUP_ NEW YORK, NY, UNITED STATES
CREATIVE TEAM: Jason B. Cohen, J. Kenneth Rothermich
CLIENT: O'mai

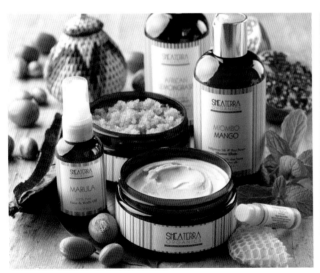

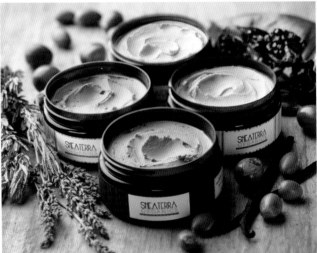

INDEPENDENT/FREELANCE_ VA, UNITED STATES
CREATIVE TEAM: Darren Kurre
CLIENT: Darren Kurre

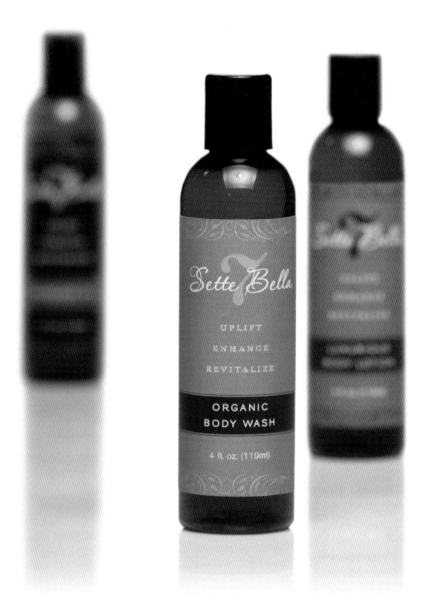

JENN DAVID DESIGN_ SAN DIEGO, CA, UNITED STATES
CREATIVE TEAM: Jenn David Connolly
CLIENT: Bella D'ora Spa

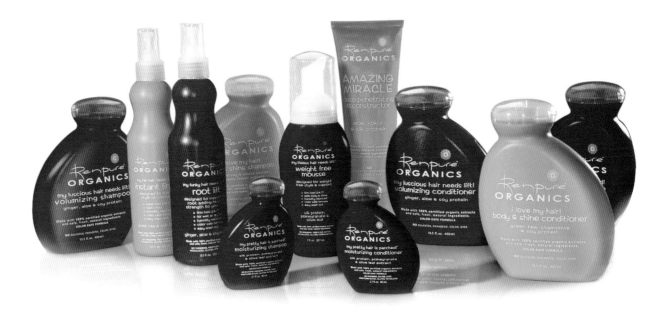

An In-Depth Look

Renpure Organics Hair Care

The name "Renpure" stems from the word *ren*—Mandarin for *"honest."* That, plus a concept and the formulations for a line of hair-care products with no sulfates, parabens, or dyes, was all Tom Redmond—of the legendary "Redmond" Aussie brand hair-care fame—had in hand when he came to Studio One Eleven on the recommendation of a sales representative.

"Studio One Eleven had an in-depth understanding of what we were trying to do," says Redmond. "It felt like we were their only customer. When we need something, they jump right on it; their turnaround time is amazing."

"Without sounding too sentimental about it, we love our client," says Scott Jost, Studio Director at Studio One Eleven. "The reason we're able to respond so quickly is because we're dealing with Tom directly—he's the decision maker. There weren't layers to penetrate or committees to consult. Tom was always accessible, always available. It was an ideal scenario."

So when Redmond—who, as Jost notes, "operates from a 'gut feel' branding playbook, and it works"—offered license to design a package that would be truly unique to the category, his accessibility, combined with Studio One Eleven's innovative business model, brought a complex bottle from concept to production in less than eight months.

The Renpure bottle, nicknamed the "chicks' bottle," is a design that "engineering and operations folks furrow their brows over. There isn't a

straight line on it, it's a challenge to decorate and to cap, and the custom neck finish pushes blow molding processes to the limit. In the traditional model, the design firm delivers 'options' then departs from the process. You're left to figure out who in the world is going to make the parts and hope that they'll work together. In our case, the whole process is handled in-house because we're ultimately supplying all the components. It's an end-to-end turnkey model that aligns our interests with those of our clients," says Jost of the relationship between Studio One Eleven and its $600 million parent firm Berlin Packaging.

The studio began with pre-design analysis, looking to the fresh produce aisle for inspiration. They settled on six solutions, some easy to produce, some not, but they knew the more challenging designs would change the category.

"We advised Tom that he shouldn't launch this new brand in something generic," says creative director Richard Barkaway. "Hence the chicks' bottle." In addition to baby chicks, the bottle evokes a fruit or vegetable with its fresh, bright color palette. The pure white typography mirrors its positioning. The Asian-inspired "Renpure" lettering is hand-drawn. Berlin Packaging made the prototypes in-house, sourced the bottles domestically and the caps from China, and focused on expanding their market—

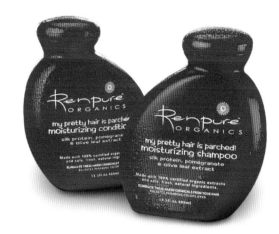

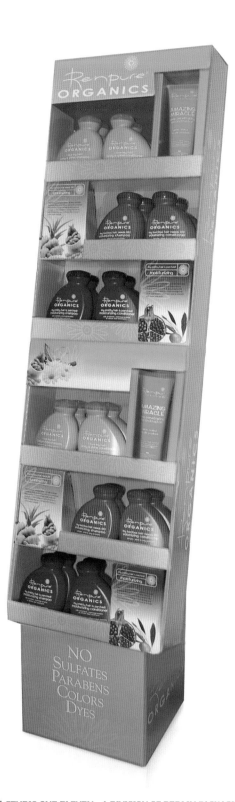

"predominantly female, thirty five—your white-hot target demographic—but well-read, high-involvement. The no-sulfates/no-parabens claim was so far ahead of its time that we had to bring people into the franchise via the shape, the colors, the excitement of the pack—folks who might not be highly involved but that we could get up to speed through trial."

When Redmond brought the product to an ECRM trade show—an event that Jost describes as "like speed-dating for manufacturers and retailers"—he received interest from every account. They're on track to be in fourty thousand stores in North America in 2010. And Redmond is excited about the next generations of Renpure Organics designs. "It's going to be another one of those "holy shit!" designs," he says. "That's key in our industry. You've got to stand out on shelf. You've got to be lucky. And you've got to have good partners.

"These designers have no boundaries," Redmond marvels, "no preconceived ideas of 'we can go this far and no farther.' And the TLC you get from them—they really are a partner in your business.

"Here's an example of the difference. We have roughly thirteen new items that Studio One Eleven has designed. They're not ready to roll out yet. We have literally one month before I have to show finished goods to all my retailers, and I'm not in panic mode. It's an extremely good feeling to know you have that kind of support."

STUDIO ONE ELEVEN - A DIVISION OF BERLIN PACKAGING
CHICAGO, IL, UNITED STATES
CREATIVE TEAM: Studio One Eleven
CLIENT: Renpure Organics

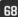

STUDIO ONE ELEVEN - A DIVISION OF BERLIN PACKAGING_
CHICAGO, IL, UNITED STATES
CREATIVE TEAM: Studio One Eleven
CLIENT: Renpure Organics

Renpure™
ORGANICS

my luscious hair needs lif
volumizing condition
ginger. aloe & soy protei

Made with **100%** certified organic e
and safe, fresh, **natural** ingredie

ELIMINATE THESE HARSH CHEMICALS FROM YO
SULFATES,PARABENS,COLORS,DYES

13.5fl.oz. 400ml

i lo
body & g
hydrolyzed
chamom

Made with **100%** c
and safe, fresh

ELIMINATE THESE HARS
SULFATES,PAR

Renpure
ORGANICS

my pretty hair is parched!
moisturizing shampoo
silk protein, pomegranate
& olive leaf extract

Made with **100%** certified organic extracts
and safe, fresh, natural ingredients.
ELIMINATE THESE HARSH CHEMICALS FROM YOUR HAIR
SULFATES, PARABENS, COLORS, DYES

13.5fl.oz. 400ml

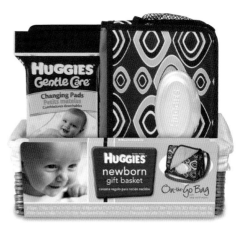

LEIBOLD ASSOCIATES, INC._NEENAH, WI, UNITED STATES
CREATIVE TEAM: Ryan Wienandt, Jason Konz, Joe Maas, Cindy Gullikson, Steve Zirbes
CLIENT: Kimberly-Clark, Inc.

LEIBOLD ASSOCIATES, INC._ NEENAH, WI, UNITED STATES
CREATIVE TEAM: Ryan Wienandt, Therese Joanis, Mark Vanden Berg, Heidi Vanden Boom
CLIENT: Kimberly-Clark, Inc.

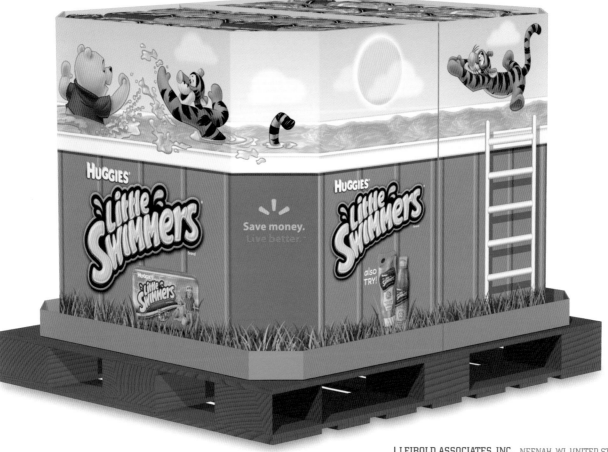

LEIBOLD ASSOCIATES, INC._ NEENAH, WI, UNITED STATES
CREATIVE TEAM: Ryan Wienandt, Jason Konz, Joe Maas, Cindy Gullikson, Steve Zi
CLIENT: Kimberly-Clark, Inc.

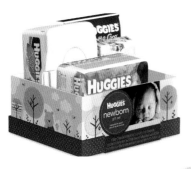
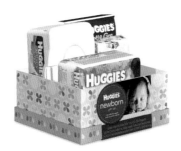

LEIBOLD ASSOCIATES, INC._ NEENAH, WI, UNITED STATES
CREATIVE TEAM: Ryan Wienandt, Jake Weiss, Mark Vanden Berg
Heidi VanderBoom, Lisa Kocourek, Cindy Gullikson
CLIENT: Kimberly-Clark, Inc.

LEIBOLD ASSOCIATES, INC._ NEENAH, WI, UNITED STATES
CREATIVE TEAM: Ryan Wienandt, Therese Joanis, Mark Vanden Berg
CLIENT: Kimberly-Clark, Inc.

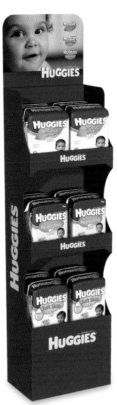

LEIBOLD ASSOCIATES, INC._ NEENAH, WI, UNITED STATES
CREATIVE TEAM: Ryan Wienandt, Therese Joanis, Mark Vanden Berg, Heidi VanderBoom
CLIENT: Kimberly-Clark, Inc.

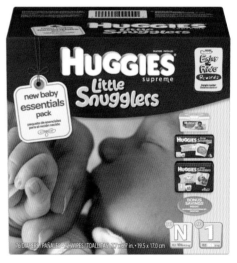

LEIBOLD ASSOCIATES, INC._ NEENAH, WI, UNITED STATES
CREATIVE TEAM: Jake Weiss, Nick Maggio, Mark Vanden Berg
CLIENT: Kimberly-Clark, Inc.

LEIBOLD ASSOCIATES, INC._ NEENAH, WI, UNITED STATES
CREATIVE TEAM: Jane Oliver, Jake Weiss,
Mark Vanden Berg, Heidi Vanden Boom
CLIENT: Kimberly-Clark, Inc.

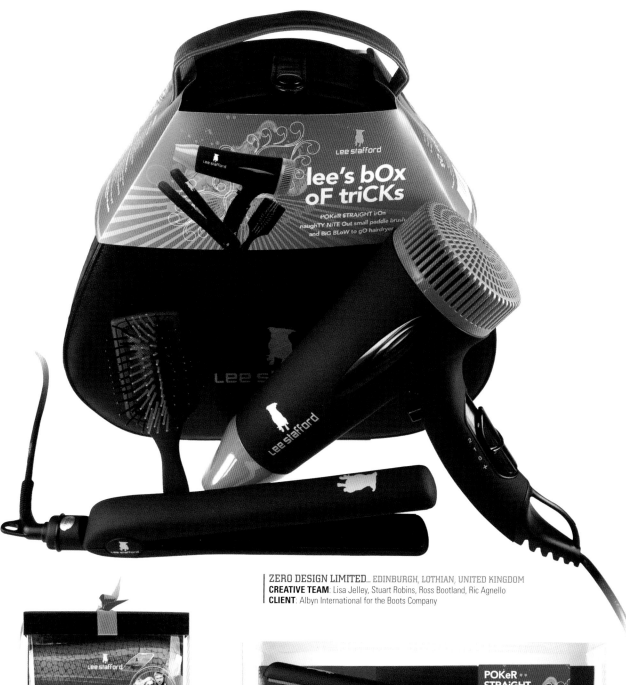

ZERO DESIGN LIMITED_ EDINBURGH, LOTHIAN, UNITED KINGDOM
CREATIVE TEAM: Lisa Jelley, Stuart Robins, Ross Bootland, Ric Agnello
CLIENT: Albyn International for the Boots Company

FACTOR TRES_ MEXICO CITY, MEXICO
CREATIVE TEAM: Rodrigo Cordova
CLIENT: Novad Laboratories

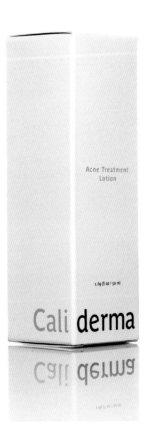

PENTAGRAM DESIGN_ AUSTIN, TX, UNITED STATES
CREATIVE TEAM: DJ Stout, Julie Savasky,
CLIENT: Caliderma

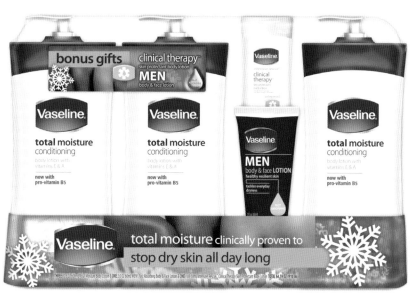

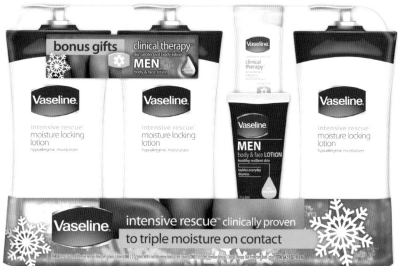

TFI ENVISION, INC._ NORWALK, CT, UNITED STATES
CREATIVE TEAM: Elizabeth P. Ball, Chris Plaisted, Mary Ellen Butkus
CLIENT: Unilever Home & Personal Care USA

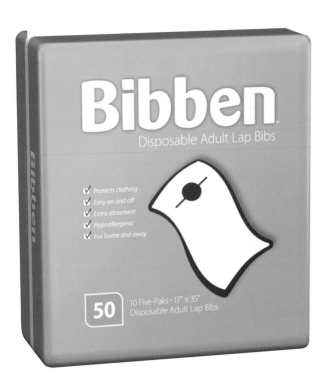

LEIBOLD ASSOCIATES, INC. NEENAH, WI, UNITED STATES
CREATIVE TEAM: Therese Joanis, Jason Konz, Greg Madson
CLIENT: R.Sabee Company, LLC

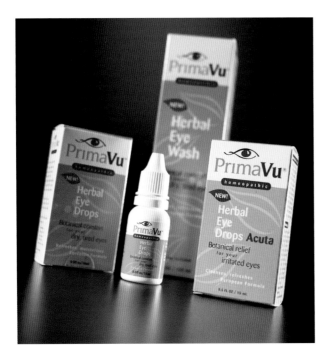

LCDA SAN DIEGO, CA, UNITED STATES
CREATIVE TEAM: Laura Coe Wright, Tracy Castle
CLIENT: PrimaPharm

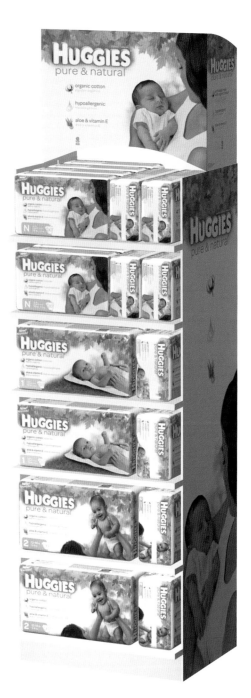

LEIBOLD ASSOCIATES, INC. NEENAH, WI, UNITED STATES
CREATIVE TEAM: Ryan Wienandt, Jake Weiss, Mark Vanden Berg, Heidi Vanden Boom
Lisa Kocourik, Cindy Gullikson
CLIENT: Kimberly-Clark, Inc.

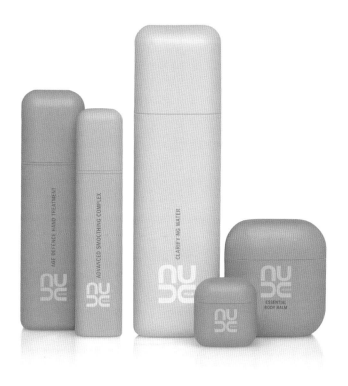

PEARLFISHER_ LONDON, UNITED KINGDOM
CREATIVE TEAM: Jonathan Ford, Natalie Chung, Sarah Butler
CLIENT: Nude Skincare

77

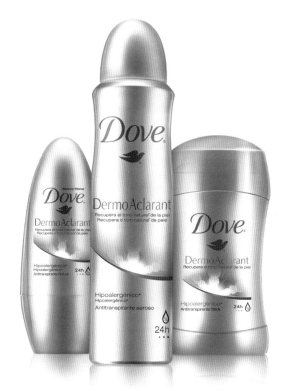

CASA REX_ SÃO PAULO, BRAZIL
CREATIVE TEAM: Gustavo Piqueira, Lilian Meireles
CLIENT: Unilever Latin America

INSIDE & OUT: HOME & GARDEN

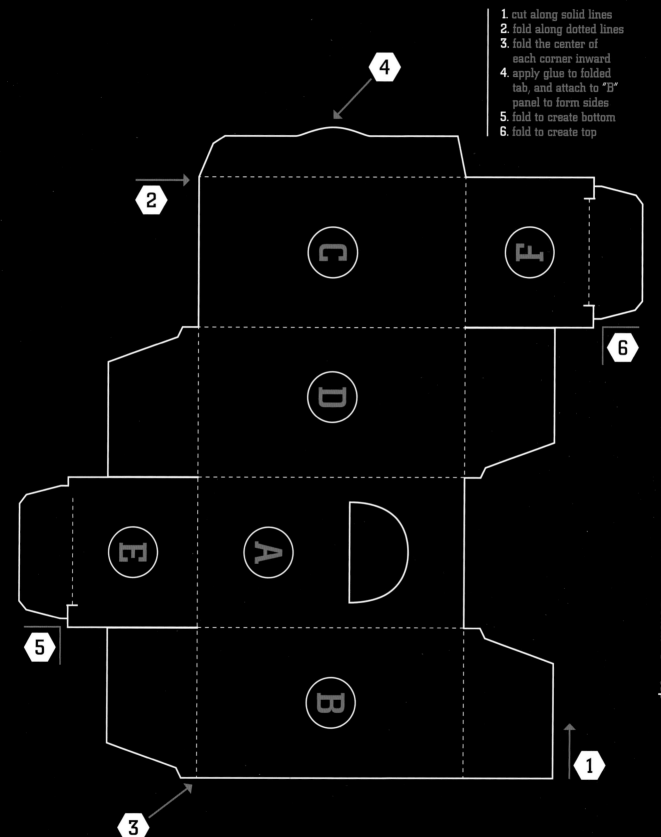

1. cut along solid lines
2. fold along dotted lines
3. fold the center of each corner inward
4. apply glue to folded tab, and attach to "B" panel to form sides
5. fold to create bottom
6. fold to create top

A = Front / B = Side / C = Back / D = Side / E = Bottom / F = Top

TRIDIMAGE_ BUENOS AIRES, ARGENTINA
CREATIVE TEAM: Adriana Cortese, Hernán Braberman, Virginia Gines
CLIENT: Clorox

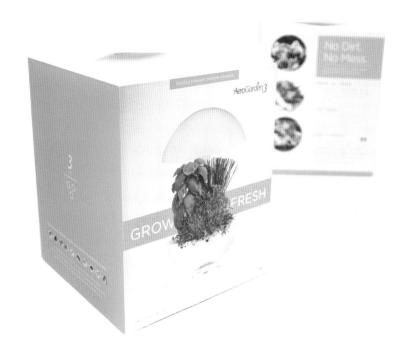

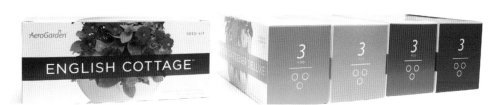

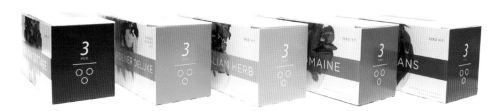

ELLEN BRUSS DESIGN_ DENVER, CO, UNITED STATES
CREATIVE TEAM: Ellen Bruss, Gabe Re
CLIENT: AeroGrow

TRIDIMAGE_ BUENOS AIRES, ARGENTINA
CREATIVE TEAM: Adriana Cortese, Hernán Braberman, Virginia Gines
CLIENT: Clorox

82

STUDIO ONE ELEVEN_ CHICAGO, IL, UNITED STATES
CREATIVE TEAM: Studio One Eleven
CLIENT: oneCARE Company

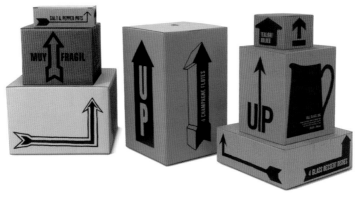

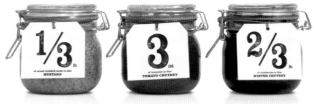

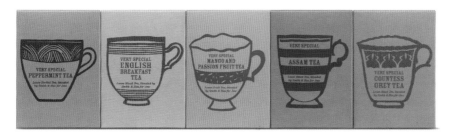

PEARLFISHER_ LONDON, UNITED KINGDOM
CREATIVE TEAM: Jonathan Ford, Natalie Chung, Sarah Pidgeon
CLIENT: Jamie Oliver

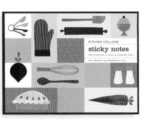

84

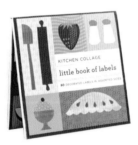

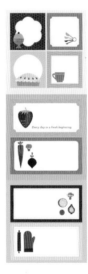

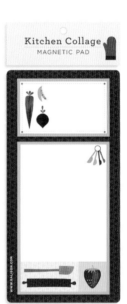

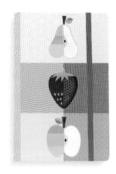

GALISON_ NEW YORK, NY, UNITED STATES
CREATIVE TEAM: Juanita Dharmazi, Heather Schellhase, Lorena Siminovich
CLIENT: Galison

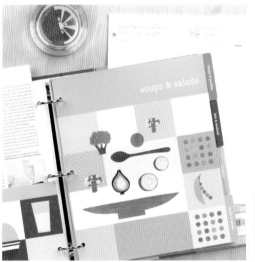

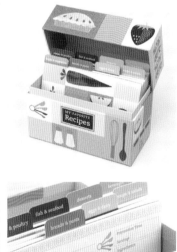

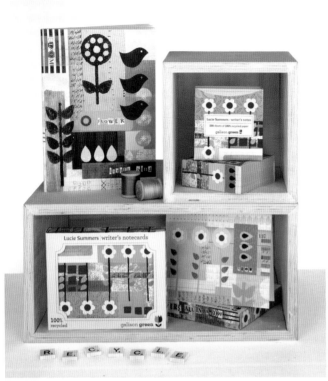

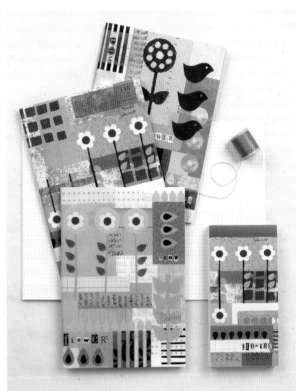

An In-Depth Look

Galison Green Stationery Collection

"What was important about this project was the fact that it was completely green—everything was made with 100% recycled material and nontoxic inks," says Galison's Creative Director Juanita Dharmazi of the new Galison Green stationery collection. "We felt strongly as a company that we wanted to do something that was good for the environment, but also something attractive. There's a lot of green stuff out there, so our goal was to create products that stood out from the crowd in a fresh, trendy, and inspiring way."

Galison produces a variety of stationery items featuring both fine art and contemporary imagery. Museum shops, boutiques, and bookstores across the country carry their products. Galison has sales reps all over North America, is carried internationally, and also maintains a user-friendly website.

Pricing ranges from $5-15. For the Green line, they were selective about the material used and aimed for simple, minimal design and packaging. No bells and whistles like glitter or metallic inks here, only 100% recycled ingredients.

The Green Line introduced four new formats and a total of 16 SKUs. The Writer's Notebooks are sold in sets of three (one blank, one lined, one graph) with coordinated covers. At a slim forty pages, these journals are just the right thickness for noting ideas and inspiration. Writer's Notes are perfect for

jotting short memos while Writer's Notepads, with graph-lined, perforated pages, are well-suited to lists of all kinds. Writer's Notecards make it easy to send off a few lines to friends and family.

One of the main inspirations for the Green line imagery was nature. Leaves, branches, birds, and flowers captured the spirit that the Galison team wanted to convey. "While our target market is mostly women, we wanted to reach all environmentally concerned people who want trendy products—even men," says Managing Editor Julia Hecomovich. "We always try to include some gender-neutral imagery and in this case, it's our typography line. But we also wanted the artwork for this line to be fun, so we came up with the idea of embedding a word in the letters. One design has the word 'play' hidden in it. If you turn the notebook over, the other side says 'work.' We like to use unique touches like this to make the product special."

"This was such an amazing project," Dharmazi added. "It was especially rewarding because of the green concept—after so many years of talking about going green, it was exciting to finally have these 16 beautiful, environmentally friendly SKUs. We plan to add more items in the future."

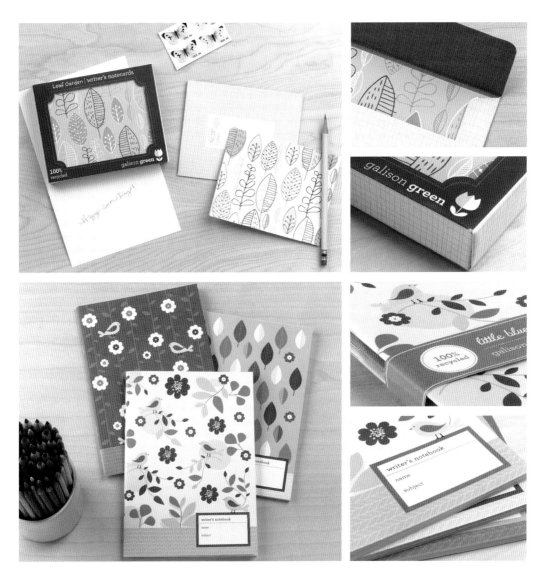

GALISON_ NYC, NY, UNITED STATES
CREATIVE TEAM: Juanita Dharmazi, Shelby Spears, Heather Schellhase,
Julia Hecomovich, Janice Ostendorf, LucieSummers, Javier Agostinelli
CLIENT: In-House products

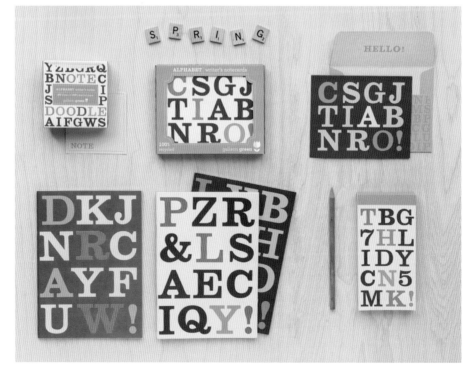

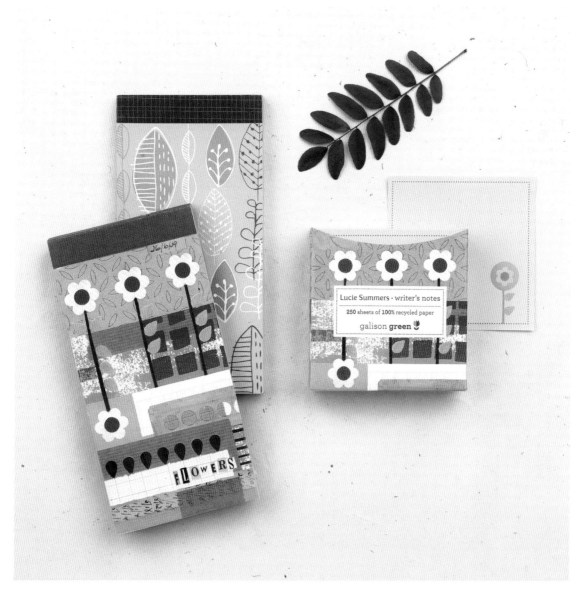

GALISON_ NYC, NY, UNITED STATES
CREATIVE TEAM: Juanita Dharmazi, Shelby Spears, Heather Schellhase,
Julia Hecomovich, Janice Ostendorf, Lucie Summers, Javier Agostinelli
CLIENT: In-House products

CASA REX_ SAO PAULO, BRAZIL
CREATIVE TEAM: Gustavo Piqueira, Ingrid Lafalce, Danilo Helvadjian, Lilian Meireles
CLIENT: Unilever Turkey

STUDIO INTERNATIONAL_ ZAGREB, CROATIA
CREATIVE TEAM: Boris Ljubicic
CLIENT: Chromos

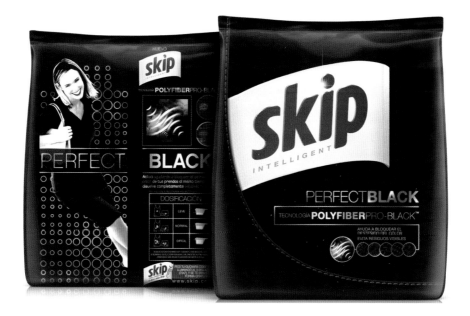

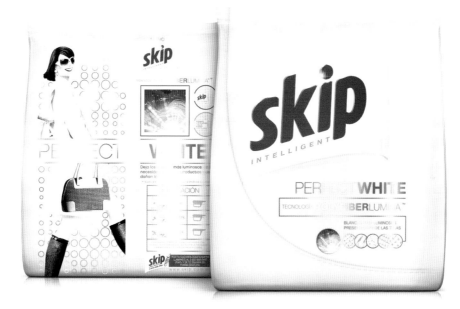

CASA REX_ SAO PAULO, BRAZIL
CREATIVE TEAM: Gustavo Piqueira, Ingrid Lafalce, Danilo Helvadjian, Leonardo Rodrigues, Lilian Meireles
CLIENT: Unilever Argentina

91

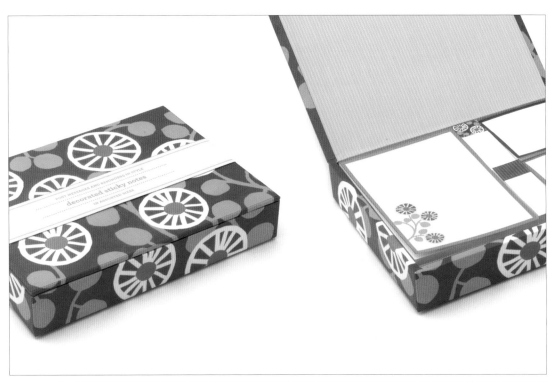

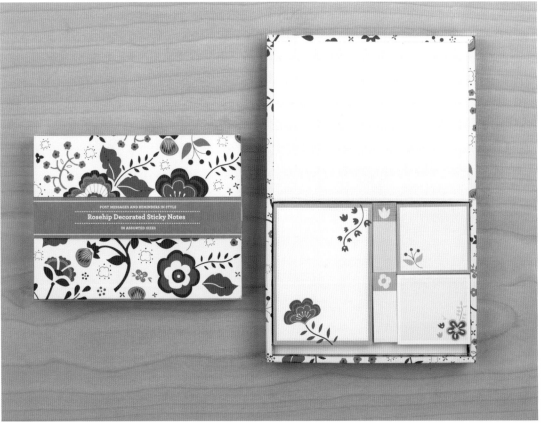

GALISON_ NEW YORK, NY, UNITED STATES
CREATIVE TEAM: Juanita Dharmazi, Shelby Spears, Erica De Masi, Heather Schellhase
CLIENT: Anthropologie

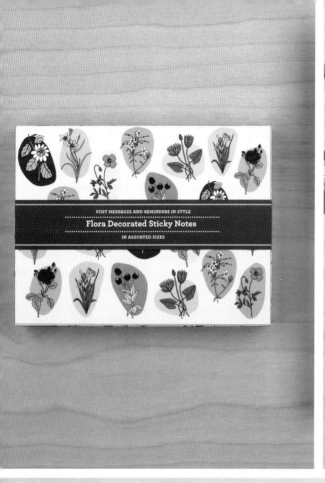

POST MESSAGES AND REMINDERS IN STYLE

Flora Decorated Sticky Notes

IN ASSORTED SIZES

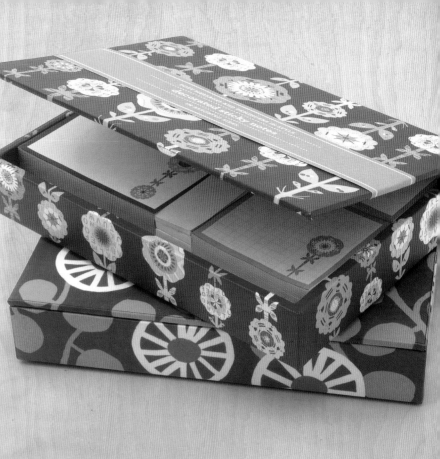

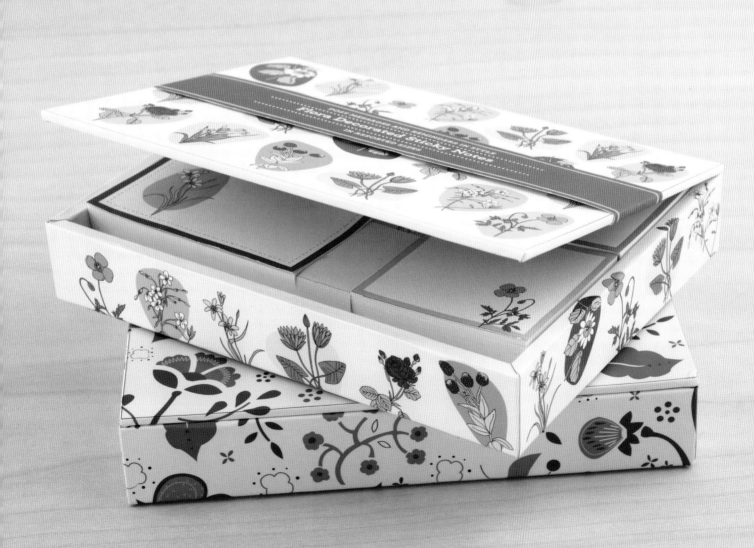

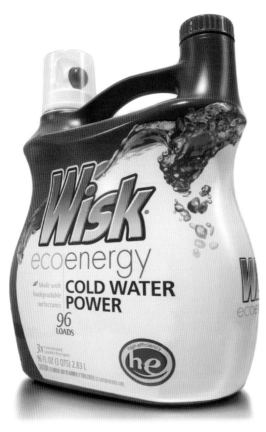

94

LITTLE BIG BRANDS_ NYACK, NY, UNITED STATES
CREATIVE TEAM: John Nunziato, Stuart Harvey Lee, Vin Masotta
CLIENT: The Sun Products Corporation

STUDIO INTERNATIONAL_ ZAGREB, CROATIA
CREATIVE TEAM: Boris Ljubicic
CLIENT: Labud, Zagreb, Croatia

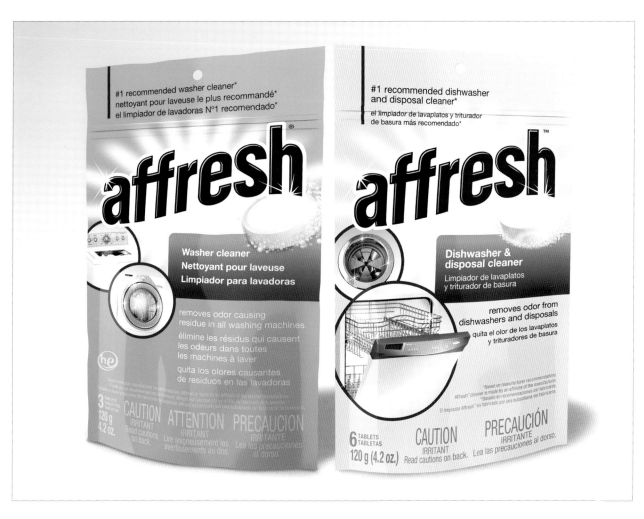

R.BIRD_ WHITE PLAINS, NY, UNITED STATES
CREATIVE TEAM: Richard Bird, Joseph Favata
CLIENT: Whirlpool Corporation

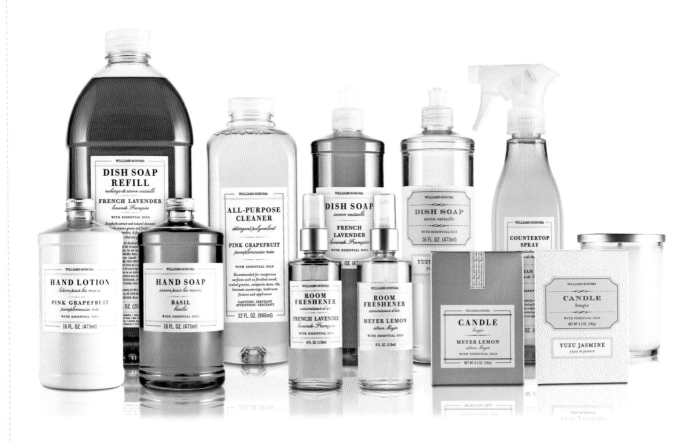

An In-Depth Look

Williams-Sonoma Soaps and Lotions Program

When it comes to food packaging, Michael Osborne calls Williams-Sonoma's in-store strategy "a house of brands."

"When you look at the food products, it looks like there are a hundred brands in there. The packaging is designed by food category, so the pasta sauce looks like pasta sauce, and the coffee looks like coffee, and if you didn't know better, you'd think it was all from different sources—but it's all Williams-Sonoma. As long as the logotype is on the package—and it's in small size, usually—it's theirs. That is their strategy."

By way of contrast, Osborne points to the project he did for Target's Archer Farms. "If I threw a pizza box in there, it would practically design itself. There's a strong, consistent format across the whole line of products. Williams-Sonoma is kind of the opposite. After working with them for a while in fine packaging, you learn to understand the store brand, the personality that the store wants to convey and that consumers love. It changes throughout the packaging, of necessity—candy has to look like candy—but the guiding aesthetic, the personality, is pretty much the same. We know what it is, now."

The Williams-Sonoma line of soaps and lotions had been doing well for several years, but sales had slowed. They wanted to update the packaging,

so they hired a design firm to do a major overhaul. The firm designed award-winning packaging, complete with individual proprietary structures, bottles with flavor imagery on the backs that you could see through the front—and as a still life, they were beautiful. But in the store, they didn't work.

"I think it just wasn't that Williams-Sonoma personality," says Osborne. "It was like taking a little chunk of Bath & Body Works and dropping it into Williams-Sonoma—it's not that it wasn't beautiful, it's just that it didn't fit. It wasn't what Williams-Sonoma customers had come to expect. And in a retail environment, the products proved to be very hard to decipher and read. They looked good on their own, but all together, they were confusing, off-brand. And sales went down."

Williams-Sonoma hired Michael Osborne Design to put the line back on-brand. Osborne's approach was to say, here is their old packaging, it was successful, it became dated, and now we need to update this packaging as if the redesign never happened.

"And that's the way we approached it," Osborne explains. "If you skip that interim phase and look at what we did, it is an evolutionary update, and the overall look and feel is more modern, even more Wiliams-Sonoma, than it was in the beginning. Some of the bottles are clear, so the product makes

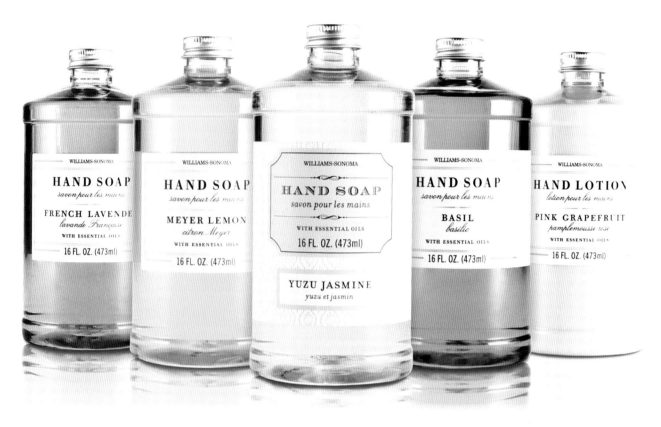

MICHAEL OSBORNE DESIGN_ SAN FRANCISCO, CA, UNITED STATES
CREATIVE TEAM: Michael Osborne, Alice Koswara, Sheri Kuniyuki
CLIENT: Williams-Sonoma

the major color impact, but in others—the candles, for instance—the major color impact is the boxes. It's sort of Old England, with a bit of French flavor added—an interesting set of borders, a few different fonts, some ribbons and seals.

"We've worked with this client long enough that they know our process, and vice versa, and we weren't long coming to a mutual conclusion," Osborne says. It's a big range with a number of SKUs, but the process was remarkably fast, approximately 6-8 weeks from conception to production. And once the re-designed line was on shelf, sales went right back up to where they should have been.

"Williams-Sonoma knows exactly who their audience is, and they have neither the need nor the desire to change that. What they really want to do is get them to put more things in the shopping bag before they leave. That personality, that overall aesthetic, is what we design for."

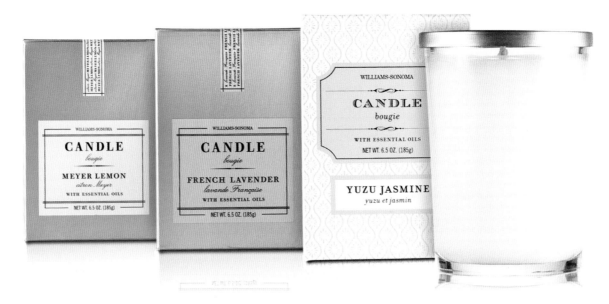

MICHAEL OSBORNE DESIGN_ SAN FRANCISCO, CA, UNITED STATES
CREATIVE TEAM: Michael Osborne, Alice Koswara, Sheri Kuniyuki
CLIENT: Williams-Sonoma

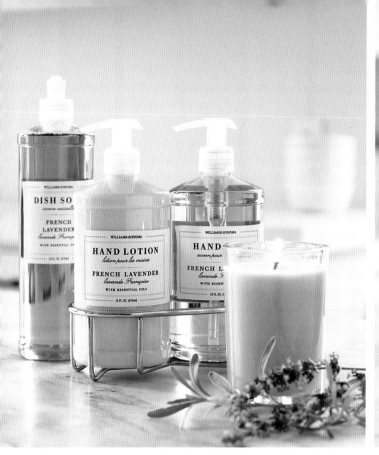

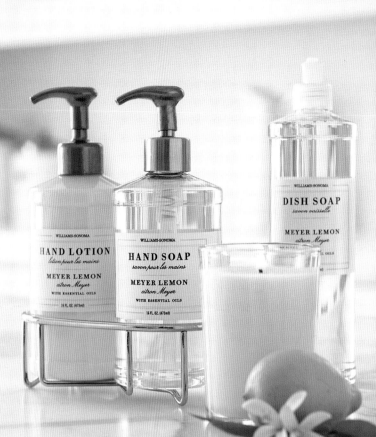

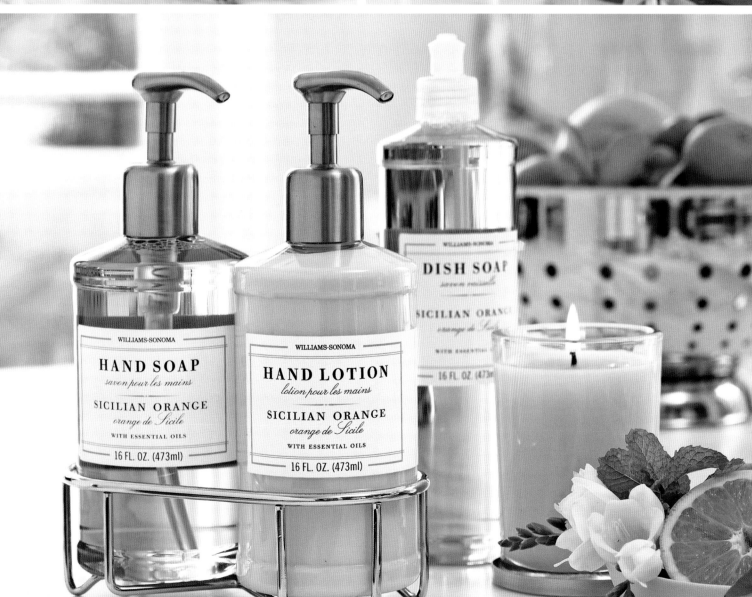

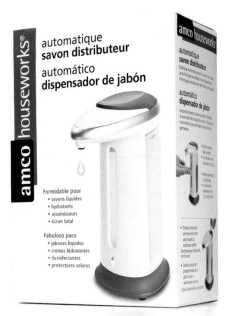

TFI ENVISION, INC._ NORWALK, CT, UNITED STATES
CREATIVE TEAM: Elizabeth P. Ball, Mary Ellen Butkus
CLIENT: Focus Products Kitchen Group, LLC

R.BIRD_ WHITE PLAINS, NY, UNITED STATES
CREATIVE TEAM: Richard Bird, Joseph Favata
CLIENT: Ellery Homestyles

STUDIO INTERNATIONAL_ ZAGREB, CROATIA
CREATIVE TEAM: Boris Ljubicic
CLIENT: Labud, Zagreb, Croatia

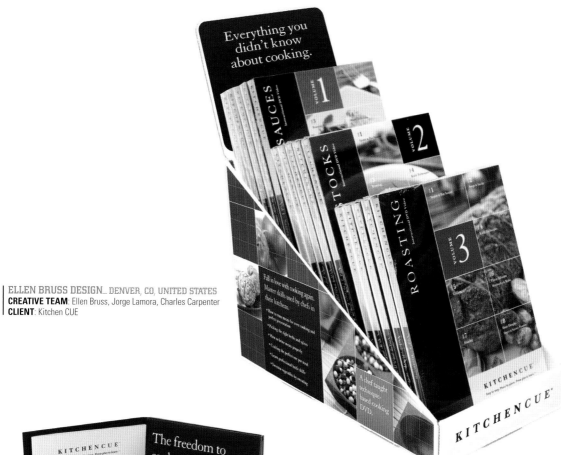

ELLEN BRUSS DESIGN... DENVER, CO, UNITED STATES
CREATIVE TEAM: Ellen Bruss, Jorge Lamora, Charles Carpenter
CLIENT: Kitchen CUE

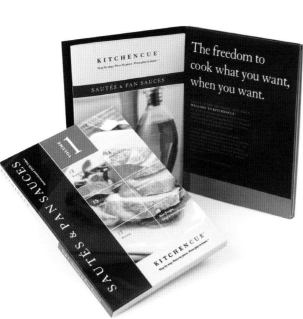

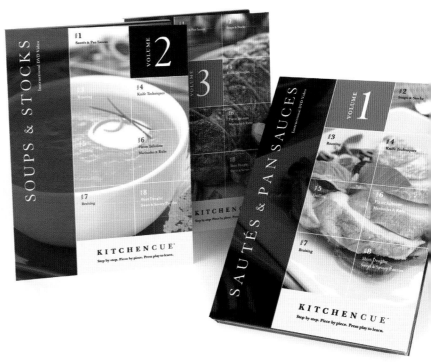

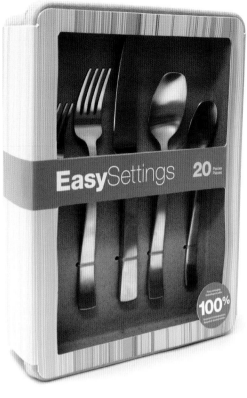

MONNET DESIGN_ TORONTO, ON, CANADA
CREATIVE TEAM: Stephane Monnet
CLIENT: Gourmet Settings

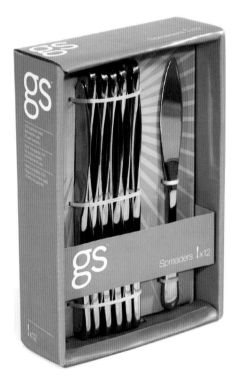

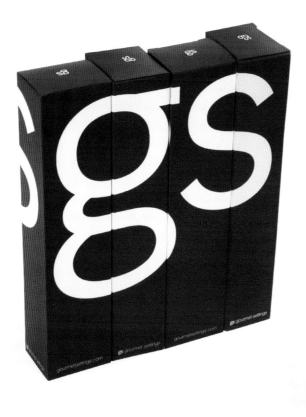

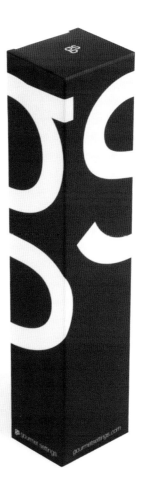

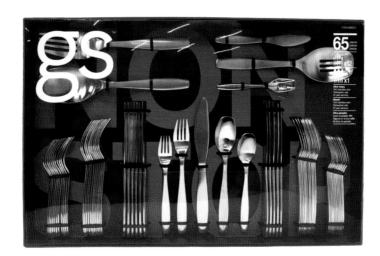

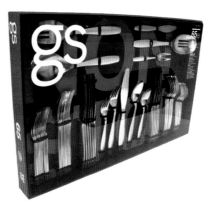

MONNET DESIGN_ TORONTO, ON, CANADA
CREATIVE TEAM: Stephane Monnet
CLIENT: Gourmet Settings

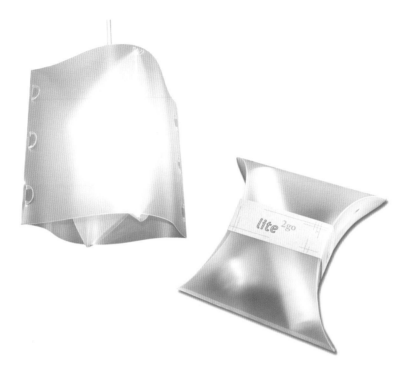

104

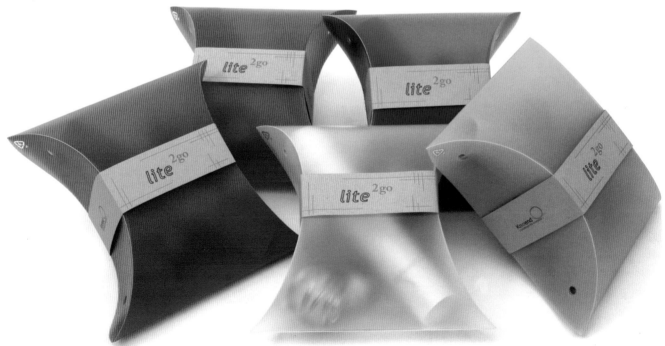

KNOEND_ HI, UNITED STATES
CREATIVE TEAM: Ivy Chuang, Anila Jain, Jane Rabanal
CLIENT: Knoend

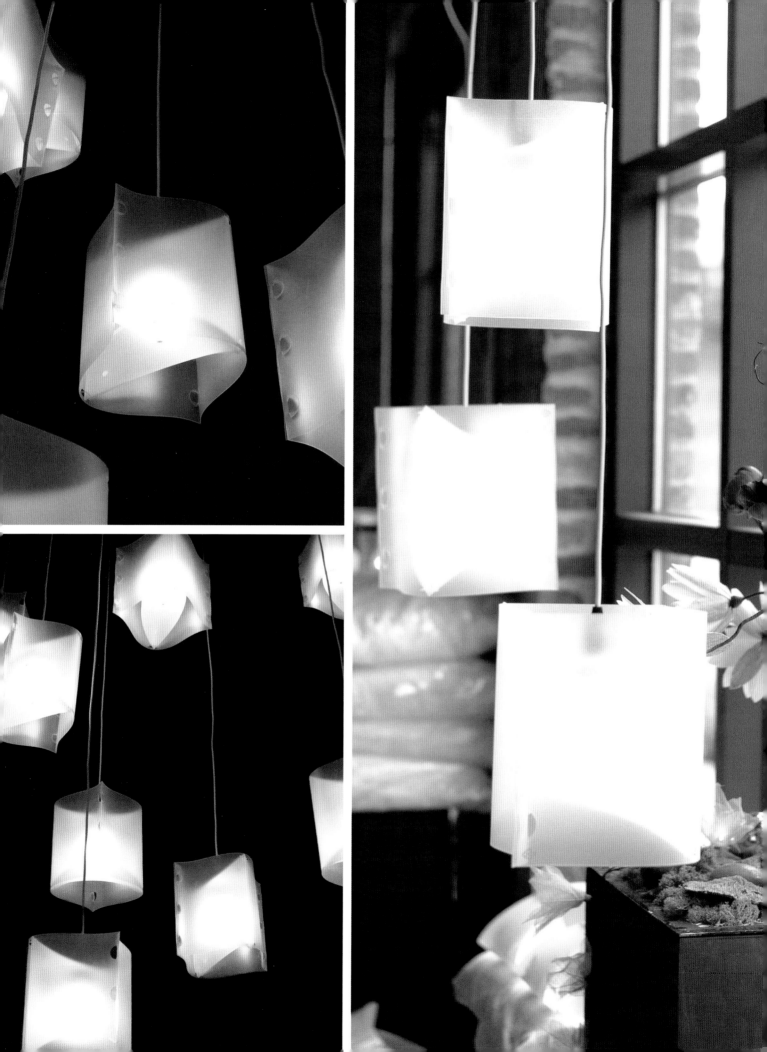

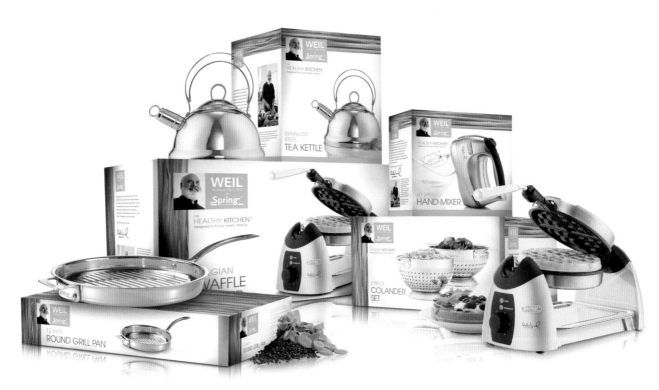

FAI DESIGN GROUP_ IRVINGTON, NY, UNITED STATES
CREATIVE TEAM: Marion Fraternale, Robert Scully
CLIENT: Dr Weil Spring

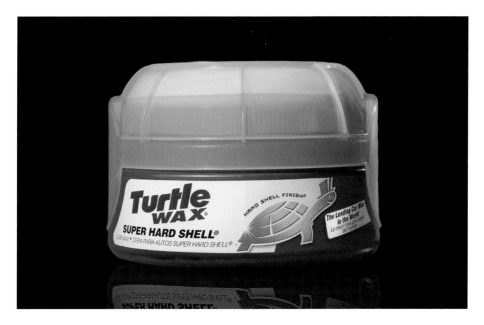

STUDIO ONE ELEVEN_ CHICAGO, IL, UNITED STATES
CREATIVE TEAM: Studio One Eleven
CLIENT: Turtle Wax

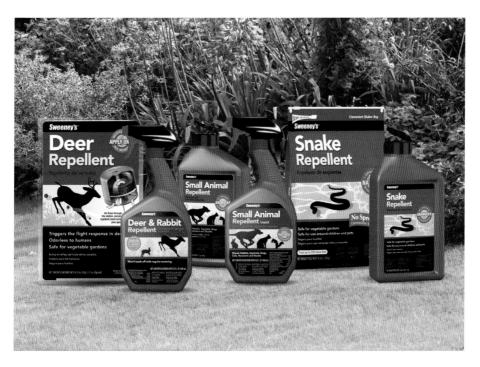

R.BIRD_ WHITE PLAINS, NY, UNITED STATES
CREATIVE TEAM: Richard Bird, Joseph Favata
CLIENT: Senoret Chemical Company

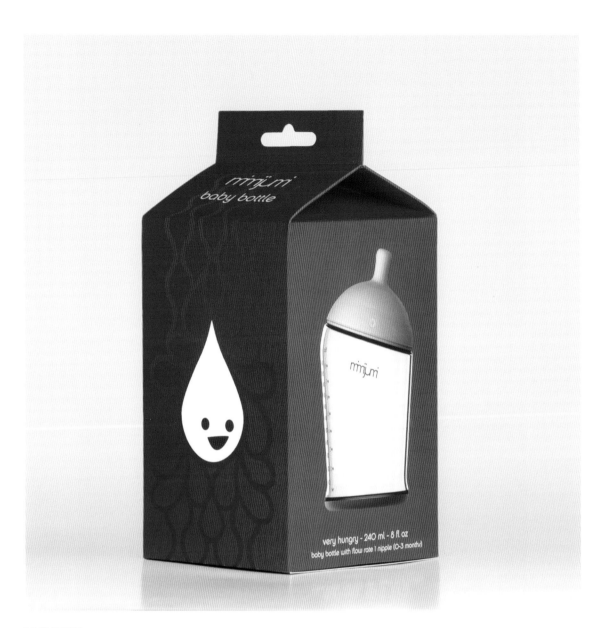

108

DAN STILES_ PORTLAND, OR, UNITED STATES
CREATIVE TEAM: Dan Stiles
CLIENT: Mimijumi

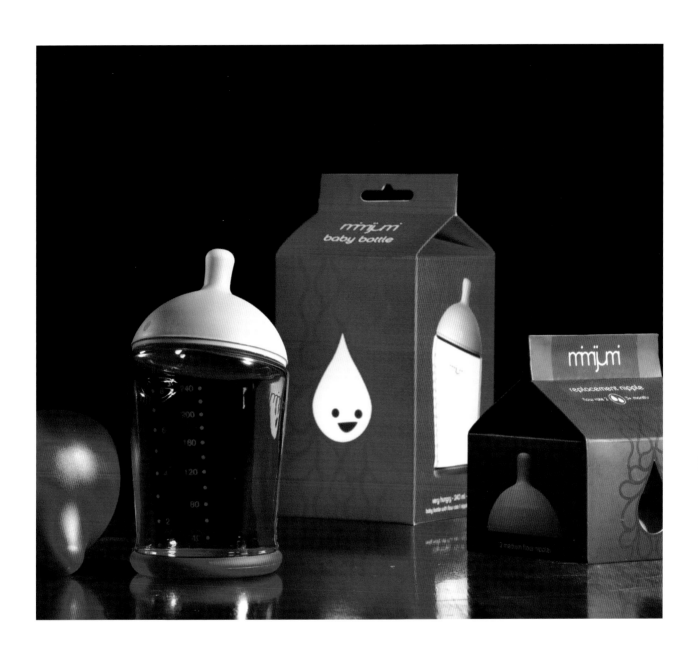

110

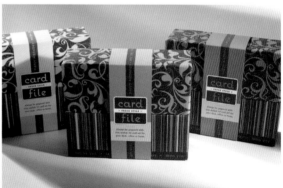

DEFTELING DESIGN_ PORTLAND, OR, UNITED STATES
CREATIVE TEAM: Alex Wijnen
CLIENT: Cecily Ink

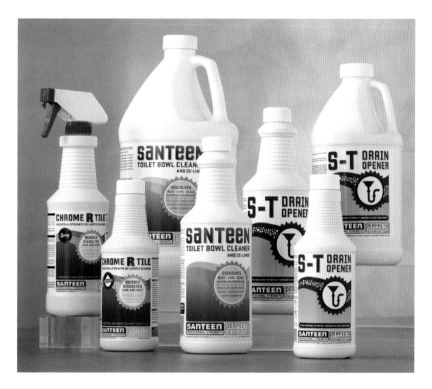

OLIGRAPHIC_ MINNEAPOLIS, MN, UNITED STATES
CREATIVE TEAM: Charlie Ross, Jeff Johnson
CLIENT: Santeen

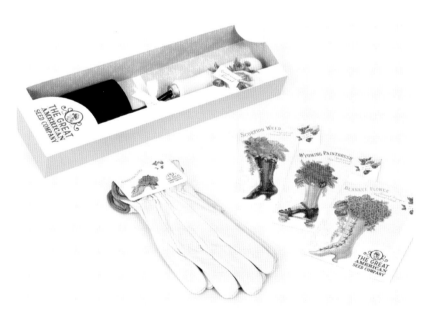

TYLER SCHOOL OF ART_ WARRINGTON, PA, UNITED STATES
CREATIVE TEAM: Jamielynn Miller
CLIENT: University Tyler School of Art, Temple University

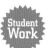

TASTY TREATS: FOOD & BEVERAGE

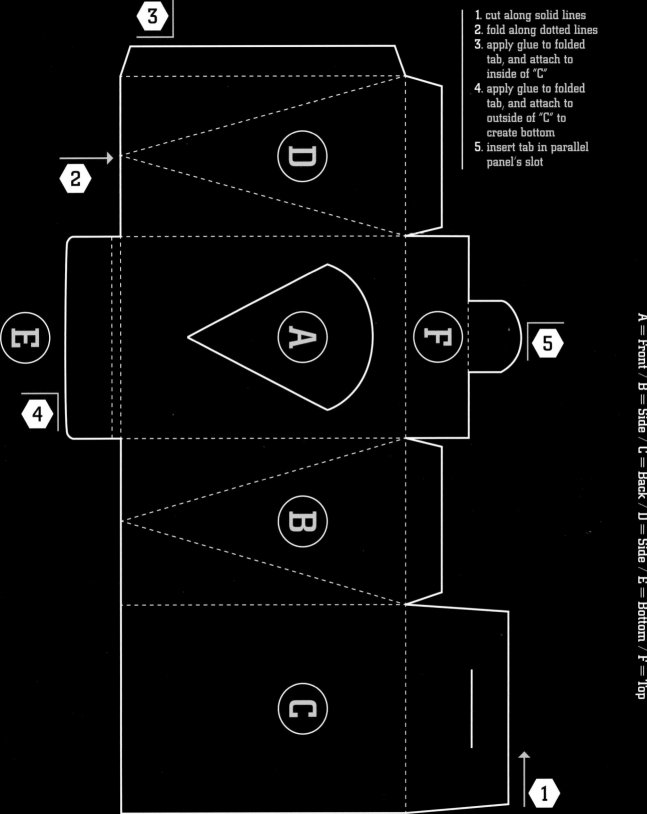

3

1. cut along solid lines
2. fold along dotted lines
3. apply glue to folded
 tab, and attach to
 inside of "C"
4. apply glue to folded
 tab, and attach to
 outside of "C" to
 create bottom
5. insert tab in parallel
 panel's slot

2

D

E

A

F

5

4

B

1

C

A = Front / B = Side / C = Back / D = Side / E = Bottom / F = Top

114

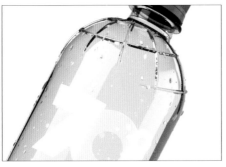

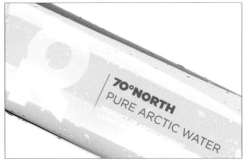

TANK DESIGN TROMSØ_ **NORWAY**
CREATIVE TEAM: Jens K. Styve, Bjoern Viggo Ottem, Simen Justdal
CLIENT: Alta Water Company

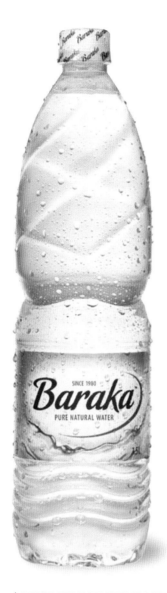

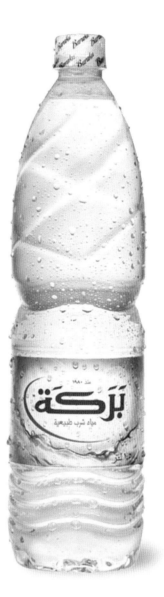

CORNERSTONE STRATEGIC BRANDING, NEW YORK, NY, UNITED STATES
CREATIVE TEAM: Cornerstone Creative Staff
CLIENT: Nestlé Waters Egypt

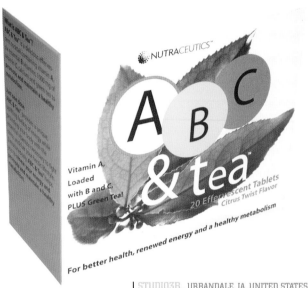

STUDIO3B_ URBANDALE, IA, UNITED STATES
CREATIVE TEAM: Cyndi Wiley, Jennifer Cherry
CLIENT: Nutraceutics Corporation

TRIDIMAGE_ BUENOS AIRES, ARGENTINA
CREATIVE TEAM: Adriana Cortese, Hernán Braberman,
Virginia Gines
CLIENT: Sabores y Placeresn

RICHARD BAIRD LTD_ NOTTINGHAM, UNITED KINGDOM
CREATIVE TEAM: Richard Baird, Sellers & Rogers
CLIENT: Sellers & Rogers

TEPINO, CORAL GABLES, FL, UNITED STATES
CREATIVE TEAM: Dee Friedman, Todd Friedman
CLIENT: Co.Exist Nutrition Corporation - Marco Borges, Exercise Physiologist

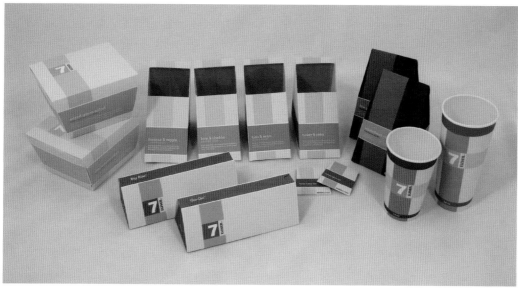

117

DREXEL UNIVERSITY, ANTOINETTE WESTPHAL COLLEGE OF MEDIA ARTS & DESIGN,
PHILADELPHIA, PA, UNITED STATES
CREATIVE TEAM: Jenna Navitsky, E. June Roberts-Lunn
CLIENT: Student Work

Student Work

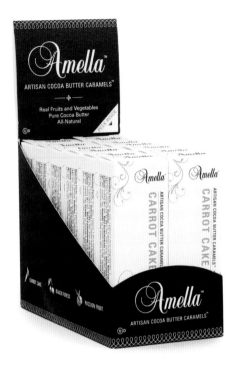

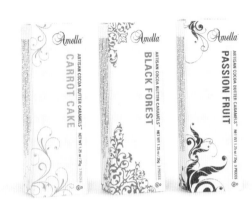

118

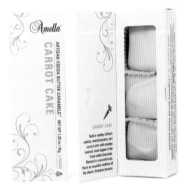

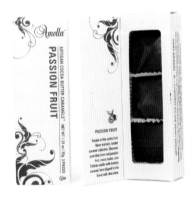

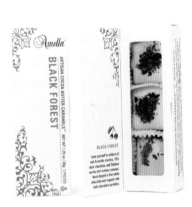

COPIA CREATIVE, INC._ SANTA MONICA, CA, UNITED STATES
CREATIVE TEAM: Copia Creative Team
CLIENT: Artisan Cocoa

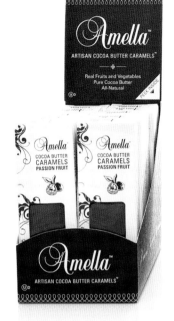

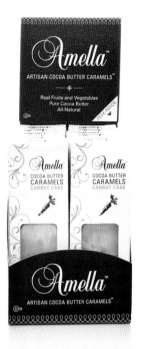

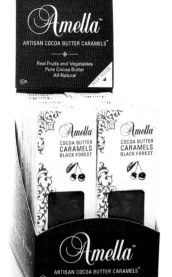

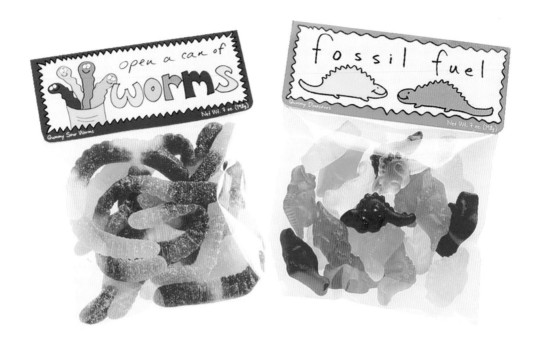

An In-Depth Look

Pepper Creek Farms Packaging

Even if you didn't know Jenn David Connolly had a toddler, one glance at the gummy candy bags she designed for Pepper Creek Farms would give it away. Only someone with a two-year-old boy in her life comes up with food labels that say, "open a can of worms" while goofy gummy worms smile at you from the label, sprung like jack-in-the-boxes from a can, and bags of grinning gummy dinosaurs snicker, "fossil fuel."

"It's great when you can get paid to have fun," says Connolly, a hard-working mom whose love for life and passion for design feed her work—and vice versa. "It was hard keeping the product away from him while I was working on this," she laughs. "And doing the cartoon illustrations for this project definitely helped get me in touch with my inner kid."

Small wonder.

Pepper Creek Farms, whose products are sold at national retail chains like Homegoods and Steinmart, specialty food shops, gift stores, and online at their website, was exhibiting at the Winter Fancy Food Show in 2008 when Connolly approached them with some examples of her work and asked if they'd consider her for any upcoming packaging projects. "They gave me the first project right there at the show!" she exclaims.

So when the client wanted a new look to celebrate the rollout of a number of new products, they turned again to Connolly. They wanted to com-bine new product packaging with a revamp of their older packaging. Three product lines—gummy candy in cups, decorating candies and colored sugars in jars, and gummies in bags—three distinct looks, yet cohesive enough that you can tell they're all family.

"It was three different lines within a greater candy campaign," says Connolly. They wanted the gummies in cups to evoke a nostalgic, candy-shoppe feel; a gourmet, upscale look for the decorating candies and sugars, sold mostly in regional department stores; and a fun, whimsical look for the gummies in bags.

"There's sort of a funny story with that one," Connolly muses. "The cartoons were their idea. But they didn't have the budget for an illustrator, and they said, 'Well, you can doodle, right?'—sort of encouraging me. I'd done drawing in school, but I'd never done that type of illustration profes-sionally. And the client said, 'Why don't you try it? We're just looking for something really whimsical, nothing perfect or polished or anything.' So we just went with it, and it worked out.

"It was fun to really push myself into an area that was quite differ-ent from the other work that I had done. It was a good challenge, and I've actually gotten a lot of positive feedback on that. It gave me a lot more confidence in that area."

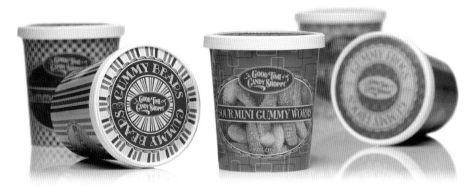

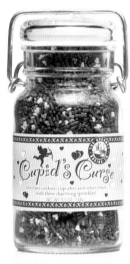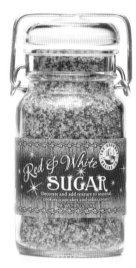

JENN DAVID DESIGN SAN DIEGO, CA, UNITED STATES
CREATIVE TEAM: Jenn David Connolly, Jessie Turcotte
CLIENT: Pepper Creek Farms

Connolly didn't need much inspiration beyond the products themselves. "In my office, I have all my packaging all around me, and a book of clippings, but I normally just focus on the product itself, and let it evolve. Inspiration builds over time, consciously and subconsciously, and after a few days of simmering in the back of my mind, the idea just forms. 'Organic' is a good way to describe it."

The challenges this project presented were all good ones. "I've been working with this client for a few years and in general, it's a pretty comfortable relationship. They're really open during the creative process and are generally ok with what I present to them. They trust me." Connolly normally presents a client with three ideas to choose from.

"I loved all the variety in these projects. Candy, colors, all the different types of packaging— there are nearly 100 products in these lines, altogether. Each line has its own distinct look. And within the lines—especially the jars—each one is individual but still clearly belongs to the family. They all work together.

"Each time I get a new product from this client, I have to go a little further, explore new possibilities. How do I make this one unique, yet keep it in the family? There are a lot of brothers and sisters in that family, and the more we add, the more challenging it gets."

122

JENN DAVID DESIGN, SAN DIEGO, CA, UNITED STATES
CREATIVE TEAM: Jenn David Connolly, Jessie Turcotte
CLIENT: Pepper Creek Farms

123

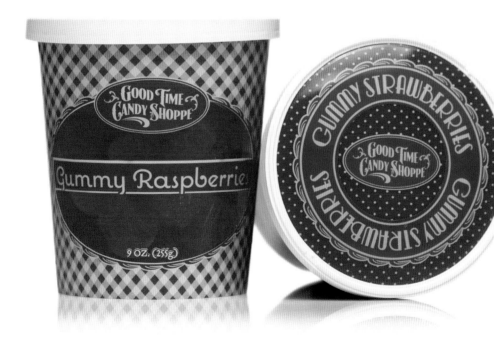

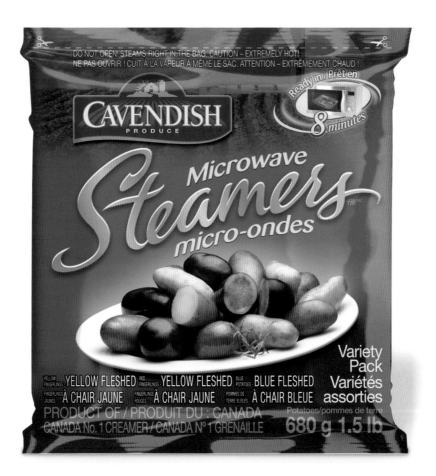

124

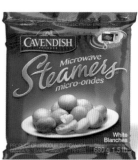

MAROVINO VISUAL STRATEGY_ TORONTO, ON, CANADA
CREATIVE TEAM: Marianne Bozzo, Carol Murphie
CLIENT: Cavendish Produce

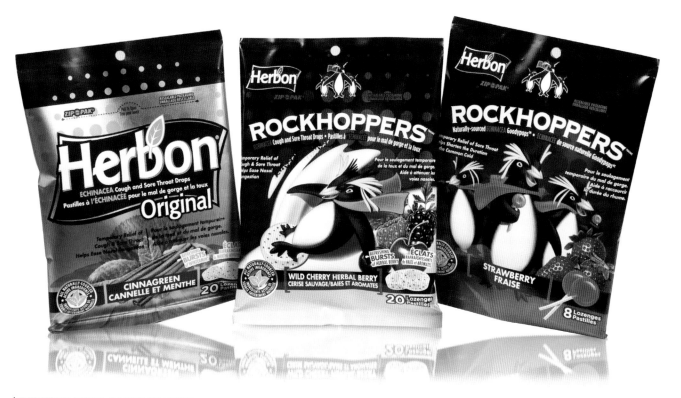

SHIKATANI LACROIX. TORONTO, ON, CANADA
CREATIVE TEAM: Richard Dirstein, Kim Yokota, Paula Jacobs, Chris Woo
CLIENT: Purity Life

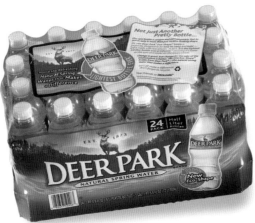

 CORNERSTONE STRATEGIC BRANDING_ NEW YORK, NY, UNITED STATES
CREATIVE TEAM: Cornerstone Creative Staff
CLIENT: Nestlé Waters Egypt

126

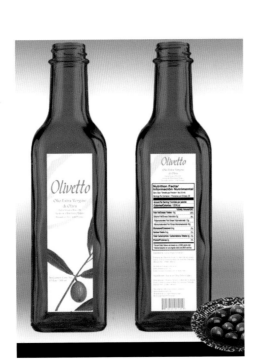

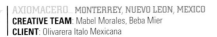 AXIOMACERO_ MONTERREY, NUEVO LEON, MEXICO
CREATIVE TEAM: Mabel Morales, Beba Mier
CLIENT: Olivarera Italo Mexicana

KROG_ LJUBLJANA, SLOVENIA
CREATIVE TEAM: Edi Berk
CLIENT: Rakican

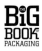

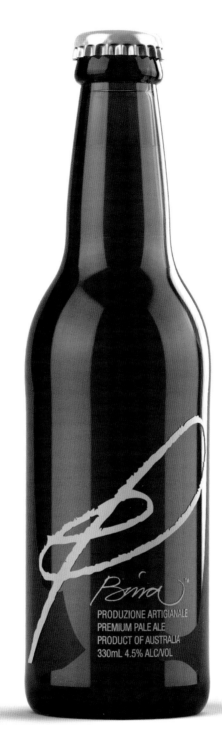

PRODUZIONE ARTIGIANALE
PREMIUM PALE ALE
PRODUCT OF AUSTRALIA
330mL 4.5% ALC/VOL

ASPREY CREATIVE_ MELBOURNE, AUSTRALIA
CREATIVE TEAM: Asprey Creative
CLIENT: Mauro Marcucci

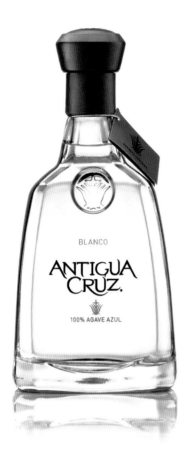
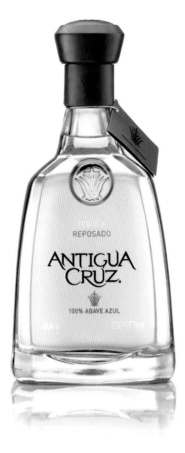
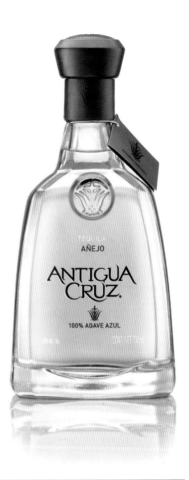

128

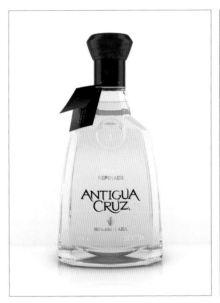
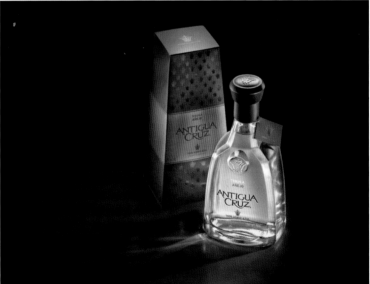

TRIDIMAGE_ BUENOS AIRES, ARGENTINA
CREATIVE TEAM: Adriana Cortese, Hernán Braberman, Virginia Gines
CLIENT: Tequilera de Arandas

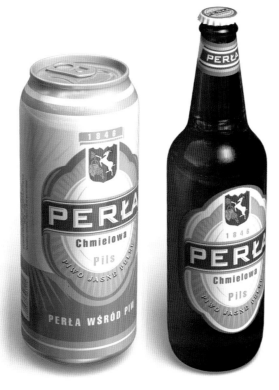

DSN, WARSAW, POLAND
CREATIVE TEAM: Michal Piotrowski
CLIENT: Perla Brewery

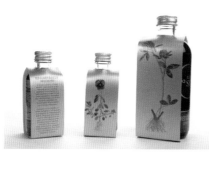

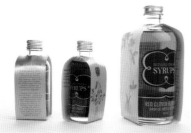

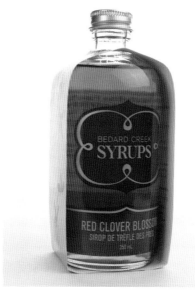

TAP COMMUNICATIONS, SASKATOON, CANADA
CREATIVE TEAM: Tim Neal, David Melashenko
CLIENT: Bedard Creek Acres

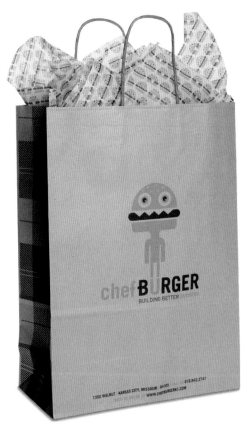

130

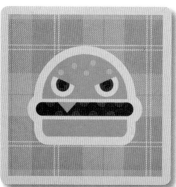

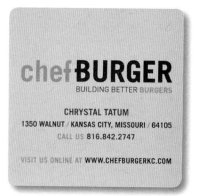

DESIGN RANCH_ **KANSAS CITY, MO, UNITED STATES**
CREATIVE TEAM: Michelle Sonderegger, Ingred Sidie, Tad Carpentar
CLIENT: Chef Burger

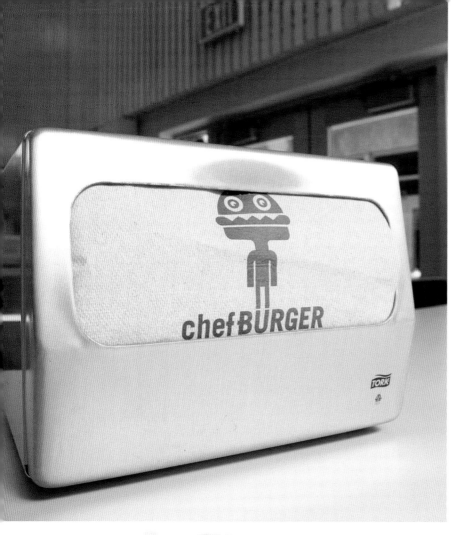
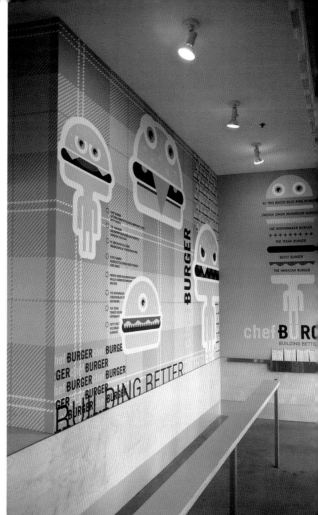

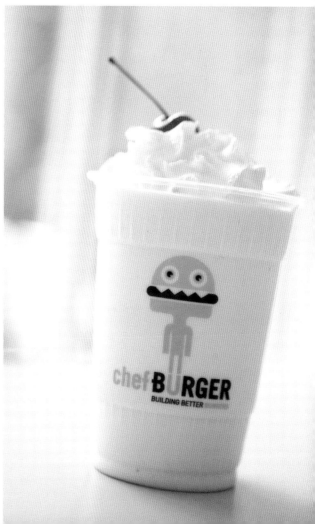

132

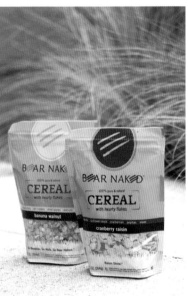

PTARMAK, INC._ AUSTIN, TX, UNITED STATES
CREATIVE TEAM: JR Crosby, Zach Ferguson, Caleb Everitt
CLIENT: Bear Naked, Inc.

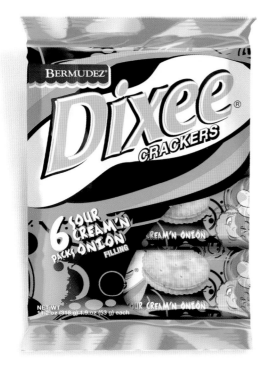

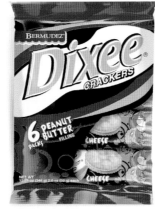

MAROVINO VISUAL STRATEGY... TORONTO, ON, CANADA
CREATIVE TEAM: Marianne Bozzo, Pete Smith, Carol Murphie
CLIENT: Bermudez

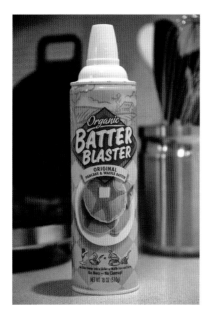

FOCUS DESIGN...
SAN RAFAEL, CA, UNITED STATES
CREATIVE TEAM: Brian Jacobson, Anthony Luk,
Kirby Veach
CLIENT: Batter Blaster

CJCOM... MEXICO
CREATIVE TEAM: Jorge Cejudo
CLIENT: Enrique Olvera

133

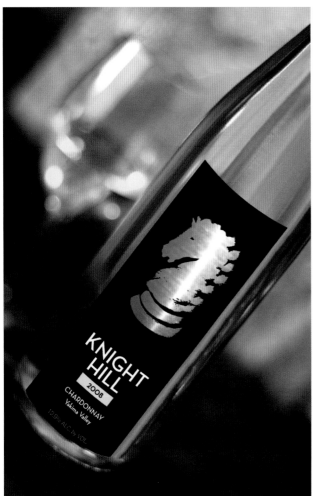
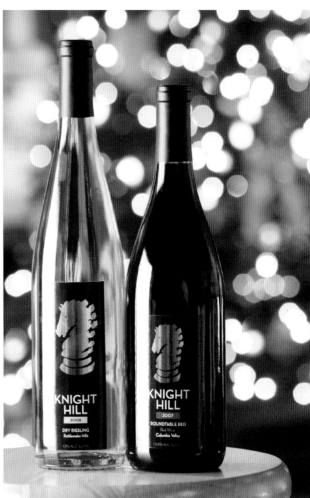

134

SARA NELSON DESIGN, LTD._ PASCO, WA, UNITED STATES
CREATIVE TEAM: Sara Nelson, Herb Leonhard
CLIENT: Knight Hill Winery

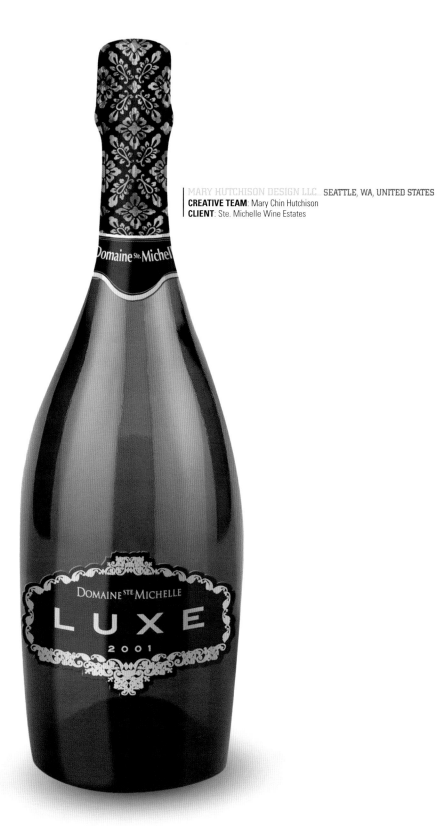

MARY HUTCHISON DESIGN LLC. SEATTLE, WA, UNITED STATES
CREATIVE TEAM: Mary Chin Hutchison
CLIENT: Ste. Michelle Wine Estates

135

PROJECTGRAPHICS.EU_ PRISHTINA, KOSOVA, ALBANIA
CREATIVE TEAM: Agon Ceta
CLIENT: Bonus

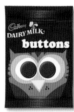
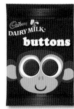
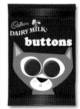
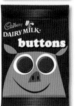
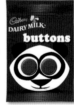
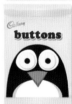

TRIDIMAGE_ BUENOS AIRES, ARGENTINA
CREATIVE TEAM: Adriana Cortese, Hernán Braberman, Virginia Gines
CLIENT: Mexicana de Bebidas

PEARLFISHER_ LONDON, UNITED KINGDOM
CREATIVE TEAM: Jonathan Ford, Natalie Chung, Jamie Nash
CLIENT: Cadbury Dairy Milk

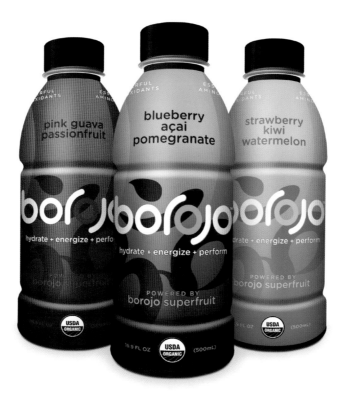

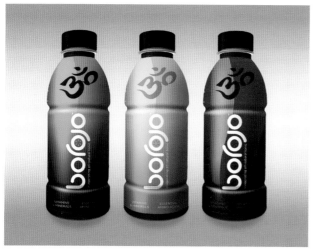

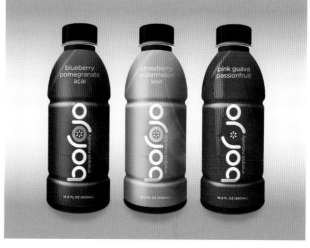

SOMA CREATIVE, MIAMI, FL, UNITED STATES
CREATIVE TEAM: Brian Eickhoff, Nathalie Plagnol, Jody Finver
CLIENT: Borojo Beverages LLC

FAI DESIGN GROUP_ IRVINGTON, NY, UNITED STATES
CREATIVE TEAM: Allison Schwartz, Robert Scully
CLIENT: Brownie Points Bakery

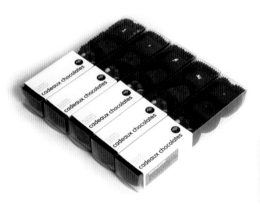
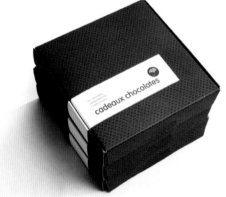

GRAPHITL SEATTLE, WA, UNITED STATES
CREATIVE TEAM: Kelly Pensell
CLIENT: Cadeaux Chocolates

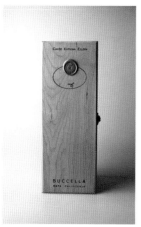 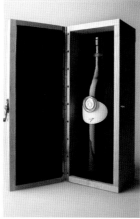 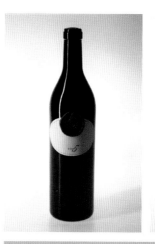 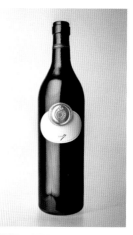

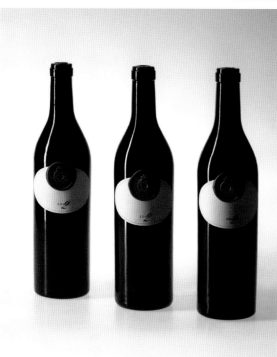 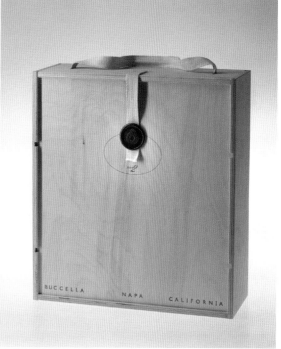

UXUS, NETHERLANDS
CREATIVE TEAM: UXUS
CLIENT: Buccella

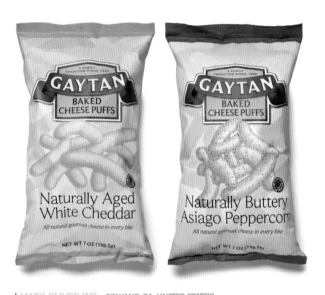

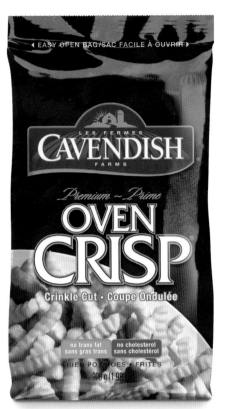

MARK OLIVER INC._ SOLVANG, CA, UNITED STATES
CREATIVE TEAM: Mark Oliver, Patty Driskel, Robert Evans
CLIENT: Gaytan Foods

MAROVINO VISUAL STRATEGY_ TORONTO, ON, CANADA
CREATIVE TEAM: Pete Smith, Carol Murphie
CLIENT: Cavendish Farms

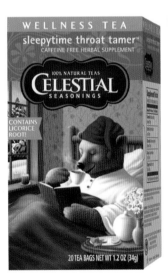

AMERICAN ARTIST REPS_ LARCHMONT, NY, UNITED STATES
CREATIVE TEAM: Jerry LoFaro
CLIENT: Celestial Seasonings Inc.

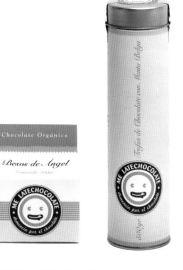

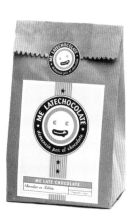

FACTOR TRES / BRANDING AND STRATEGIC DESIGN, MEXICO CITY, MEXICO
CREATIVE TEAM: Rodrigo Cordova, Angel Gonzalez
CLIENT: MelateChocolate

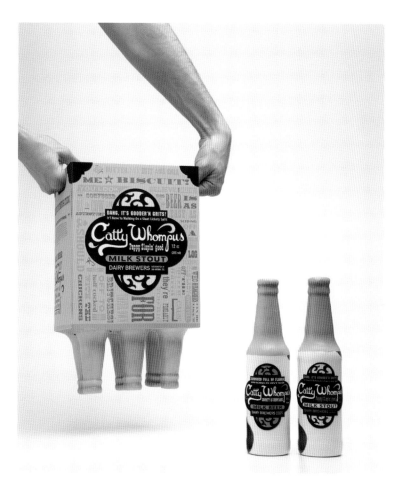

RENNEKAMPDESIGN, EAST STROUDSBURG, PA, UNITED STATES
CREATIVE TEAM: Stephen Rennekamp, Todd Vachon,
CLIENT: Student Work

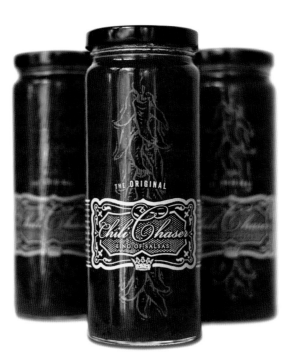

SUDDUTH DESIGN CO._ AUSTIN, TX, UNITED STATES
CREATIVE TEAM: Toby Sudduth
CLIENT: Lava Foods

142

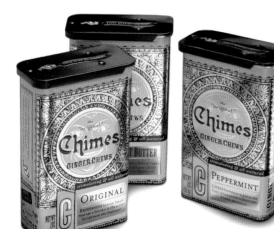

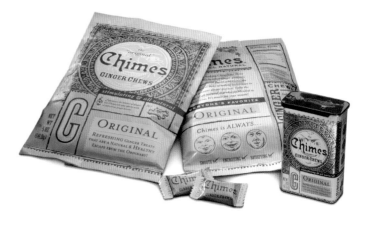

SUDDUTH DESIGN CO._ AUSTIN, TX, UNITED STATES
CREATIVE TEAM: Toby Sudduth
CLIENT: Roxy Trading Co.

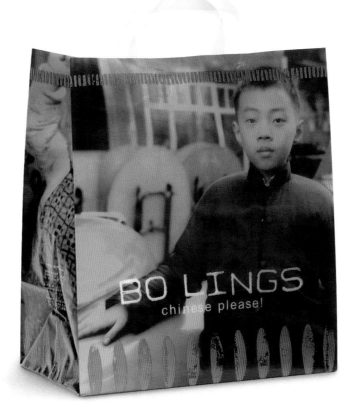

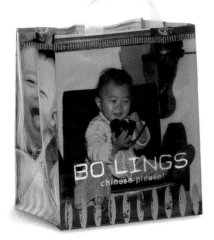

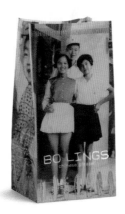

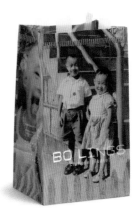

143

DESIGN RANCH KANSAS CITY, MO, UNITED STATES
CREATIVE TEAM: Michelle Sonderegger, Ingred Sidie
CLIENT: BoLings

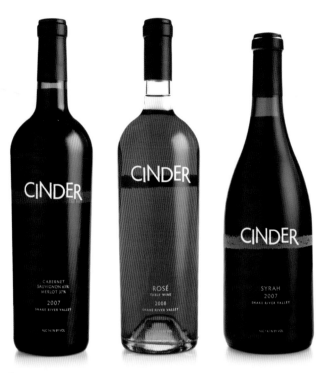

CAREW CO._ BOISE, ID, UNITED STATES
CREATIVE TEAM: Paul Carew
CLIENT: Cinder

144

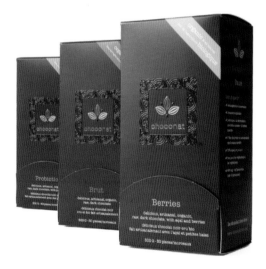

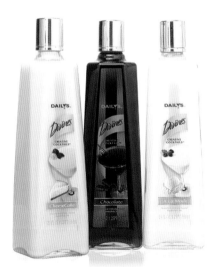

 MARY HUTCHISON DESIGN LLC._ SEATTLE, WA, UNITED STATES
CREATIVE TEAM: Mary Chin Hutchison
CLIENT: Smart Chocolate LLC

THE BIONDO GROUP_ STAMFORD, CT, UNITED STATES
CREATIVE TEAM: Charles Biondo, Gary Labra, Meg Russell, Marvin Bernfeld
CLIENT: American Beverage Corp

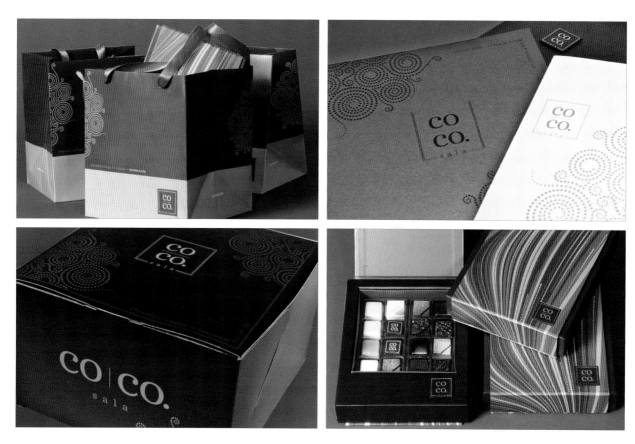

HZDG, INC. ROCKVILLE, MD, UNITED STATES
CREATIVE TEAM: Karen Zuckerman, Leslie Harris, Chris Walker, Joey Tarbell
CLIENT: Co Co. Sala

DI DONATO DESIGN_ **CHICAGO, IL, UNITED STATES**
CREATIVE TEAM: Peter DiDonato, Eziana Sardone, Robert Kingsley
CLIENT: JuiceHeads Inc.

146

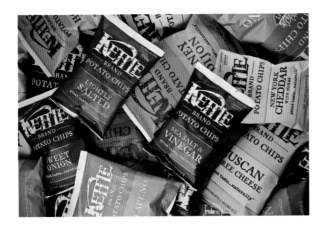
JOEY'S CORNER_ **SAN FRANCISCO, CA, UNITED STATES**
CREATIVE TEAM: Michael Osborne, Alice Koswara
CLIENT: Kettle Foods

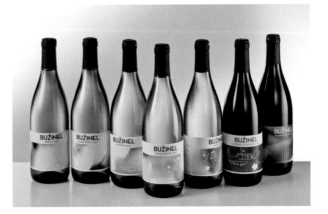
STUDIOBOTAS_ **SLOVENIA**
CREATIVE TEAM: Boštjan Botas Kenda, Primož Fijavž, Peter Rauch, Urh Soboan
CLIENT: Kmetija Bužinel

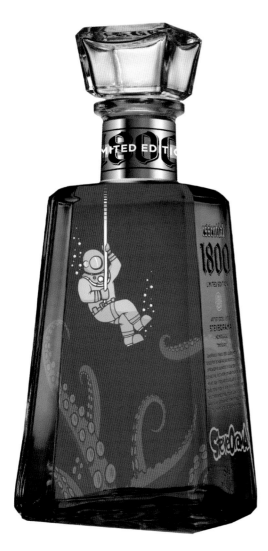

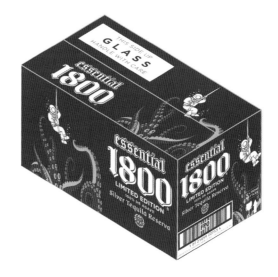

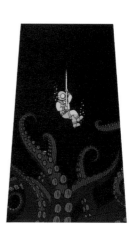

147

STEVEORAMA GRAPHICS. SAN DIEGO, CA, UNITED STATES
CREATIVE TEAM: SteveOramA, Elwyn Gladstone, Marissa Hayes
CLIENT: Proximo Spirits, Incorporated and 1800 Tequila

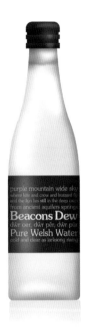

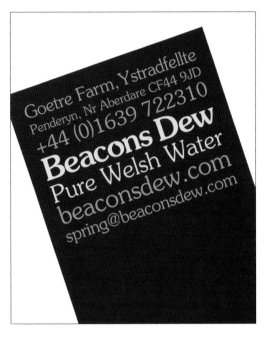

ELFEN_ CARDIFF, UNITED KINGDOM
CREATIVE TEAM: Gwion Prydderch, Andrew Cavanagh
CLIENT: Beacons Dew

148

TYLER SCHOOL OF ART_
WARRINGTON, PA, UNITED STATES
CREATIVE TEAM: Jamielynn Miller
CLIENT: Student Work

EPIXS.EU_ VARNA, BULGARIA
CREATIVE TEAM: Jordan Jelev
CLIENT: Dragomir Winery Estate

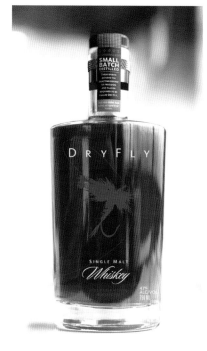

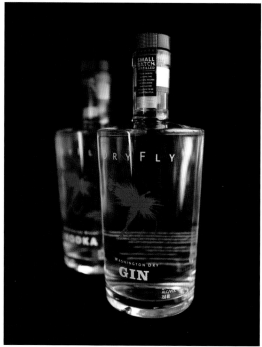

HL2_ WA, UNITED STATES
CREATIVE TEAM: Dave Estep, Noah Tannen, Jen Shawver
CLIENT: Dry Fly Distilling

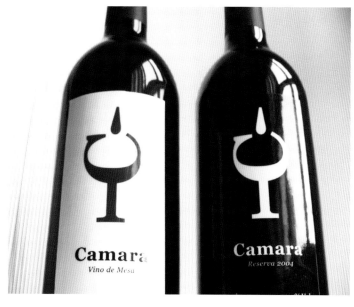

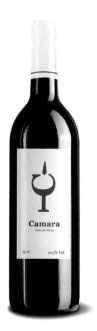

SALVARTES DISEÑO Y ESTRATEGIAS DE COMUNICACIÓN_ CÁDIZ, SPAIN
CREATIVE TEAM: Salva Garcia-Ripoll Toledano
CLIENT: Camera wines

BORSAWALLACE_ NEW YORK, NY, UNITED STATES
CREATIVE TEAM: Jeffrey Wallace, Frank Borsa, Jason Davis, Cecilia Molina
CLIENT: Schneider Associates

150

TRIDIMAGE_ BUENOS AIRES, ARGENTINA
CREATIVE TEAM: Adriana Cortese, Hernán Braberman,
Virginia Gines, Gonzalo Berro
CLIENT: Grupo Osborne

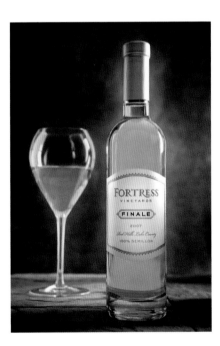

JOEY'S CORNER_ SAN FRANCISCO, CA, UNITED STATES
CREATIVE TEAM: Michael Osborne, Alice Koswara
CLIENT: Fortress Vineyards

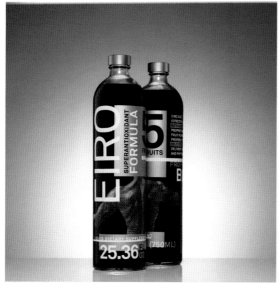

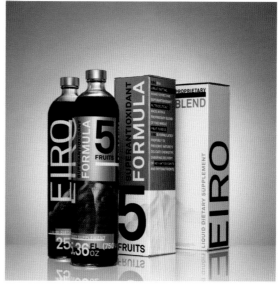

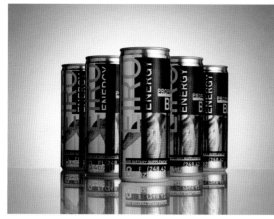

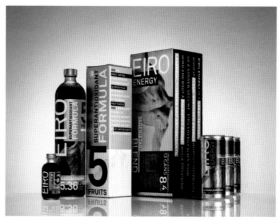

PENTAGRAM DESIGN, AUSTIN, TX, UNITED STATES
CREATIVE TEAM: Julie Savasky, DJ Stout
CLIENT: EIRO Reasearch

151

SUDDUTH DESIGN CO._ AUSTIN, TX, UNITED STATES
CREATIVE TEAM: Toby Sudduth, Don Mason
CLIENT: Continental Mills

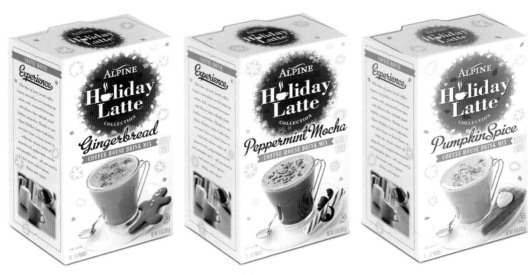

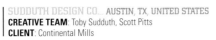 SUDDUTH DESIGN CO._ AUSTIN, TX, UNITED STATES
CREATIVE TEAM: Toby Sudduth, Scott Pitts
CLIENT: Continental Mills

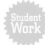

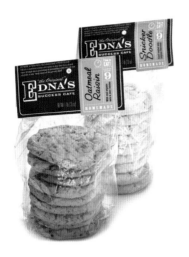

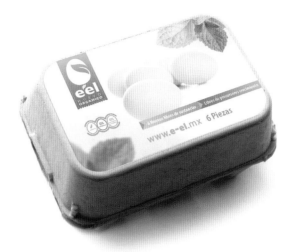

SUDDUTH DESIGN CO. AUSTIN, TX, UNITED STATES
CREATIVE TEAM: Toby Sudduth
CLIENT: Edna's Success Café

FACTOR TRES / BRANDING AND STRATEGIC DESIGN
MEXICO CITY, MEXICO
CREATIVE TEAM: Rodrigo Córdova, Sergio Enriquez
CLIENT: BioSfuerzo

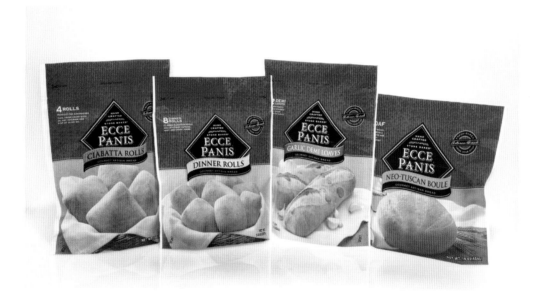

153

CORNERSTONE STRATEGIC BRANDING NEW YORK, NY, UNITED STATES
CREATIVE TEAM: Cornerstone Creative Staff
CLIENT: Ecce Panis

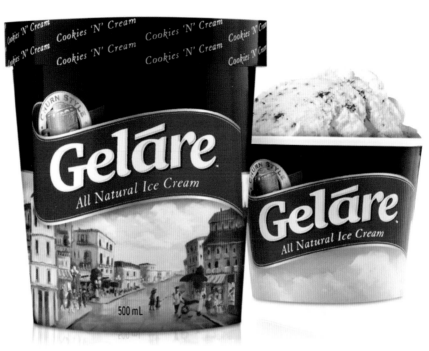

 SLOAT DESIGN GROUP_ SAN RAFAEL, CA, UNITED STATES
CREATIVE TEAM: Carrie Dufour
CLIENT: Gelare

154

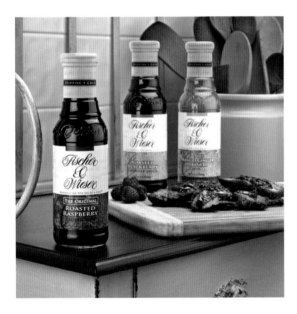

STUDIO ONE ELEVEN - A DIVISION OF BERLIN PACKAGING_
CHICAGO, IL, UNITED STATES
CREATIVE TEAM: Studio One Eleven
CLIENT: Fischer & Wieser

SABINGRAFIK, INC._ CARLSBAD, CA, UNITED STATES
CREATIVE TEAM: Tracy Sabin
CLIENT: Self-Promotion

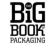

SUDDUTH DESIGN CO., AUSTIN, TX, UNITED STATES
CREATIVE TEAM: Toby Sudduth
CLIENT: Cibolo Creek Vineyards

JOEY'S CORNER_ SAN FRANCISCO, CA, UNITED STATES
CREATIVE TEAM: Michael Osborne
CLIENT: Brown-Forman

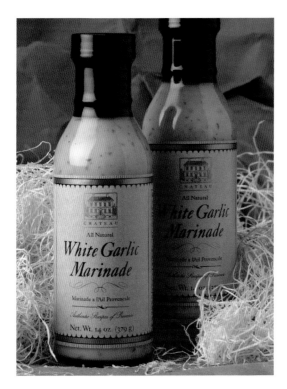

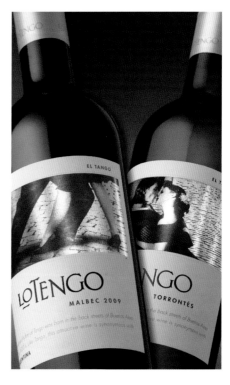

FOCUS DESIGN_ SAN RAFAEL, CA, UNITED STATES
CREATIVE TEAM: Brian Jacobson, Eileen Carey, Kirby Veach
CLIENT: Golden West Specialty Foods

ESTUDIO IUVARO_ MENDOZA, ARGENTINA
CREATIVE TEAM: Cecilia Iuvaro, Silvia Keil, Celia Grezzi, Valeria Aise
CLIENT: Bodega Norton Marketing Department

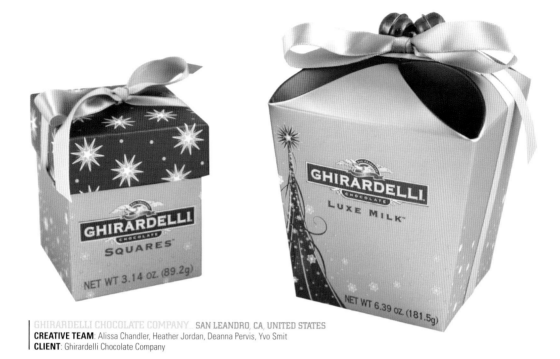

GHIRARDELLI CHOCOLATE COMPANY SAN LEANDRO, CA, UNITED STATES
CREATIVE TEAM: Alissa Chandler, Heather Jordan, Deanna Pervis, Yvo Smit
CLIENT: Ghirardelli Chocolate Company

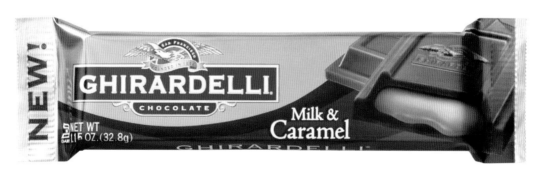

GHIRARDELLI CHOCOLATE COMPANY SAN LEANDRO, CA, UNITED STATES
CREATIVE TEAM: Alissa Chandler, Cynthia Siedel, Melinda Winter, Mona Maher
CLIENT: Ghirardelli Chocolate Company

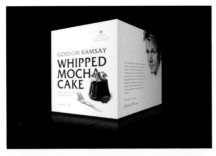

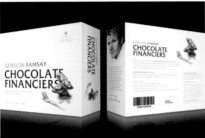
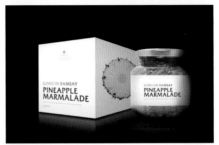

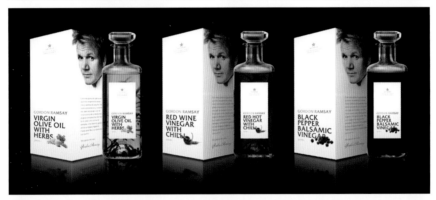

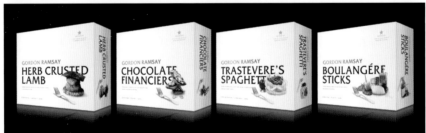

GWORKSHOP_ BARCELONA, SPAIN
CREATIVE TEAM: José Luis Garcia Eguiguren
CLIENT: Gordon Ramsay

MINE_ SAN FRANCISCO, CA, UNITED STATES
CREATIVE TEAM: Christopher Simmons, Tim Belonax
CLIENT: AIGA/Clos du Val

ASPREY CREATIVE_ MELBOURNE, AL, AUSTRALIA
CREATIVE TEAM: Asprey Creative
CLIENT: Kadac

160

DESIGN RANCH_ KANSAS CITY, MO, UNITED STATES
CREATIVE TEAM: Ingred Sidie, Michelle Sonderegger, Martha Rich, Meg Cundiff
CLIENT: Blue Q

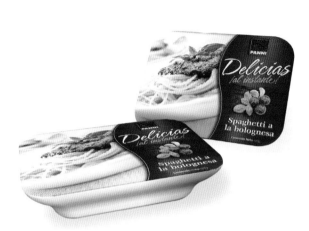

FACTOR TRES / BRANDING AND STRATEGIC DESIGN MEXICO CITY, MEXICO
CREATIVE TEAM: Rodrigo Cordova
CLIENT: Panni Spain

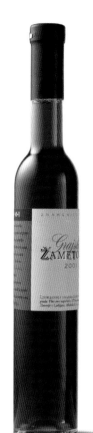

KROG SLOVENIA
CREATIVE TEAM: Edi Berk, Janez Bogataj
CLIENT: Festival Ljubljana

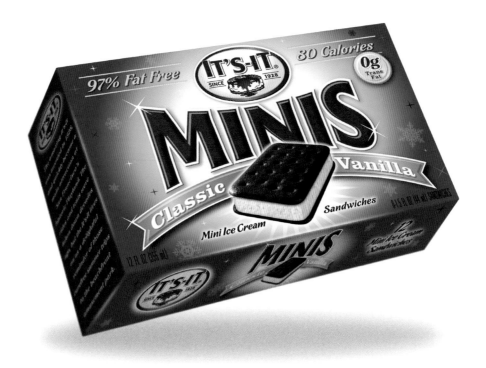

SUDDUTH DESIGN CO. AUSTIN, TX, UNITED STATES
CREATIVE TEAM: Toby Sudduth, Mike Wepplo
CLIENT: It's It

162

THE BIONDO GROUP STAMFORD, CT, UNITED STATES
CREATIVE TEAM: Charles Biondo, Gary Labra, Meg Russell, Marvin Bernfeld
CLIENT: Hain Celestial

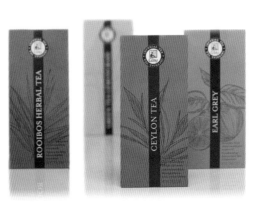

JENN DAVID DESIGN SAN DIEGO, CA, UNITED STATES
CREATIVE TEAM: Jenn David Connolly
CLIENT: CJay Teas

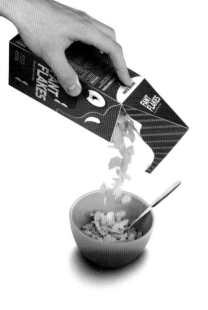

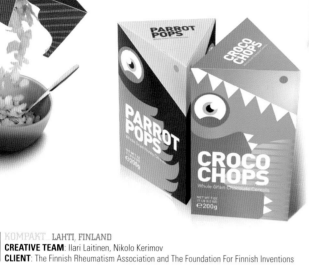

KOMPAKT_ LAHTI, FINLAND
CREATIVE TEAM: Ilari Laitinen, Nikolo Kerimov
CLIENT: The Finnish Rheumatism Association and The Foundation For Finnish Inventions

163

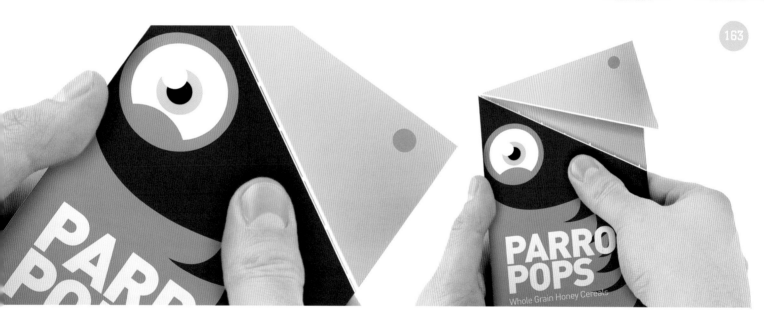

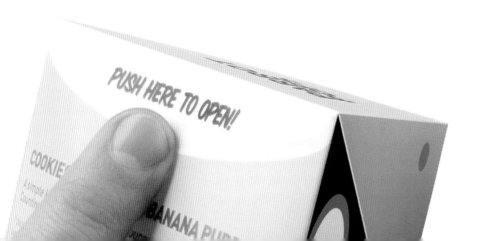

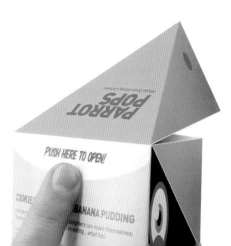

164

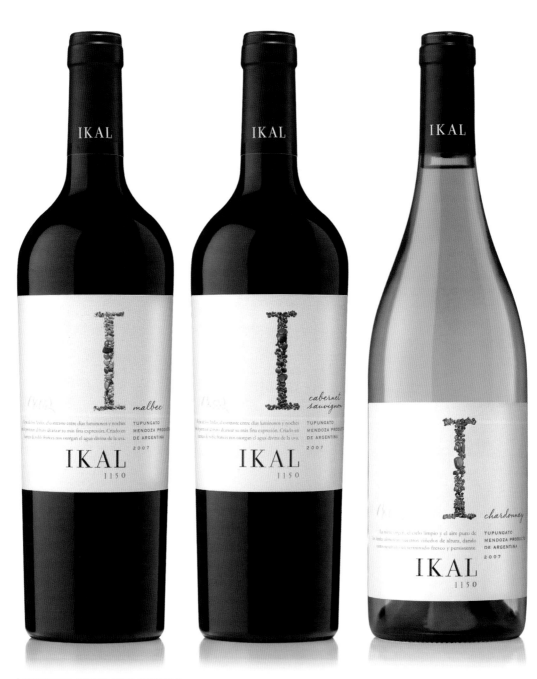

TRIDIMAGE_ BUENOS AIRES, ARGENTINA
CREATIVE TEAM: Adriana Cortese, Hernán Braberman, Virginia Gines
CLIENT: Bodegas Ikal

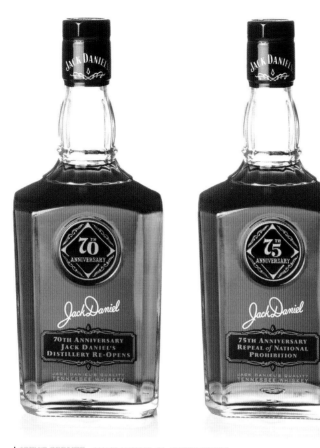

JOEY'S CORNER... SAN FRANCISCO, CA, UNITED STATES
CREATIVE TEAM: Michael Osborne Design, Brown-Forman
CLIENT: Brown-Forman

IOWA STATE UNIVERSITY... AMES, IA, UNITED STATES
CREATIVE TEAM: Bethany Weber
CLIENT: Iowa State University

KUBLY DESIGN_ OAKLAND, CA, UNITED STATES
CREATIVE TEAM: Eric Kubly, Toby Sudduth, Judy Swinks
CLIENT: Unilever

166

MARK OLIVER INC._ SOLVANG, CA, UNITED STATES
CREATIVE TEAM: Mark Oliver, Patty Driskel, Deborah Denker
CLIENT: Original Rangoon Company

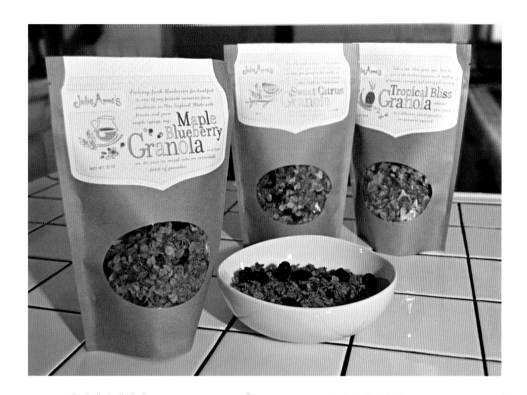

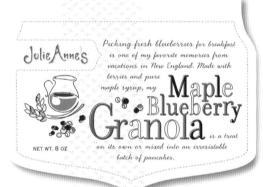

Julie Anne's

Picking fresh blueberries for breakfast is one of my favorite memories from vacations in New England. Made with berries and pure maple syrup, my **Maple Blueberry Granola** *is a treat on its own or mixed into an irresistable batch of pancakes.*

NET WT. 8 OZ

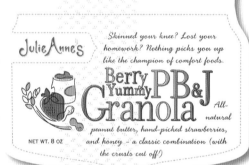

Julie Anne's

Skinned your knee? Lost your homework? Nothing picks you up like the champion of comfort foods. **Berry Yummy PB&J Granola** *All-natural peanut butter, hand-picked strawberries, and honey – a classic combination (with the crusts cut off!)*

NET WT. 8 OZ

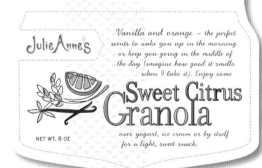

Julie Anne's

Vanilla and orange – the perfect scents to wake you up in the morning or keep you going in the middle of the day (imagine how good it smells when I bake it). Enjoy some **Sweet Citrus Granola** *over yogurt, ice cream or by itself for a light, sweet snack.*

NET WT. 8 OZ

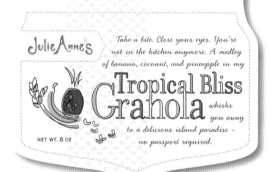

Julie Anne's

Take a bite. Close your eyes. You're not in the kitchen anymore. A medley of banana, coconut, and pineapple in my **Tropical Bliss Granola** *whisks you away to a delicious island paradise – no passport required.*

NET WT. 8 OZ

CDI STUDIOS, LAS VEGAS, NV, UNITED STATES
CREATIVE TEAM: Brian Felgar
CLIENT: Julie Anne's Fine Foods

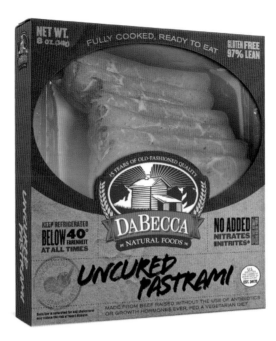

VERSION-X DESIGN CORP._ BURBANK, CA, UNITED STATES
CREATIVE TEAM: Adam Stoddard, Steve Silvas, Chris Fasan
CLIENT: DaBecca Natural Foods

168

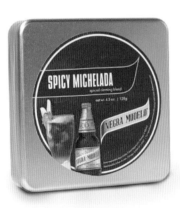

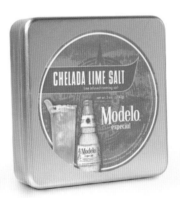

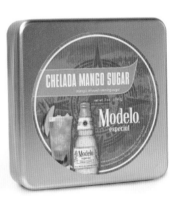

HEXANINE_ CHICAGO, IL, UNITED STATES
CREATIVE TEAM: Tim Lapetino, Jim Dygas (Creative Commune)
CLIENT: Negra Modelo

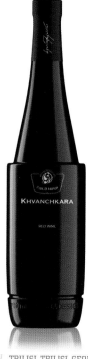

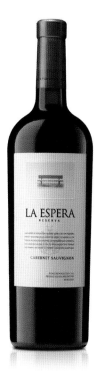

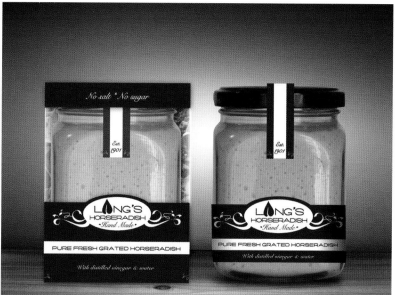

TSIKOLIA DESIGN, TBILISI, TBILISI, GEORGIA
CREATIVE TEAM: Zviad Tsikolia
CLIENT: KHVANCHKARA Ltd.

TRIDIMAGE, BUENOS AIRES, ARGENTINA
CREATIVE TEAM: Adriana Cortese, Hernán Braberman, Virginia Gines
CLIENT: Bodega Funckenhausen

MIAMI AD SCHOOL, MIAMI, FL, UNITED STATES
CREATIVE TEAM: Enas Rashwan, Vicente Jorge, Nicholas Bond
CLIENT: Student Work

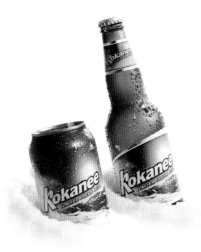

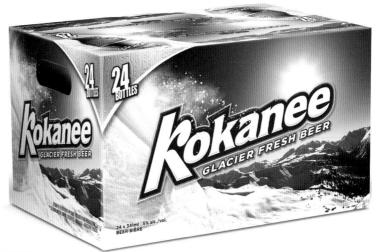

JUMP BRANDING & DESIGN INC._ TORONTO, ON, CANADA
CREATIVE TEAM: Richard Patmore, Adam Armstrong, Jerry Alfieri
CLIENT: Labatt Breweries of Canada

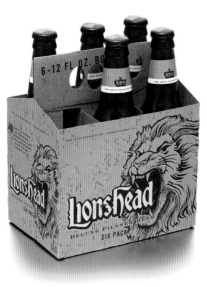

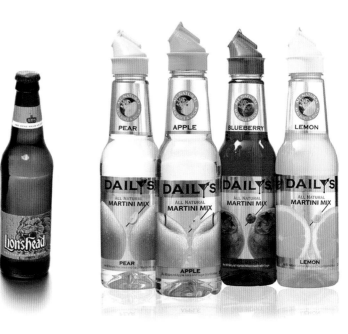

LITTLE BIG BRANDS_ NYACK, NY, UNITED STATES
CREATIVE TEAM: John Nunziato, Phil Foster
CLIENT: The Lion Brewery

THE BIONDO GROUP_ STAMFORD, CT, UNITED STATES
CREATIVE TEAM: Charles Biondo, Gary Labra, Meg Russell, Marvin Bernfeld
CLIENT: American Beverage Corp

OGILVY GROUP – KYIV, UKRAINE
CREATIVE TEAM: Will Rust, Taras Dzendrovskii, Alexander Katkov, Evgeniya Dzyubenko, Palina Pliashchanka, Nadezhda Diachenko, Dmitriy Shishkin, Evgenii Krylov, Alexandra Savonik, Martin Alles, Irina Pigal
CLIENT: Geoplant Ltd.

171

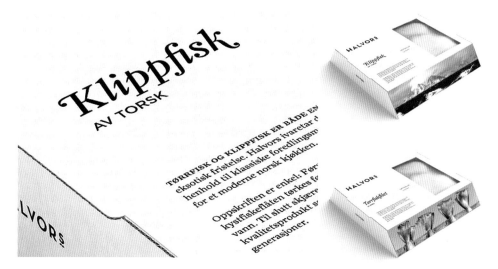

TANK DESIGN TROMSØ AS – TROMSØ, NORWAY
CREATIVE TEAM: Sandro Kvernmo, Bjørn Viggo Ottem
CLIENT: Halvors Tradisjonsfisk

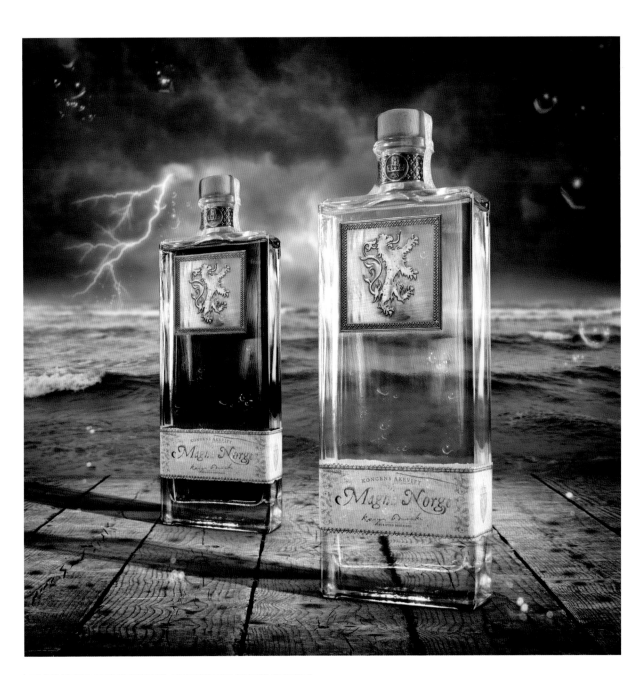

BRAUE BRAND DESIGN EXPERTS_ BREMERHAVEN, BREMEN, GERMANY
CREATIVE TEAM: Kai Braue, Marcel Robbers, Florian Eybe
CLIENT: Hotel am Medemufer GmbH

172

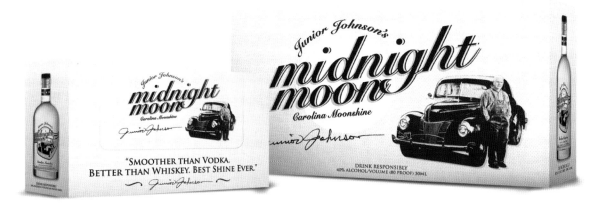

AIRTYPE STUDIO WINSTON-SALEM, NC, UNITED STATES
CREATIVE TEAM: Bryan Ledbetter
CLIENT: Piedmont Distilllers, Inc

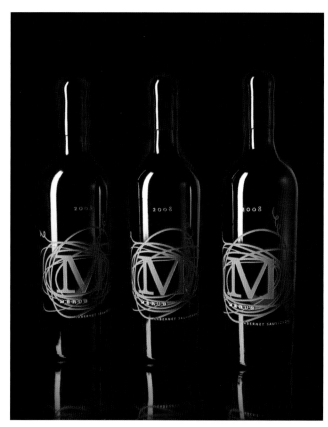

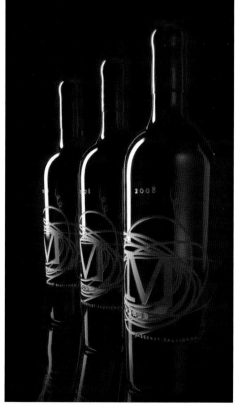

UXUS AMSTERDAM, NETHERLANDS
CREATIVE TEAM: UXUS
CLIENT: Merus Wines

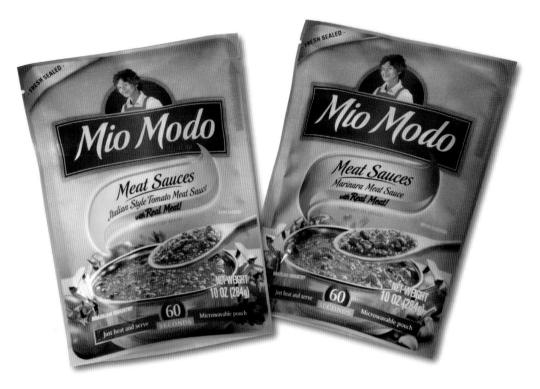

CORNERSTONE STRATEGIC BRANDING_ NEW YORK, NY, UNITED STATES
CREATIVE TEAM: Cornerstone Creative Staff
CLIENT: International Food Company

 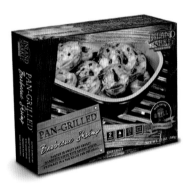

SELLIER DESIGN_ MARIETTA, GA, UNITED STATES
CREATIVE TEAM: Julie Cofer
CLIENT: Inland Market

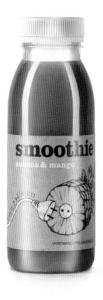 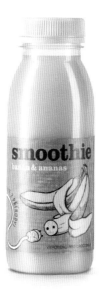 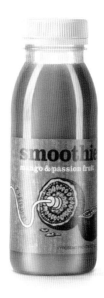 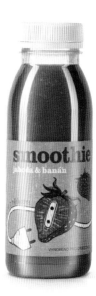

TOMAN GRAPHIC DESIGN PRAGUE, CZECH REPUBLIC
CREATIVE TEAM: Jiri Toman
CLIENT: Crocodille CR

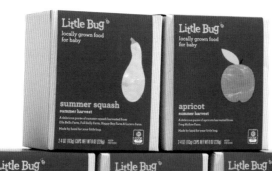

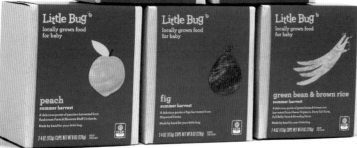

175

BRAND ENGINE SAUSALITO, CA, UNITED STATES
CREATIVE TEAM: Bob Hullinger, Meegan Peery, Bill Kerr, Geoff Nilsen
CLIENT: Little Bug, Inc.

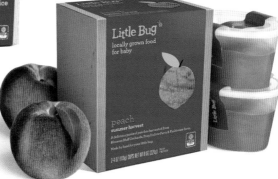

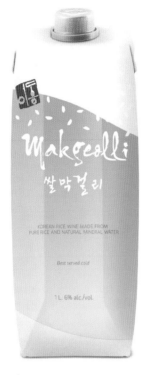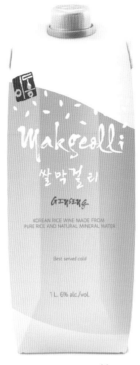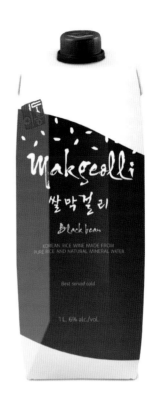

 SCHOOL OF VISUAL ARTS_ NEW YORK, NY, UNITED STATES
CREATIVE TEAM: Inyoung Kim
CLIENT: E-dong

Student Work

176

GRUMPYBOY STUDIOS_ NY, UNITED STATES
CREATIVE TEAM: Nick Guarracino
CLIENT: Utmost Brands inc., Grown-up Soda

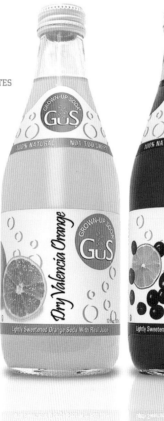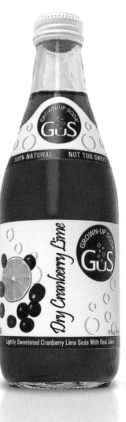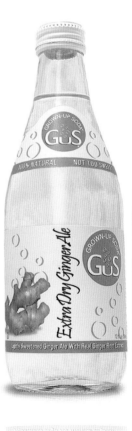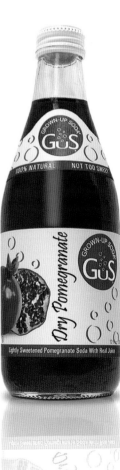

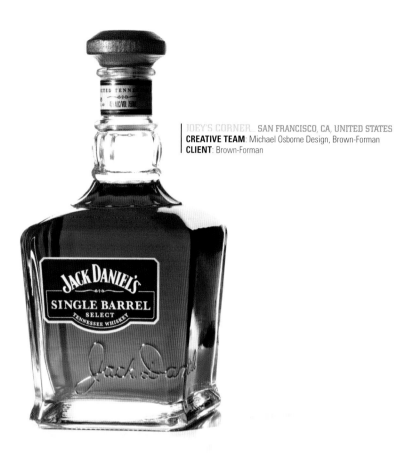

JOEY'S CORNER, SAN FRANCISCO, CA, UNITED STATES
CREATIVE TEAM: Michael Osborne Design, Brown-Forman
CLIENT: Brown-Forman

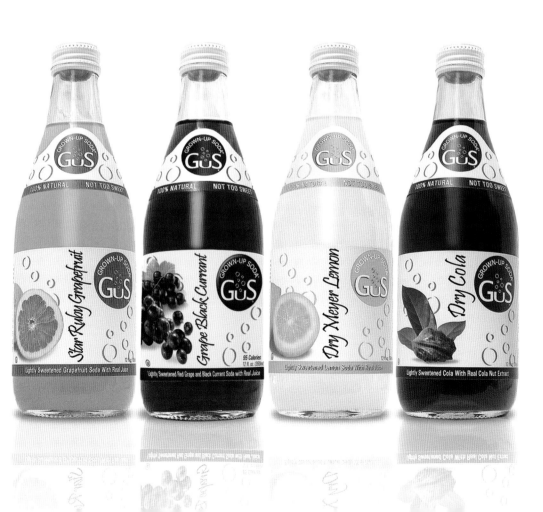

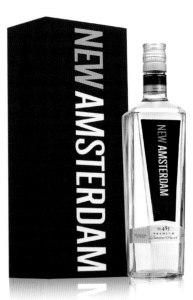

BORSAWALLACE_ NEW YORK, NY, UNITED STATES
CREATIVE TEAM: Jason Davis, Cecilia Molina, Rebecca Marshall, Cristina Ortega
CLIENT: DeVries Public Relations

THE GRAFIOSI_ NEW DELHI, INDIA
CREATIVE TEAM: Pushkar Thakur
CLIENT: SliderBar Cafe

COURTNEY BARO_ PA, UNITED STATES
CREATIVE TEAM: Courtney Baro
CLIENT: Student Work

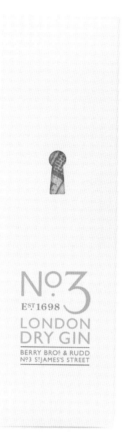

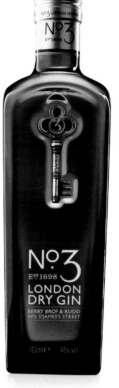

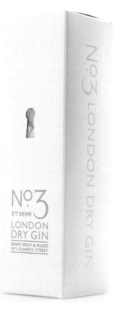
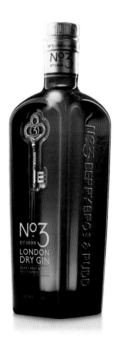

BRANDHOUSE, LONDON, UNITED KINGDOM
CREATIVE TEAM: David Beard, Bronwen Edwards, Pip Dale, Keely Jackman
CLIENT: Berry Brothers & Rudd

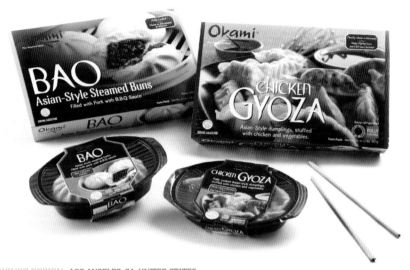

WINGZ DESIGN_ LOS ANGELES, CA, UNITED STATES
CREATIVE TEAM: Shirin Raban, Jennifer Boggs, Denise Woleben
CLIENT: Okami Foods

180

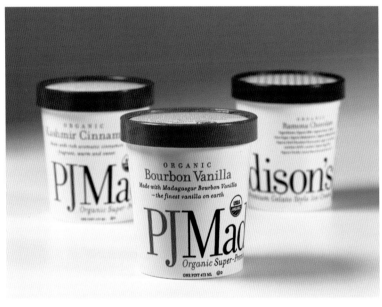

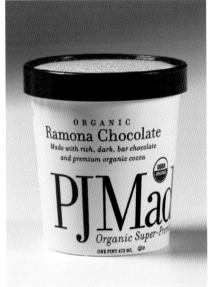

PENTAGRAM DESIGN_ AUSTIN, TX, UNITED STATES
CREATIVE TEAM: DJ Stout, Julie Savasky
CLIENT: PJ Madison's

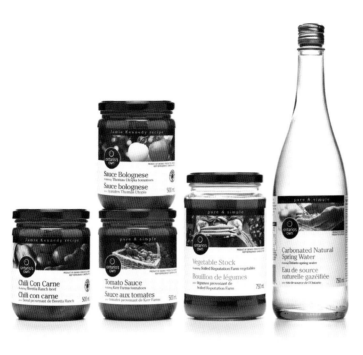

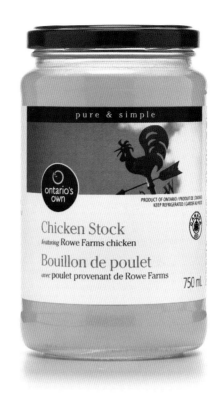

WATT INTERNATIONAL, TORONTO, ON, CANADA
CREATIVE TEAM: Randy Redford, Chris Sutton, Ash Pabani
CLIENT: The Great Ontario Food

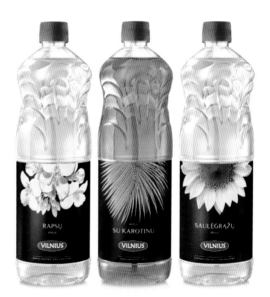

TRIDIMAGE, BUENOS AIRES, ARGENTINA
CREATIVE TEAM: Adriana Cortese, Hernán Braberman, Virginia Gines
CLIENT: VRS - Tikras Kelias

TRIDIMAGE, BUENOS AIRES, ARGENTINA
CREATIVE TEAM: Adriana Cortese, Hernán Braberman, Virginia Gines
CLIENT: Adesso

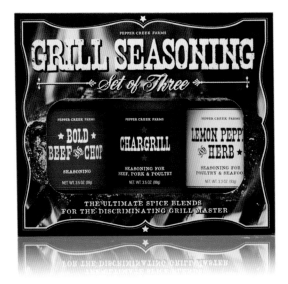
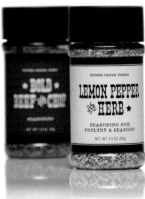

JENN DAVID DESIGN_ SAN DIEGO, CA, UNITED STATES
CREATIVE TEAM: Jenn David Connolly
CLIENT: Pepper Creek Farms

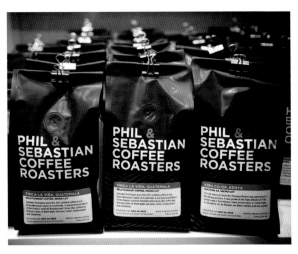

THE OFFICE OF JONATHAN HERMAN_ CALGARY, AB, CANADA
CREATIVE TEAM: Jonathan Herman, Elyse Bouvier, Flair Flexible Packaging
CLIENT: Phil & Sebastian Coffee Roasters

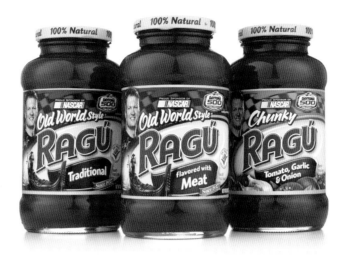

TFI ENVISION, INC., NORWALK, CT, UNITED STATES
CREATIVE TEAM: Elizabeth P. Ball, Phillip Doherty
CLIENT: Unilever Foods

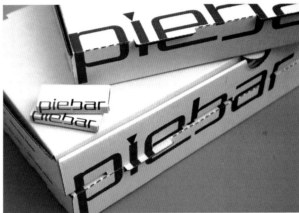

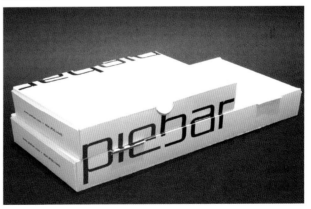

183

SKY DESIGN, ATLANTA, GA, UNITED STATES
CREATIVE TEAM: W. Todd Vaught, Carrie Wallace Brown, Tiffany Chen
CLIENT: Concentrics Restaurant Group

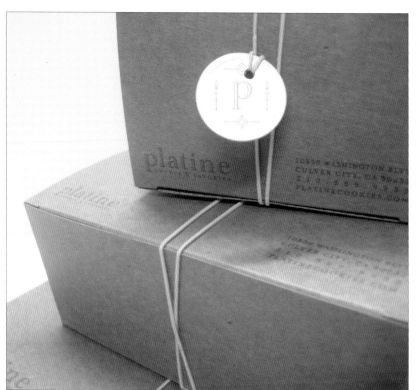
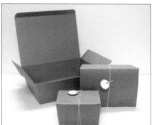

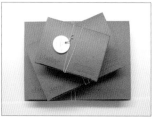

184

UNIT DESIGN COLLECTIVE_ SAN FRANCISCO, CA, UNITED STATES
CREATIVE TEAM: Shardul Kiri, Ann Jordan, Erin Delorefice
CLIENT: Platine

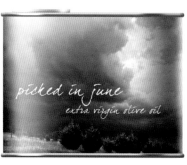

WATTS DESIGN_ SOUTH MELBOURNE, VICTORIA, AUSTRALIA
CREATIVE TEAM: Peter Watts
CLIENT: Picked in June

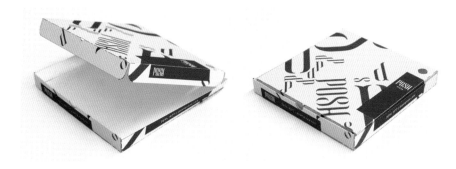

STUDIO CREAM DESIGN SYDNEY, AUSTRALIA
CREATIVE TEAM: John Valastro, Luisa Franco, Vicky Horvath
CLIENT: Posh Pizza

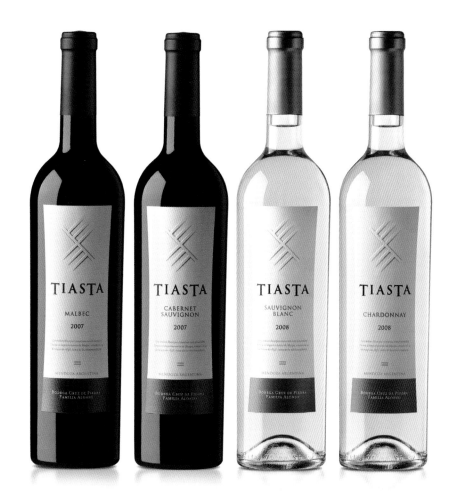

185

TRIDIMAGE BUENOS AIRES, ARGENTINA
CREATIVE TEAM: Adriana Cortese, Hernán Braberman, Virginia Gines
CLIENT: Bodega Cruz de Piedra

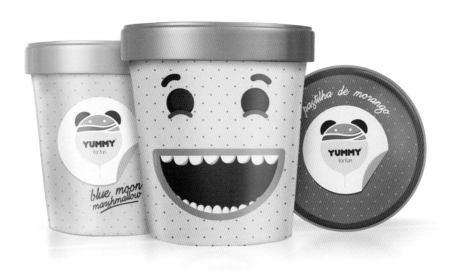

An In-Depth Look

Yummy Ice Cream

Joao Ricardo Machado loves ice cream, so it was only natural that he design packaging and brand identity for... an ice cream company. The Yummy Ice Cream identity and package design was a final college project created for the Graphic Design Project class in the College of Arts and Design Caldas da Rainha (ESAD.CR), based in Portugal.

"I looked at big, premium ice-cream companies like Häagen-Dazs and saw that they didn't have any products for kids. So I decided to create one." As an ice cream lover, Machado asked himself, "What kind of product would parents who love expensive, premium ice creams buy for their kids?"

In designing packaging for a kids' premium ice cream, Machado had several goals: packaging that kids could relate to and interact with, "making them feel how fun and delicious is to eat ice cream;" packaging they could keep to play with after eating the ice cream (and gently reinforce the notion of recycling at the same time); and packaging that would show parents that it is a quality ice cream, on equal footing with the ice cream they normally buy for themselves.

"My first choice was to use the classic ice cream cup, for several reasons: it clearly evokes the premium ice creams; it's easy to carry; and it's

easy to come up with new ways to reuse the package," Machado said.

"When I was thinking about the graphics and what the package should really be, I realized that, more than showing ice cream or its ingredients, it should incorporate something that could easily get kids' attention." The solution was to turn the whole package into a character that would wear "a face of happiness and fun," just like kids' faces when they eat ice cream. Each flavor had a different expression, changing the eyes and mouth each time, and the flavors were designated by the package color.

The package colors were defined by the real color of each ice cream flavor, making them easy to recognize. "They're basically classic ice cream colors, Machado says. "The vibrant colors give more energy to the faces and look very fun to the kids."

The labeling was intentionally divided into three parts—the happy faces, the logo/flavor name, and the essential information—"so that, when you have the happy face turned to you, all you see is this funny and cute face smiling and calling you to see what is there."

But the experience does not stop with the eating (or the washing-up). After the ice cream is gone, the package can be used again—as a toy (think

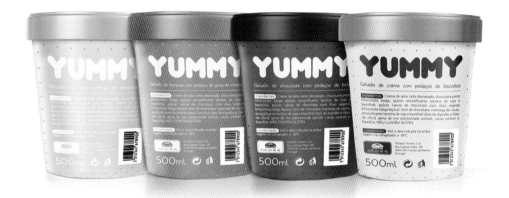

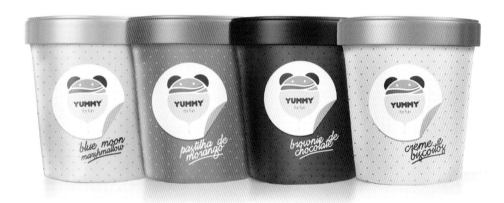

puppet shows), to stack or count, for storage, or just to collect. The cute faces look great displayed on a shelf in a kids' room or nursery.

And, as a reusable object, the package teaches eco-friendly living in a kid-friendly way and avoids putting a detrimental burden on the environment.

Machado's project specified a target market of middle- and upper-class families who would purchase the ice creams from supermarkets, specialty food stores, and in Yummy Ice Cream Stores.

Machado got great feedback from his instructors and fellow students and garnered attention from the wider design community as well, including thedieline.com, lovelypackage.com, ffffound.com, and sharesomecandy.com. Several design companies found the Yummy project in the school's catalog and commissioned him for freelance work. Best of all, a design and communications company developing a TV channel for kids and teens needed someone who could do graphic design that would speak to young people, and offered him a job.

Joao Ricardo Machado has lots of reasons to feel good about his project. Best all, he says, "I always feel like laughing when I look at these happy faces."

JOAO RICARDO MACHADO CALDAS DA RAINHA, PORTUGAL

CREATIVE TEAM: Joao Ricardo Machado
CLIENT: Student Work

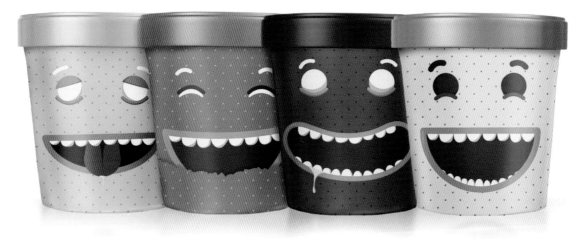

JOAO RICARDO MACHADO_ CALDAS DA RAINHA, PORTUGAL
CREATIVE TEAM: Joao Ricardo Machado
CLIENT: Student Work

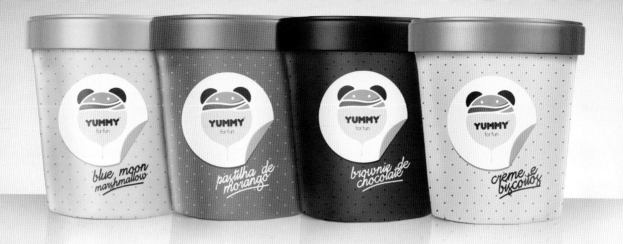

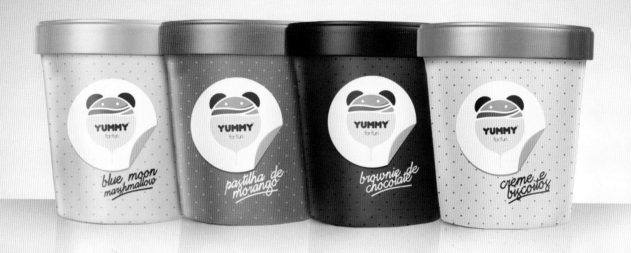

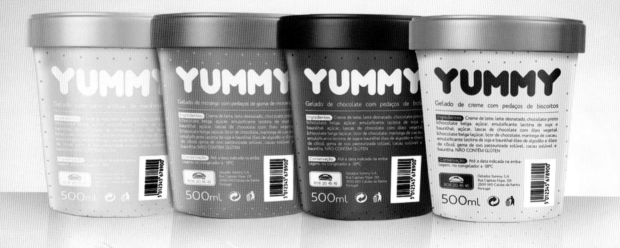

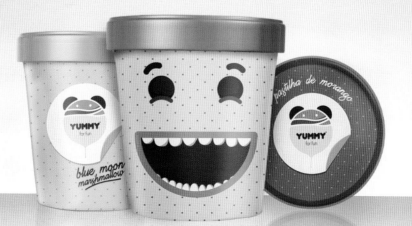

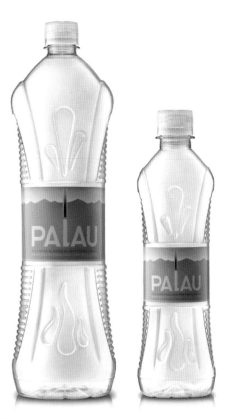

KUBLY DESIGN_ OAKLAND, CA, UNITED STATES
CREATIVE TEAM: Eric Kubly, Toby Sudduth
CLIENT: Fluid Motion Beverage Company

TRIDIMAGE_ BUENOS AIRES, ARGENTINA
CREATIVE TEAM: Adriana Cortese, Hernán Braberman, Virginia Gines
CLIENT: Plumada

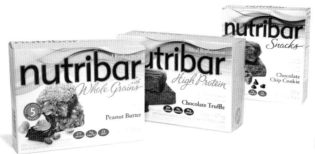

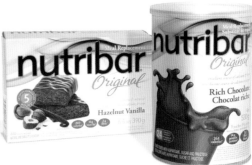

MAROVINO VISUAL STRATEGY_ TORONTO, ON, CANADA
CREATIVE TEAM: Marianne Bozzo, Carol Murphie
CLIENT: Stella Pharmaceutical Canada Inc.

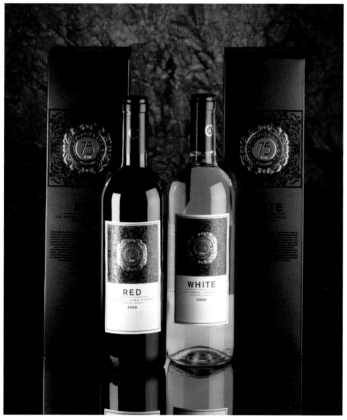

191

ZEELAND_ TURKU, FINLAND
CREATIVE TEAM: Juuso Korpinen
CLIENT: Jaakkoo-Taara Oy

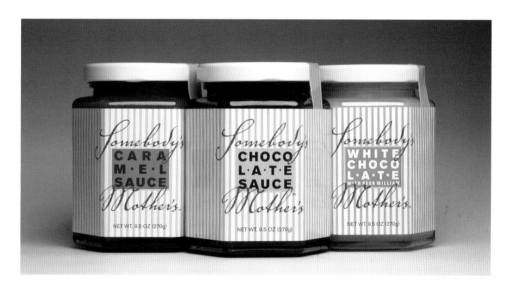

HIVELYDESIGNS_ AL, UNITED STATES
CREATIVE TEAM: Charles Hively, Sarah Munt
CLIENT: Somebody's Mother's Chocolate Sauce

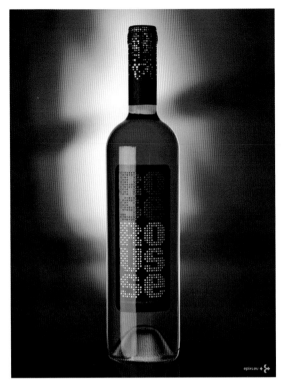

EPIXS.EU_ VARNA, BULGARIA
CREATIVE TEAM: Jordan Jelev
CLIENT: Rousse Winery

NIEDERMEIER DESIGN_ SEATTLE, WA , UNITED STATES
CREATIVE TEAM: Kurt Niedermeier
CLIENT: Sahale Snacks

LOVE COMMUNICATIONS, SALT LAKE CITY, UT, UNITED STATES
CREATIVE TEAM: Preston Wood
CLIENT: Sael Sama

SANDALS RESORTS, MIAMI, FL, UNITED STATES
CREATIVE TEAM: Scott Peiffer, Mike Menendez
CLIENT: Self-Promotion

EBERLE GMBH WERBEAGENTUR GWA_ GERMANY
CREATIVE TEAM: Jochen Eberle, Katja Schmid
CLIENT: Weibenhorner Milch Manufaktur

194

BORSAWALLACE_ NEW YORK, NY, UNITED STATES
CREATIVE TEAM: Jason Davis, Rebecca Marshall
CLIENT: Designer

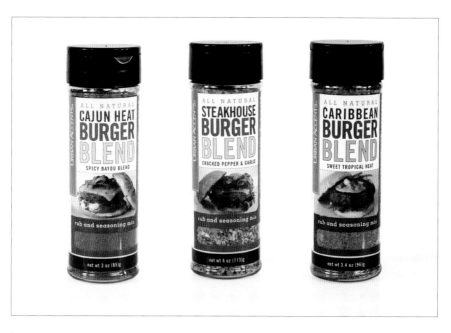

CHICAGO, IL, UNITED STATES
CREATIVE TEAM: Tim Lapetino, Jim Dygas, Beau Keda
CLIENT: Urban Accents

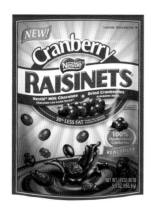 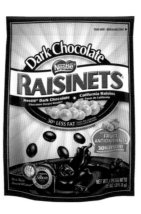

NEW YORK, NY, UNITED STATES
CREATIVE TEAM: Cornerstone Creative Staff
CLIENT: Nestlé USA, Inc.

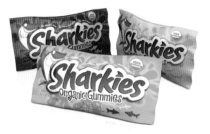

SLOAT DESIGN GROUP_ SAN RAFAEL, CA, UNITED STATES
CREATIVE TEAM: Carrie Dufour
CLIENT: Sharkies

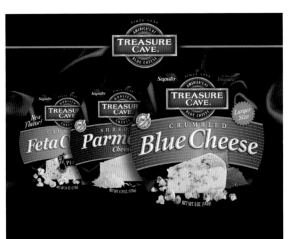

KUBLY DESIGN_ OAKLAND, CA, UNITED STATES
CREATIVE TEAM: Eric Kubly, Ray Tuazon, RJ Herrenkohl, Juid Swinks
CLIENT: Saputo Cheese USA

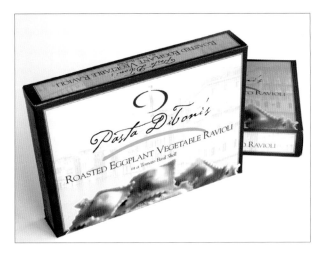

SCOTT ADAMS DESIGN ASSOCIATES_ MINNEAPOLIS, MN, UNITED STATES
CREATIVE TEAM: Scott Adams
CLIENT: Pasta DiToni

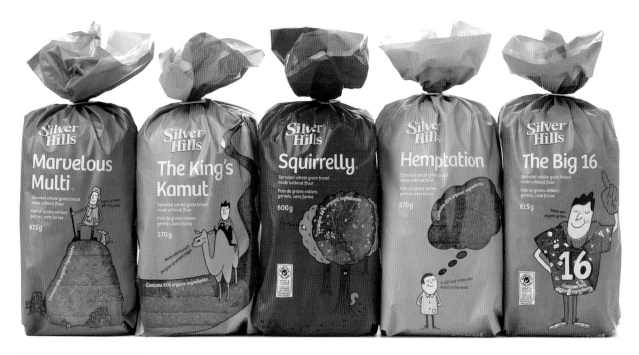

KARACTERS DESIGN GROUP. VANCOUVER, BC, CANADA
CREATIVE TEAM: James Bateman, Dan O'Leary, Jennifer Pratt, Jeff Galbraith
CLIENT: Silver Hills Bakery

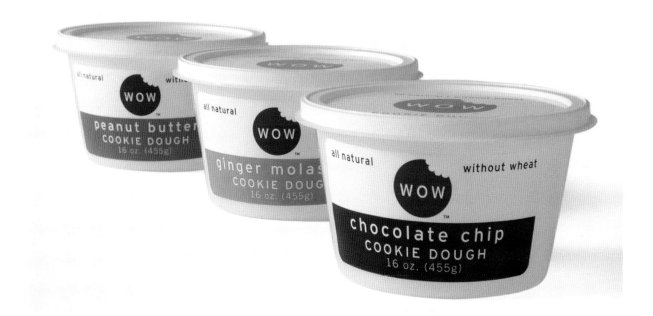

MARY HUTCHISON DESIGN LLC. SEATTLE, WA, UNITED STATES
CREATIVE TEAM: Mary Chin Hutchison
CLIENT: WOW Baking Co., LLC

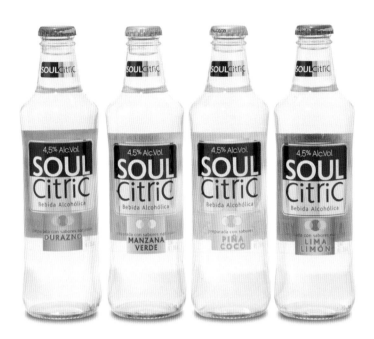

CORNERSTONE STRATEGIC BRANDING_ NEW YORK, NY, UNITED STATES
CREATIVE TEAM: Cornerstone Creative Staff
CLIENT: Cerveceria Cuauhtemoc Moctezuma

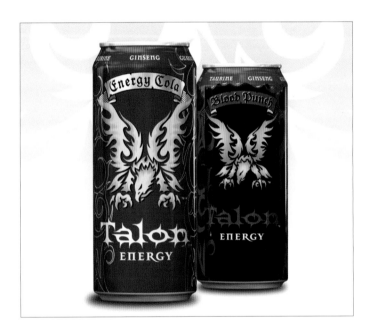

KUBLY DESIGN_ OAKLAND, CA, UNITED STATES
CREATIVE TEAM: Eric Kubly, Ray Tuazon, Filip Yip
CLIENT: Fluid Motion Beverage

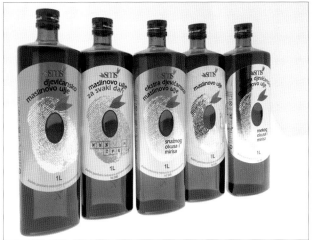

STUDIO INTERNATIONAL, ZAGREB, CROATIA
CREATIVE TEAM: Boris Ljubicic
CLIENT: SMS, Split, Croatia

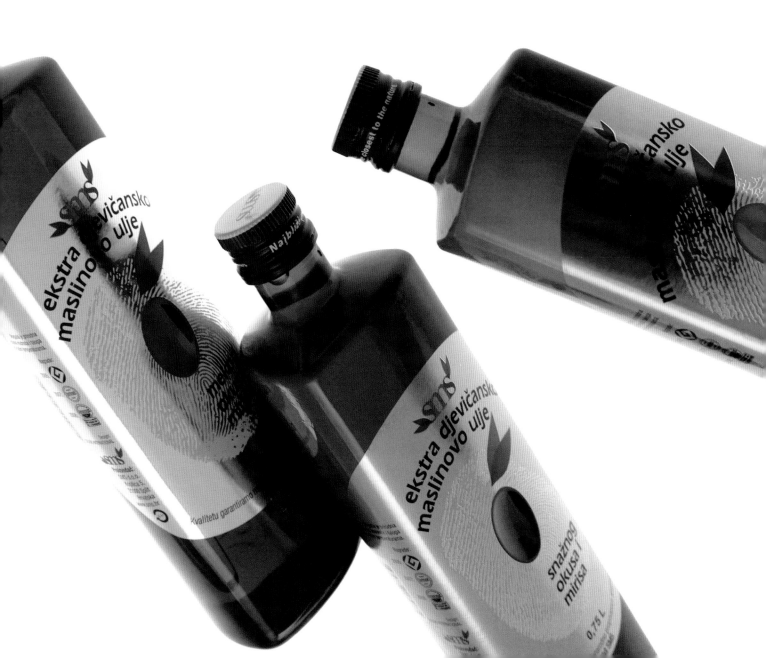

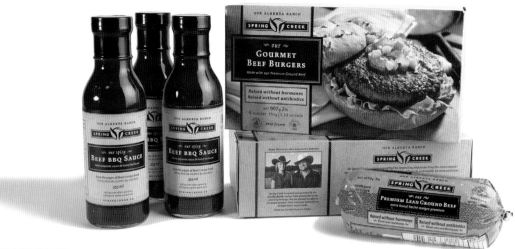

FOUNDRY CREATIVE_ CALGARY, AB, CANADA
CREATIVE TEAM: Alison Wattie, Zahra Al-Harazi, Kylie Henry
CLIENT: Spring Creek

HEXANINE_ CHICAGO, IL, UNITED STATES
CREATIVE TEAM: Tim Lapetino, Jim Dygas
CLIENT: Jim Beam

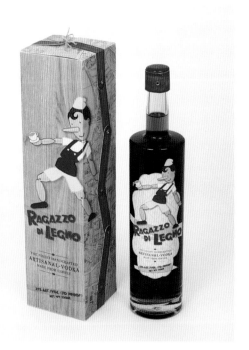

TYLER SCHOOL OF ART_ WARRINGTON, PA, UNITED STATES
CREATIVE TEAM: Jamielynn Miller
CLIENT: Tyler School of Art, Temple University

Student Work

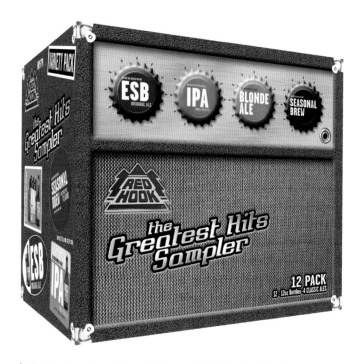

CORNERSTONE STRATEGIC BRANDING NEW YORK, NY, UNITED STATES
CREATIVE TEAM: Cornerstone Creative Staff
CLIENT: Redhook Ale Brewery

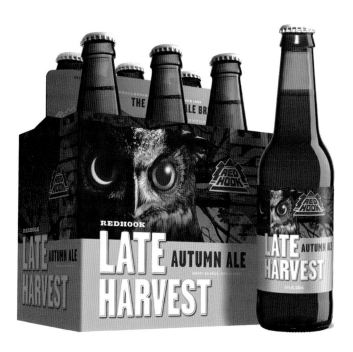

CORNERSTONE STRATEGIC BRANDING NEW YORK, NY, UNITED STATES
CREATIVE TEAM: Cornerstone Creative Staff
CLIENT: Redhook Ale Brewery

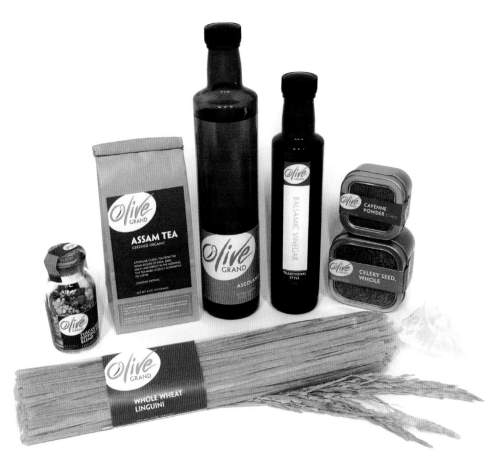

202

FUNK/LEVIS & ASSOCIATES_ EUGENE, OR, UNITED STATES
CREATIVE TEAM: Jason Anderson
CLIENT: Olive Grand

NIEDERMEIER DESIGN_ SEATTLE, WA, UNITED STATES
CREATIVE TEAM: Kurt Niedermeier
CLIENT: Queen Mary Tea

JMG, SERBIA
CREATIVE TEAM: Aleksandar Petrovic
CLIENT: Vino Zupa

HEXANINE, CHICAGO, IL, UNITED STATES
CREATIVE TEAM: Tim Lapetino, Jim Dygas
CLIENT: The Art of Spice

FACTOR TRES / BRANDING AND STRATEGIC DESIGN_ MEXICO CITY, MEXICO
CREATIVE TEAM: Rodrigo Cordova, Sergio Enriquez
CLIENT: Helados Nestle

204

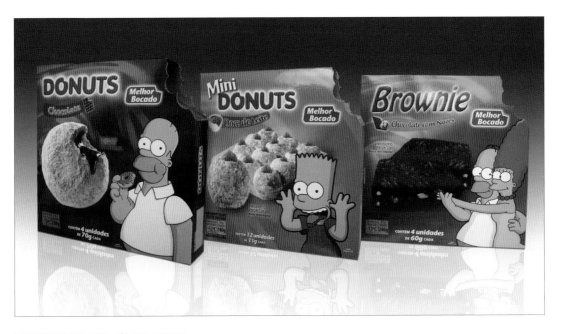

SMART PROPAGANDA_ SÃO PAULO, BRAZIL
CREATIVE TEAM: Gilberto Sato, Samuel Sanção, Viviane Candeias
CLIENT: Melhor Bocado Alimentos Ltda

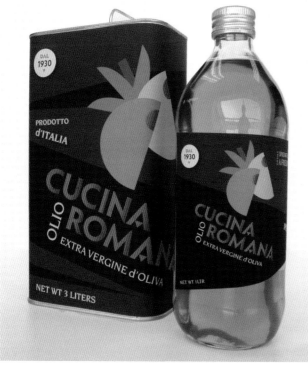

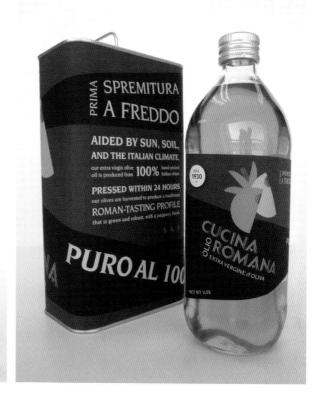

DESIGN BLISS. PHILADELPHIA, PA, UNITED STATES
CREATIVE TEAM: Christine Fajardo, Paul Sherif
CLIENT: Tyler School of Art, Temple University

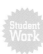

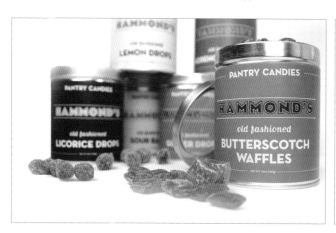

ELLEN BRUSS DESIGN. DENVER, CO, UNITED STATES
CREATIVE TEAM: Ellen Bruss, Gemma Bayly
CLIENT: Hammond's Candies

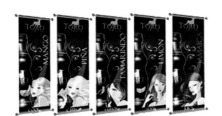

206

AXIOMACERO_ MONTERREY, NUEVO LEON, MEXICO
CREATIVE TEAM: Mabel Morales, Carmen Rodriguez, Francisco De La Vega
CLIENT: Toma Products

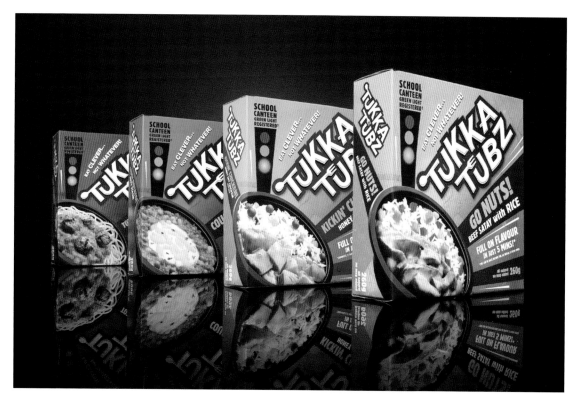

HOYNE DESIGN ST KILDA, AUSTRALIA
CREATIVE TEAM: Domenic Minieri, Huey Lau, Anthony Teoh
CLIENT: Vesco Foods

207

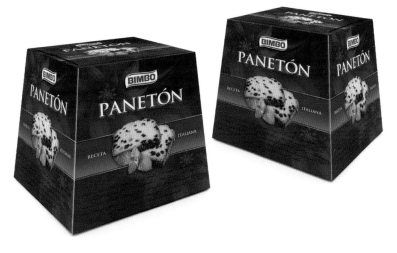

FACTOR TRES / BRANDING AND STRATEGIC DESIGN MEXICO CITY, MEXICO
CREATIVE TEAM: Rodrigo Cordova
CLIENT: Bimbo de Mexico

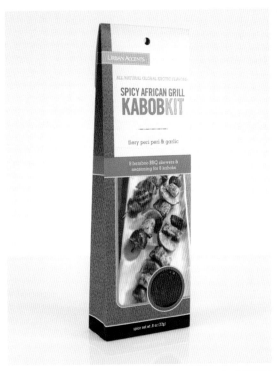

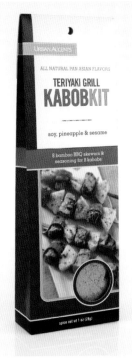

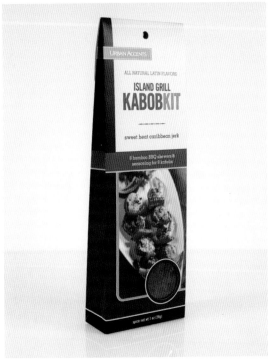

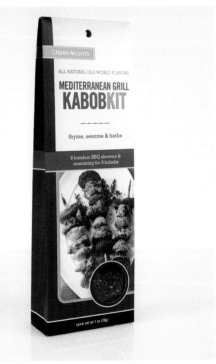

HEXANINE_ CHICAGO, IL, UNITED STATES
CREATIVE TEAM: Tim Lapetino, Jim Dygas
CLIENT: Urban Accents

CORNERSTONE STRATEGIC BRANDING, NEW YORK, NY, UNITED STATES
CREATIVE TEAM: Cornerstone Creative Staff
CLIENT: Coca-Cola North America

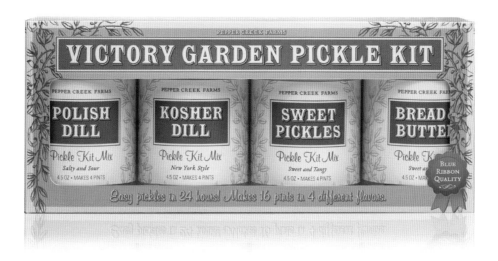

209

JENN DAVID DESIGN, SAN DIEGO, CA, UNITED STATES
CREATIVE TEAM: Jenn David Connolly
CLIENT: Pepper Creek Farms

TEN26 DESIGN GROUP, INC._ CRYSTAL LAKE, IL, UNITED STATES
CREATIVE TEAM: Tony Demakis, Kelly Demakis
CLIENT: Waterline Marketing

210

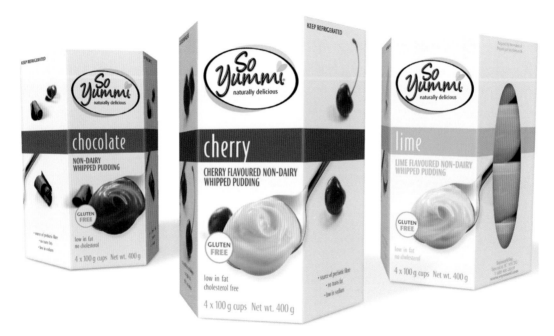

MAROVINO VISUAL STRATEGY_ TORONTO, ON, CANADA
CREATIVE TEAM: Pete Smith, Carol Murphie
CLIENT: Soyaworld Inc.

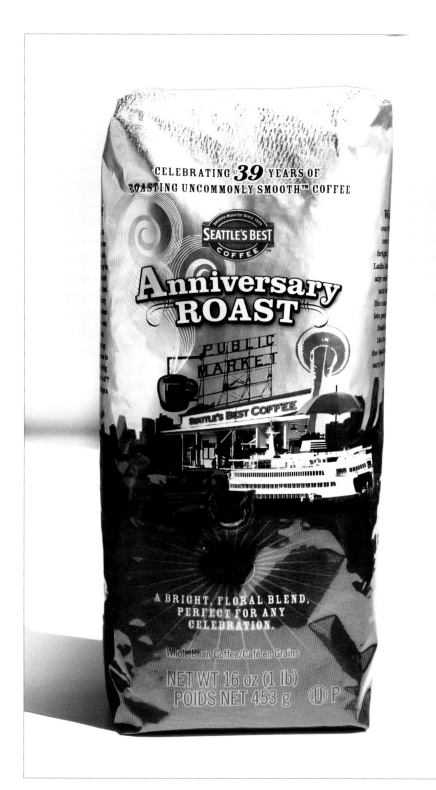

HL2 WA, UNITED STATES
CREATIVE TEAM: Dave Estep, Heidi Broadhead, Carly Schlenker, Tavo Adame
CLIENT: Seattle's Best Coffee

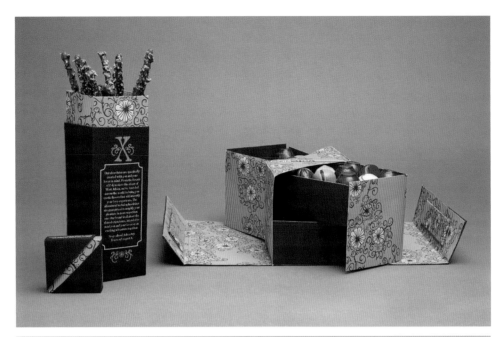

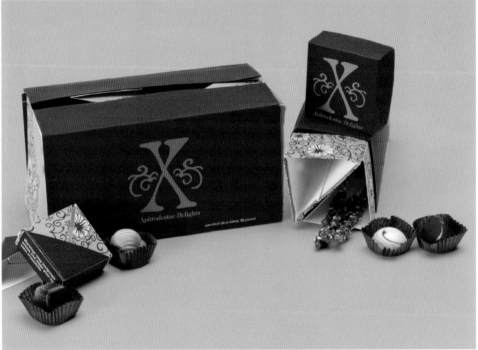

PHILADELPHIA UNIVERSITY_ PHILADELPHIA, PA, UNITED STATES
CREATIVE TEAM: Emily Zuwiala, Maribeth Kradel-Weitzel, Todd Vachon
CLIENT: Student Work

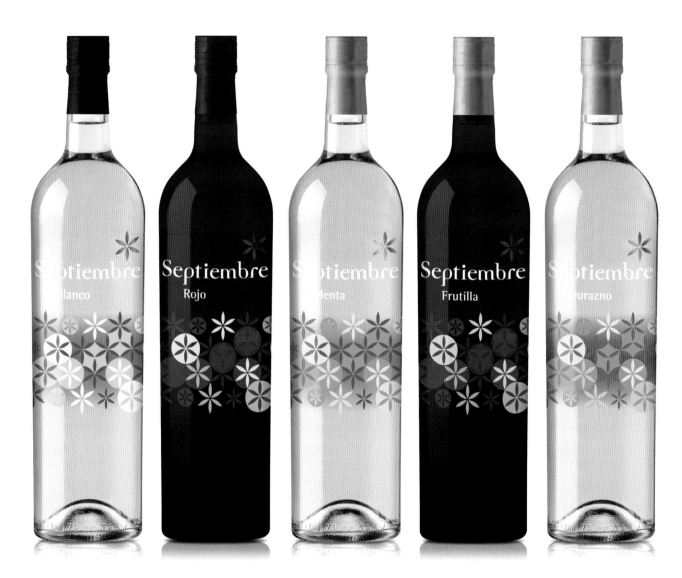

TRIDIMAGE BUENOS AIRES, ARGENTINA
CREATIVE TEAM: Adriana Cortese, Hernán Braberman, Virginia Gines
CLIENT: Bodegas Trapiche

213

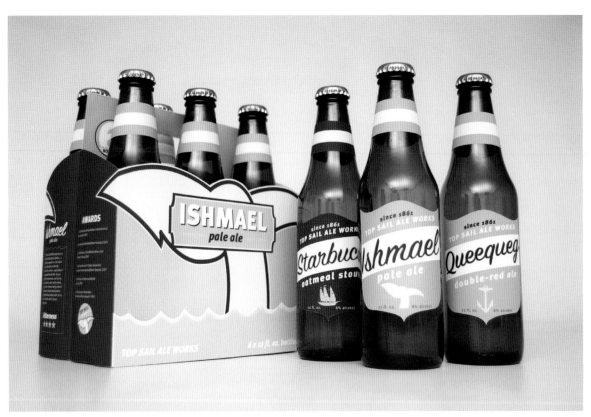

214

SUSQUEHANNA UNIVERSITY_ PA, UNITED STATES
CREATIVE TEAM: Joshua Schott
CLIENT: Top Sale Ale Works

Student Work

CORNERSTONE STRATEGIC BRANDING_ NEW YORK, NY, UNITED STATES
CREATIVE TEAM: Cornerstone Creative Staff
CLIENT: Cerveceria Cuauhtemoc Moctezuma

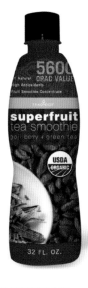 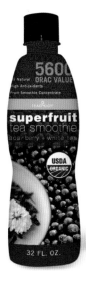 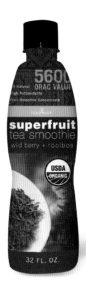

MARY HUTCHISON DESIGN LLC... SEATTLE, WA, UNITED STATES
CREATIVE TEAM: Mary Chin Hutchison
CLIENT: Innovative Beverage Concepts, Inc.

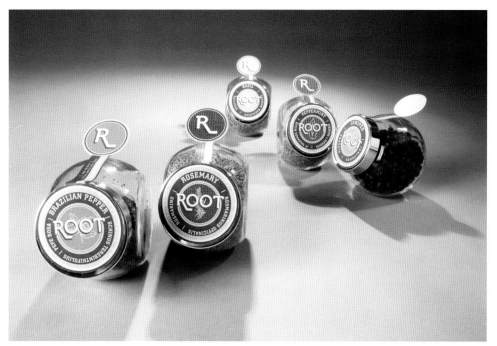

215

IOWA STATE UNIVERSITY... AMES, IA, UNITED STATES
CREATIVE TEAM: Laura Weible
CLIENT: Student Work

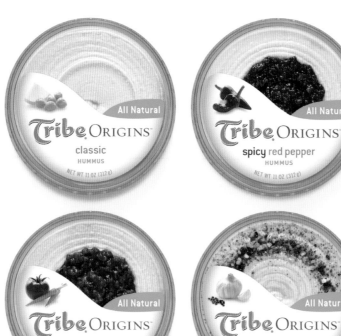

216

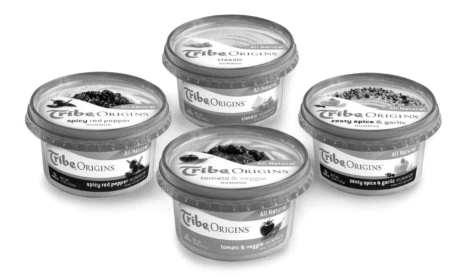

PTARMAK, INC., AUSTIN, TX, UNITED STATES
CREATIVE TEAM: JR Crosby, Annie Mayfield, Zach Ferguson
CLIENT: Tribe Hummus

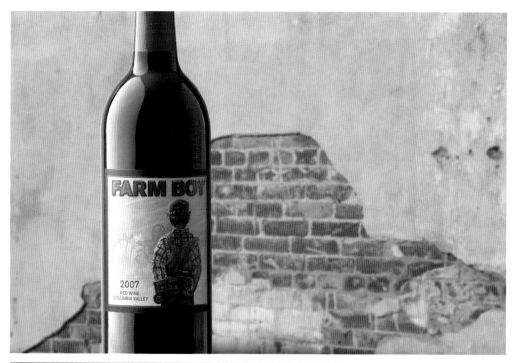

SARA NELSON DESIGN, LTD... PASCO, WA, UNITED STATES
CREATIVE TEAM: Herb Leonhard, Ken Carter, Sara Nelson
CLIENT: ROS Wines

218

MMM...GOOD DESIGN_ PHILADELPHIA, PA, UNITED STATES
CREATIVE TEAM: Meaghan Murray
CLIENT: Self-Promotion

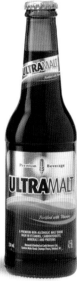

CORNERSTONE STRATEGIC BRANDING, NEW YORK, NY, UNITED STATES
CREATIVE TEAM: Cornerstone Creative Staff
CLIENT: Carib Brewery, Ltd

NALINDESIGN, NEUENRADE, GERMANY
CREATIVE TEAM: Andre Weier
CLIENT: SURGE

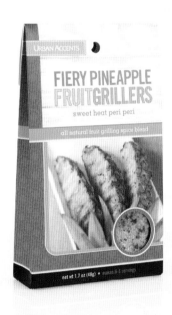

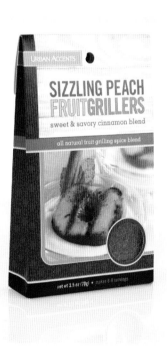

HEXANINE, CHICAGO, IL, UNITED STATES
CREATIVE TEAM: Tim Lapetino, Jim Dygas
CLIENT: Urban Accents

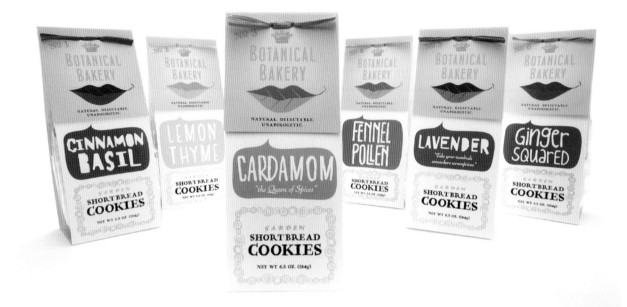

An In-Depth Look

Botanical Bakery Shortbread line

"Brands just want to have fun." So says branding Jedi David Brier, Creative Director of DBD International. And he sees to it that they do. Well—as much as possible, he says, without violating any sort of city ordinances or anything. "We love fun. People seek out fun. The brands that try to make their 'serious' dent in the world are invariably the ones that seem to have the shortest life spans. As a result, they end up promoting their category, but not their brand."

Brier saw a huge potential for fun when Sondra Wells, owner and now-titled Chief Indulgence Officer of Napa Valley's Botanical Bakery, saw one of Brier's articles on FastCompany.com and contacted him about getting her shortbread cookies properly branded. Going into their second year of business, they were positioned as prim British tea cookies, but Brier, a devout foodie, saw them for what they really were: brazen chunks of indulgence with a butter soul. The herb-infused Garden Shortbread Cookies—which are, in Brier's exact words, "these really, really, **really** delicious, absolutely rich, artisan-caliber shortbread cookies, very buttery, just *Yum. Yum.* **Yum**"—are not your ordinary, proper tea cookies. "These cookies need to be wild," he told his client. "People need to feel like they can have fun with them—not get dressed for them!" He suggested consumers should feel that they've snuck backstage to the dressing room where the cookies are hanging out to overhear what they talk about when nobody's listening. "They're risqué, outspoken, and unbelievable. You should hear what the Cardamom ones say about the Cinnamon Basil—talk about a cat fight!"

That did it. "You get us," said Wells, whom Brier characterizes as fun-loving and wildly creative. "You can take us where we need to go."

With the prim-and-proper tea cookie image off the table, Brier went to the heart of their market: foodies. His people. "Foodies," he says, "are about discovery. If I hear about any great delicacy, I don't care if it costs me $35 for a box of truffles and $25 for shipping; if it's amazing and I will have discovered something remarkable, it's worth it to me. We needed to make these cookies the coolest thing that foodies could discover, the reward they grew up to be adults for."

Something else Brier knows firsthand: foodies love information. So they created food pairings for the cookies—*the cardamom would go well on a cheese board; fennel pollen complements a glass of prosecco*—and put them on the back of the package. "We made it highly discoverable."

When DBD was brought in to revamp and upgrade the brand packaging, they began with the logo, a sort of organic-looking script with leaves. "Look," Brier told his client, "if you're going to sell me gourmet food, intoxicate me. Visually blackmail me. *Please*. If you're not going to make me involuntarily salivate, then don't do the packaging."

DBD INTERNATIONAL, LTD. MENOMONIE, WI, UNITED STATES
CREATIVE TEAM: David Brier
CLIENT: Botanical Bakery

NO 4
BOTANICAL BAKERY

**NATURAL. DELECTABLE.
UNAPOLOGETIC.**

FENNEL POLLEN

GARDEN
SHORTIES™
SHORTBREAD COOKIES

NET WT 3.5 OZ. (99.2g)

NO 4
BOTANICAL BAKERY

NATURAL. DELECTABLE. UNAPOLOGETIC.

FENNEL POLLEN

GARDEN
SHORTBREAD
COOKIES

NET WT
1 OZ.
(28.4g)

They presented the client with three different directions, including the one that eventually took. "I love that logo," Brier says. "Those leaf lips—with the little dimple—that just captured the perfect essence." The client liked it, but at first it made her—*nervous*. There was something so *different* about them.

Brier left her alone for a few days, and she came back saying, "I'm loving this. The really weird thing is, my mother makes that exact same facial smirk. And I make that same facial smirk. And my daughter makes the same facial smirk."

> "We needed to make these cookies the coolest thing that foodies could discover, the reward they grew up to be adults for."

"She felt like there was some sort of Vulcan mind-meld," Brier laughs.

They concocted a juicy, delicious color palette that was unlike anybody else's color palette. Brier told her, "Your packaging needs to convey the upcoming moments of amazing deliciousness and complete indulgence that are about to be happening right in their mouth. Anything short of that, your packaging isn't doing its job." Each variety has a slightly different typographic style that emphasizes its unique herbal ingredients and showcases its personality, yet they all work together as a complete system. No detail was too insignificant. There is even a pair of leaf lips on the bottom of each package, for absolutely no reason other than if you happen to knock the bag over, there they are, smiling back at you.

When DBD was done overhauling the entire brand, it bore no resemblance to its earlier incarnation (shown at right) with its simple cello-bag-with-label presentation. And they did it against a difficult timeline. Starting in November, with time-gobblers like holidays, deadlines, and one vendor who completely dropped the ball, they found themselves three weeks before the San Francisco Fancy Food Show with—nothing. But they pulled everything together and skidded into the January show with signs, banners, and shots of the prototypes they had designed—but no actual product.

A lesser design might have fizzled. Instead, the repackaged, rebranded cookies went, as Brier's blog trumpets, from Napa to New York City in 6 months. They hit a home run in San Francisco. In addition to their existing vendors, which included a number of mom-and-pop specialty foods shops as well as Vegas hotels and chains like Whole Foods, Botanical Bakery is also now supplying one of the world's largest tech companies with shortbread cookies for its 72 kitchens serving its 10,000 employees. The 2010 Summit International Awards gave the new logo and packaging a Bronze and a Silver out of some 4,000 entries from around the world; the 2010 World Tea Expo selected the ginger cookies as a Best New Product; they were featured in a June 1 article in the Dining & Wine section of *The New York Times*; and Botanical Bakery's new packaging won in the 2010 Communication Arts Design Annual.

They are currently telling new customers that they will have to wait quite a few weeks before placing an order.

"If company is going to get noticed," Brier preaches, "they have to rise above the noise and defy gravity." And have fun.

■ Previous Design

DBD INTERNATIONAL, LTD., WI, UNITED STATES
CREATIVE TEAM: David Brier
CLIENT: Botanical Bakery

224

TSIKOLIA DESIGN_ TBILISI, GEORGIA
CREATIVE TEAM: Zviad Tsikolia
CLIENT: SANTE GMT

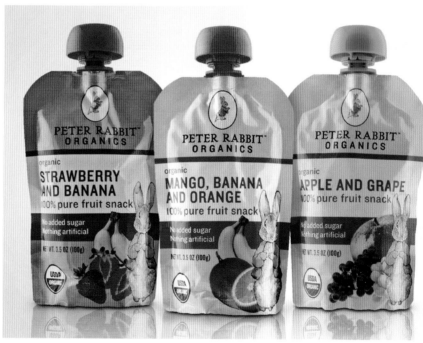

225

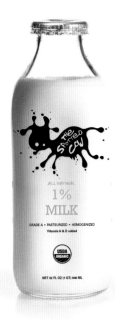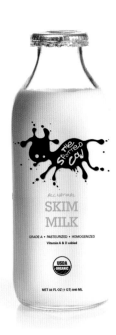

226

MOTTO AGENCY_ MYRTLE BEACH, SC, UNITED STATES
CREATIVE TEAM: Sunny Bonnell, Ashleigh Hansberger
CLIENT: The Spotted Cow

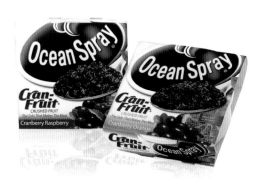

THE BIONDO GROUP_ STAMFORD, CT, UNITED STATES
CREATIVE TEAM: Charles Biondo, Gary Labra, Mark Davis, Marvin Bernfeld
CLIENT: Ocean Spray

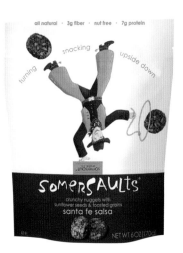

KUBLY DESIGN_ OAKLAND, CA, UNITED STATES
CREATIVE TEAM: Eric Kubly, Nicole Allin
CLIENT: Somersault Snack Company

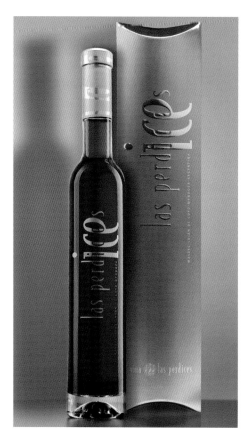

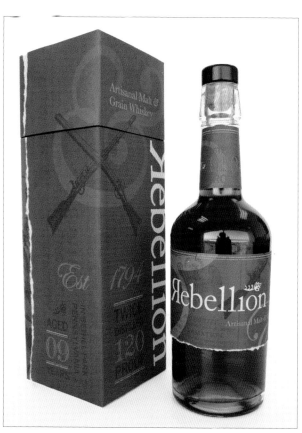

ESTUDIO IUVARO... MENDOZA, ARGENTINA
CREATIVE TEAM: Cecilia Iuvaro, Silvia Keil, Celia Grezzi, Valeria Aise
CLIENT: Carlos Muñoz

DESIGN BLISS... PHIADELPHIA, PA, UNITED STATES
CREATIVE TEAM: Christine Fajardo, Paul Sherif
CLIENT: Tyler School of Art, Temple University

Student Work

227

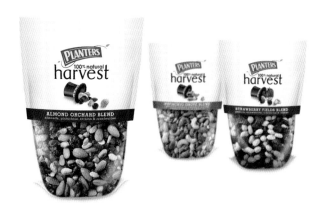

SPRING DESIGN PARTNERS, INC... NEW YORK, NY, UNITED STATES
CREATIVE TEAM: Ron Wong
CLIENT: Kraft Foods, Inc.

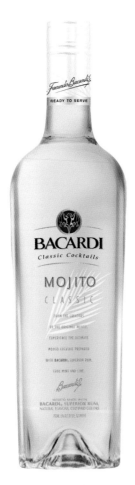

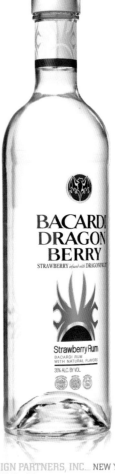

228

SPRING DESIGN PARTNERS, INC._ NEW YORK, NY, UNITED STATES
CREATIVE TEAM: Ron Wong
CLIENT: Bacardi USA

SPRING DESIGN PARTNERS, INC._ NEW YORK, NY, UNITED STATES
CREATIVE TEAM: Ron Wong
CLIENT: Bacardi USA

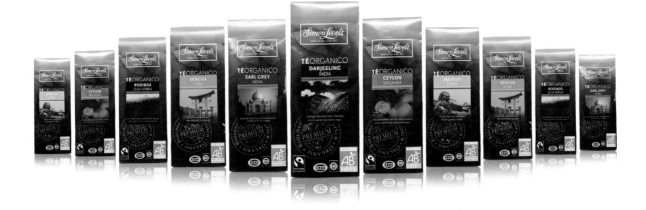

REGGS_ AMSTERDAM, NETHERLANDS
CREATIVE TEAM: Leonie van Dorssen
CLIENT: REGGS

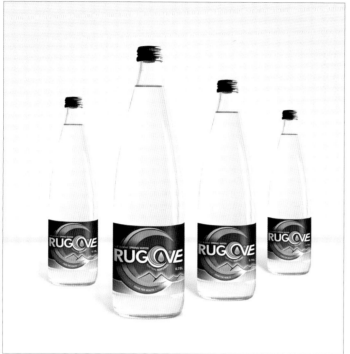

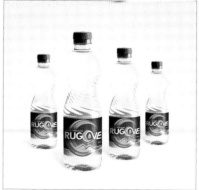

PROJECTGRAPHICS.EU PRISHTINA, KOSOVA, ALBANIA
CREATIVE TEAM: Agon Ceta
CLIENT: Rugove Water

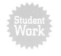

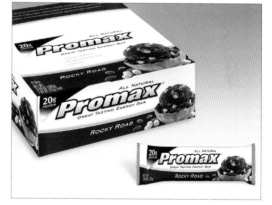

IOWA STATE UNIVERSITY AMES, IA, UNITED STATES
CREATIVE TEAM: Allison Connell
CLIENT: Student Work

KUBLY DESIGN OAKLAND, CA, UNITED STATES
CREATIVE TEAM: Eric Kubly, Toby Sudduth, Judi Swinks, Bruce Schneider
CLIENT: Promax Nutrition

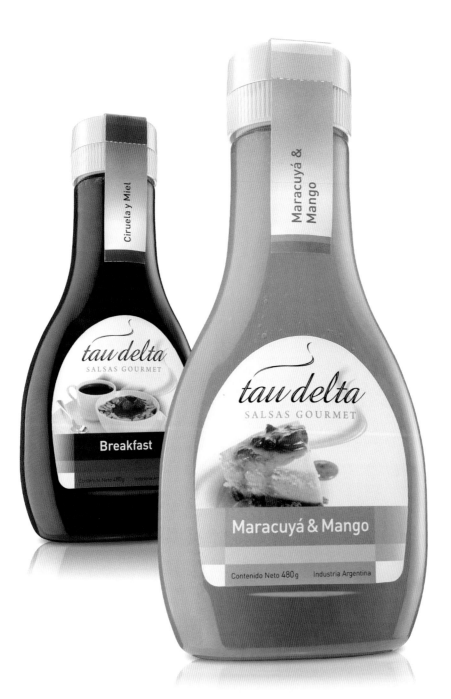

230

TRIDIMAGE_ BUENOS AIRES, ARGENTINA
CREATIVE TEAM: Adriana Cortese, Hernán Braberman, Virginia Gines
CLIENT: Tau Delta

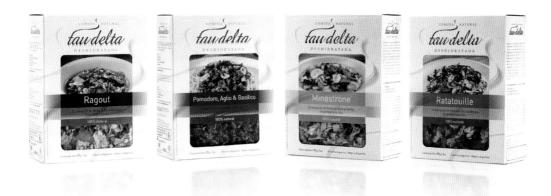

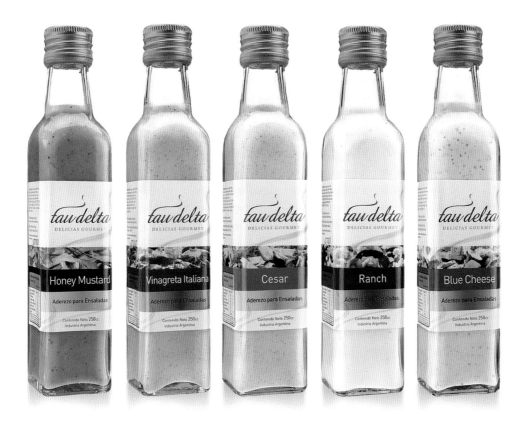

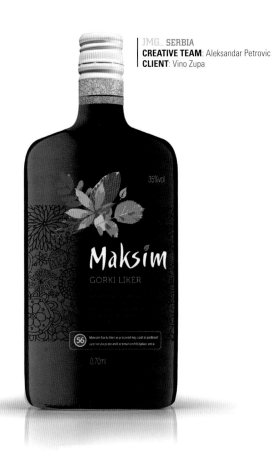

JMG_ SERBIA
CREATIVE TEAM: Aleksandar Petrovic
CLIENT: Vino Zupa

HEXANINE_ CHICAGO, IL, UNITED STATES
CREATIVE TEAM: Tim Lapetino, Jim Dygas, Beau Keda
CLIENT: Omaha Steaks

232

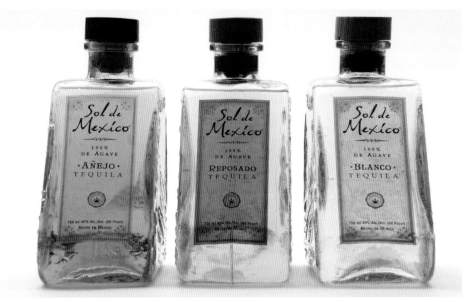

ESTUDIO RAY_ PHOENIX, AZ, UNITED STATES
CREATIVE TEAM: Joe Ray, Chris Ray, Andrew Holmes
CLIENT: Sol de Mexico

FOUNDRY CREATIVE. CALGARY, AB, CANADA
CREATIVE TEAM: Zahra Al-Harazi
CLIENT: Westrow Food Group

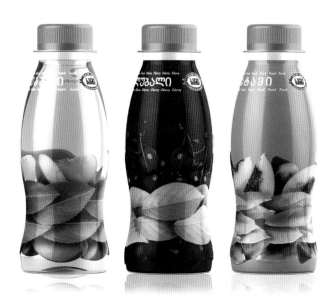

TSIKOLIA DESIGN. TBILISI, GEORGIA
CREATIVE TEAM: Zviad Tsikolia
CLIENT: SANTE GMT

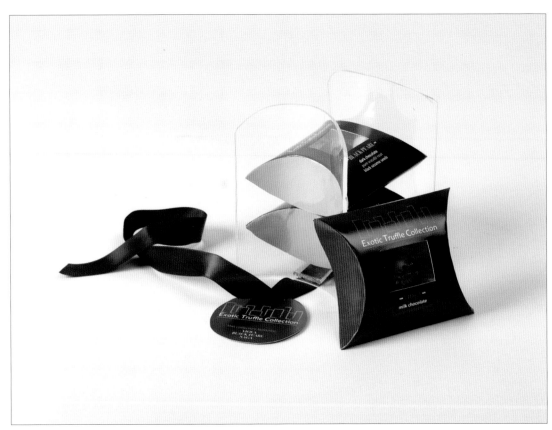

234

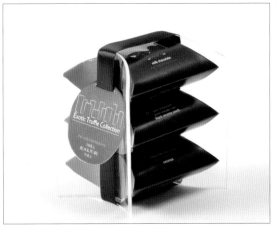

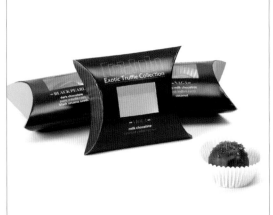

ASHLEY TAYLOR_ TOWSON, MD, UNITED STATES
CREATIVE TEAM: Ashley Taylor
CLIENT: Student Work

Student
Work

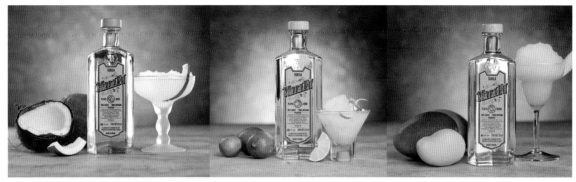

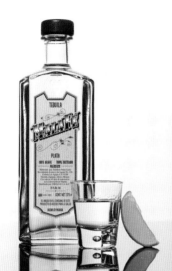

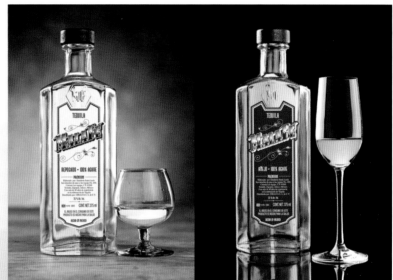

235

GAXDESIGN GUADALAJARA, MEXICO
CREATIVE TEAM: Carlos Gaxiola, Jorge Aguilar
CLIENT: Tequila Malafe

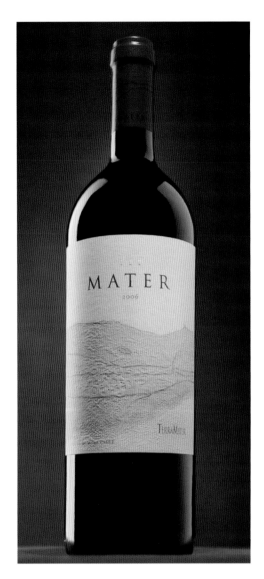

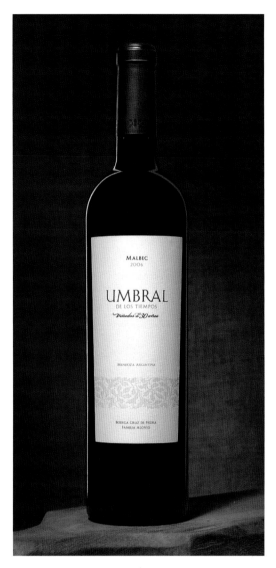

ESTUDIO IUVARO_ MENDOZA, ARGENTINA
CREATIVE TEAM: Cecilia Iuvaro, Silvia Keil, Celia Grezzi, Valeria Aise
CLIENT: Terramater Wines

TRIDIMAGE_ BUENOS AIRES, ARGENTINA
CREATIVE TEAM: Adriana Cortese, Hernán Braberman, Virginia Gines
CLIENT: Bodega Cruz de Piedra

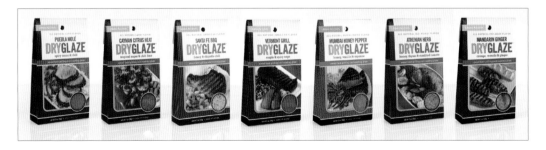

HEXANINE_ CHICAGO, IL, UNITED STATES
CREATIVE TEAM: Tim Lapetino, Jim Dygas
CLIENT: Urban Accents

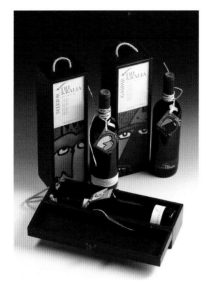

STUDIO CUCULIC_ ZAGREB, CROATIA
CREATIVE TEAM: Vanja Cuculic, Damir Bralic
CLIENT: Three Wise Men winery

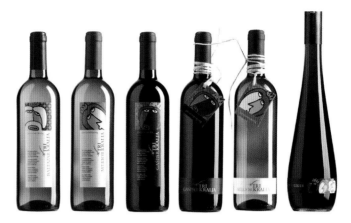

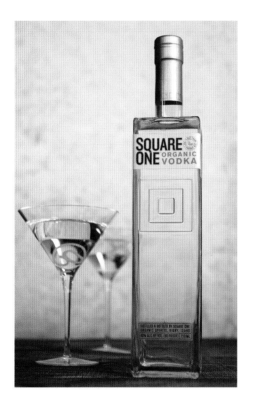

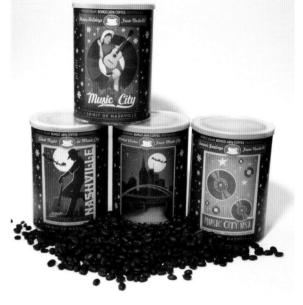

ANDERSON DESIGN GROUP_ NASHVILLE, TN, UNITED STATES
CREATIVE TEAM: Joel Anderson
CLIENT: Bongo Java Roasting Company

JOEY'S CORNER_ SAN FRANCISCO, CA, UNITED STATES
CREATIVE TEAM: Michael Osborne, Alice Koswara
CLIENT: Square One Organic Spirits

237

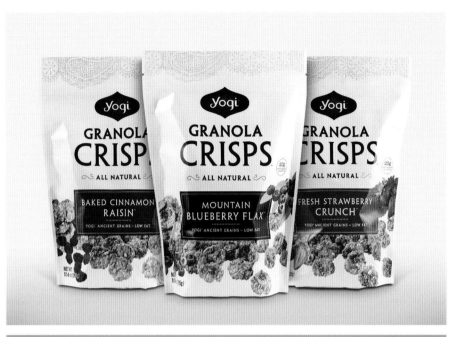

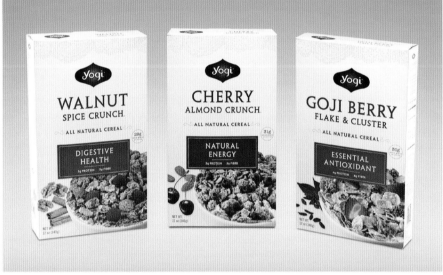

238

JOEY'S CORNER_ SAN FRANCISCO, CA, UNITED STATES
CREATIVE TEAM: Michael Osborne, Anne Tsuei
CLIENT: Yogi

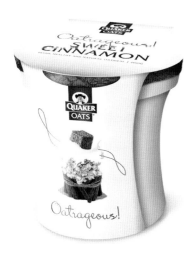

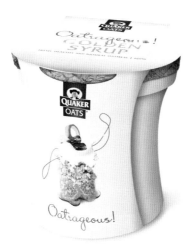

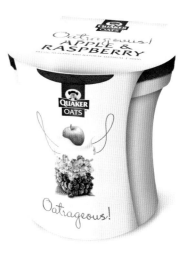

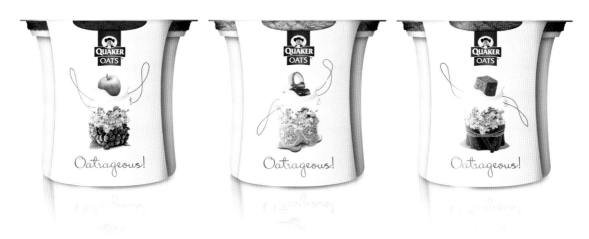

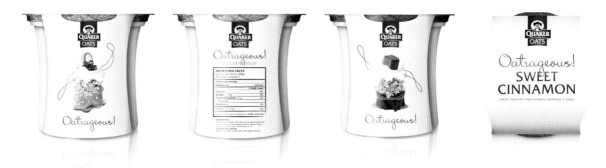

GWORKSHOP_ BARCELONA, SPAIN
CREATIVE TEAM: José Luis García Eguiguren
CLIENT: Quaker oats

240

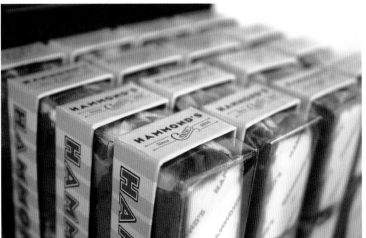

ELLEN BRUSS DESIGN_ DENVER, CO, UNITED STATES
CREATIVE TEAM: Ellen Bruss, Gemma Bayly, Charles Carpenter
CLIENT: Hammond's Candies

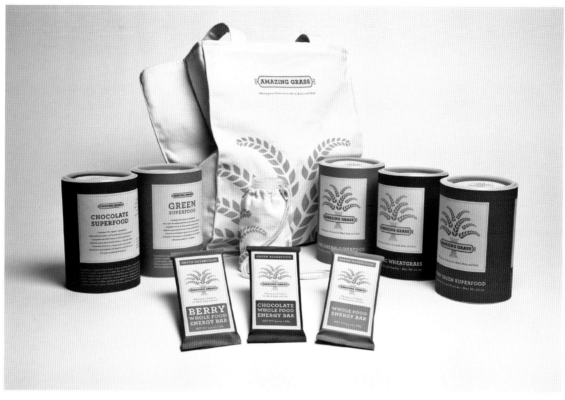

TYLER SCHOOL OF ART, PHILADELPHIA, PA, UNITED STATES
CREATIVE TEAM: Katie Hatz, Alice Drueding
CLIENT: Student Work

241

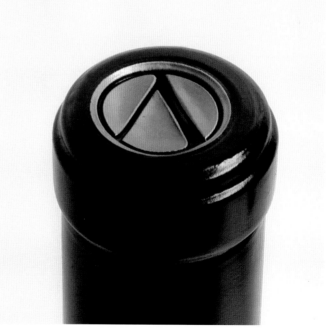

UXUS, NETHERLANDS
CREATIVE TEAM: UXUS
CLIENT: Altvs

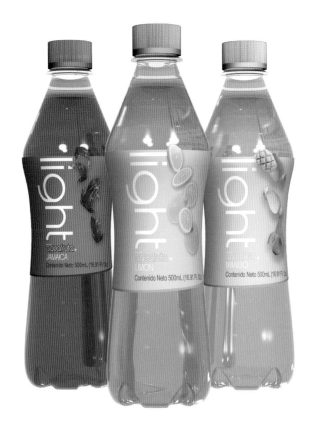

AXIOMACERO_ MONTERREY, NUEVO LEON, MEXICO
CREATIVE TEAM: Mabel Morales, Carmen Rodriguez
CLIENT: Toma Products

242

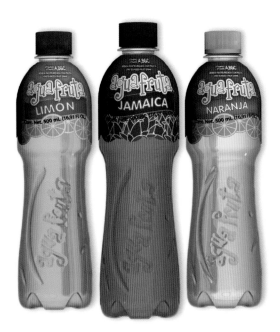

AXIOMACERO_ MONTERREY, NUEVO LEON, MEXICO
CREATIVE TEAM: Mabel Morales, Carmen Rodriguez, Alan Zuñica, Ofelia Arredondo
CLIENT: Toma Products

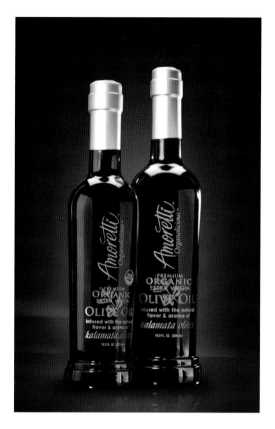

STUDIO ONE ELEVEN - A DIVISION OF BERLIN PACKAGING CHICAGO, IL, UNITED STATES
CREATIVE TEAM: Amoretti Olive Oil
CLIENT: Amoretti

243

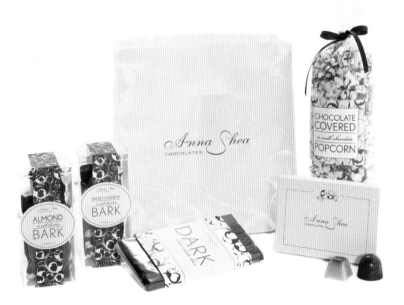

TEN26 DESIGN GROUP, INC. CRYSTAL LAKE, IL, UNITED STATES
CREATIVE TEAM: Kelly Demakis
CLIENT: Anna Shea Chocolates & Lounge

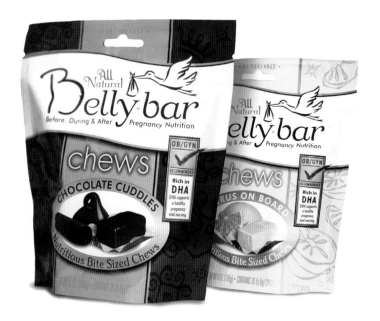

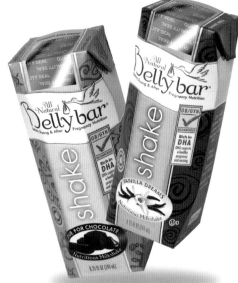

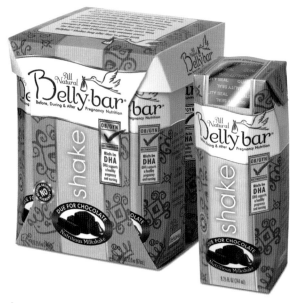

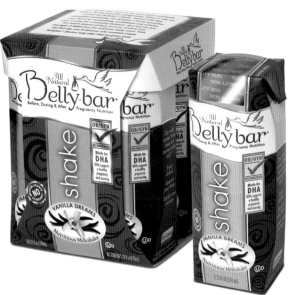

244

SUDDUTH DESIGN CO. AUSTIN, TX, UNITED STATES
CREATIVE TEAM: Toby Sudduth, Cheryl Moreno, Matthew Holmes
CLIENT: Nutrabella

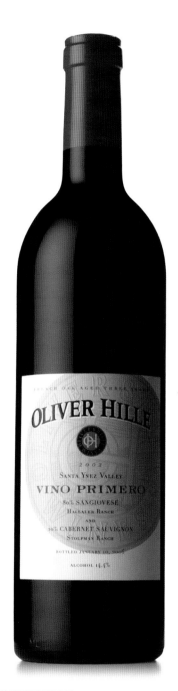

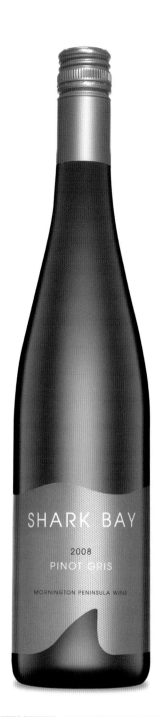

245

MARK OLIVER INC. SOLVANG, CA, UNITED STATES
CREATIVE TEAM: Mark Oliver, Tapp Printing
CLIENT: Oliver Hille

WATTS DESIGN SOUTH MELBOURNE, VICTORIA, AUSTRALIA
CREATIVE TEAM: Shane Cranford, Peter Watts
CLIENT: Shark Bay Wines

246

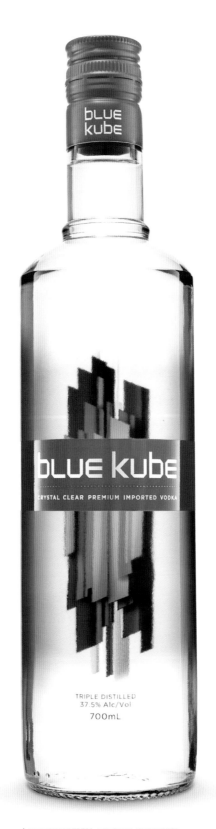

HOYNE DESIGN_ ST KILDA, AUSTRALIA
CREATIVE TEAM: Felicity Davison, Domenic Minieri
CLIENT: Coles Liquor Group

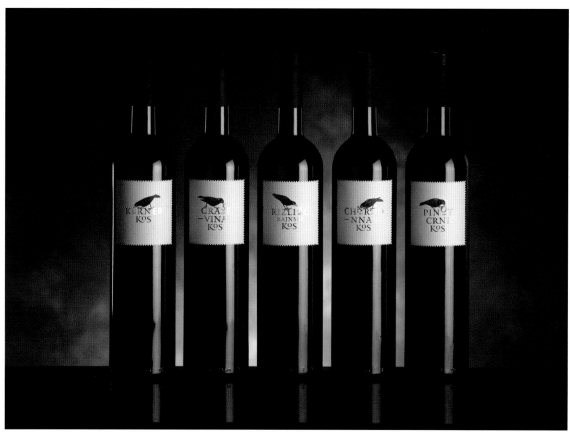

STUDIO CUCULIC, ZAGREB, CROATIA
CREATIVE TEAM: Vanja Cuculic, Tomislav Tomi
CLIENT: Vinarija Kos/Blackbird winery

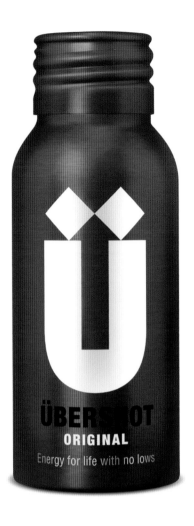

An In-Depth Look

Übershot energy drinks

After Über Drinks Ltd. saw several projects Pearlfisher had already completed in the beverage marketplace, they approached them to consider designing their new brand. Pearlfisher—whose mission is "to create challenger brands" that become the iconic brands of tomorrow—were appointed following a credentials and process presentation.

"One of the best aspects of this project was working with a client who really appreciated powerful iconic design," says Pearlfisher spokesperson Jonathan Ford. "Icons are often very simple, however, many clients feel more is more. They fail to see that 'more' can destroy the strength in the single-minded nature of the design. The Übershot client wanted an iconic design and both understood and embraced the aesthetic principles."

Übershot wanted to shake up the energy category by changing perceptions of what an energy drink can offer—and how it looks. "The category is stigmatised," says Ford, "and, until now, this has been reflected in the compensatory and 'samey' design we keep seeing. Übershot is a challenging new face of energy needing an innovative and challenging design to reflect its positioning as an integral part of modern, professional life, and so we focused on creating a

stylish, sophisticated, urban accessory. The bold icon reflects the message of the front-facing tagline, 'energy for life with no lows.'"

The small-format aluminum bottle is also a true point of difference and a design breakthrough for this category. "The aluminum bottle was a real coup. Although aluminium has been used for drinks before, it has never been used at this size. It had to go through rigorous stability testing which really challenged our timelines, but we pushed to use this as we knew it would provide a real difference in the market. The team was delighted when it passed and we could move forward. It's a small pack but expresses a big idea," adds Ford.

Über needed a quick turnaround—three months—and the unit cost of production had to be kept within a certain bracket. "This obviously guides what is feasible as an end design solution," notes Ford. "That said, we always start with an ideal and then work backwards, otherwise you don't push the boundaries."

Creative Director Natalie Chung and Designer Ian Firth provided their client with three concepts before settling on the ultimate design, working closely with the team on the development of the overall brand strategy.

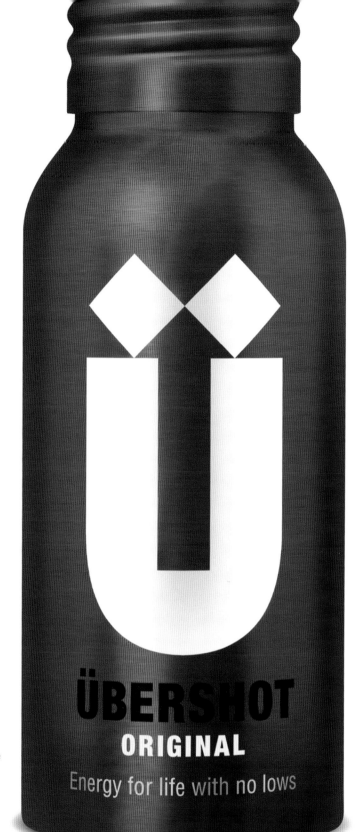

"We did try and ensure that tone of voice was kept clear for brand, packaging and website and was not lost by overloading the core communication with facts and figures," says Ford.

One of the ways they did that was to challenge the development of the website. "The client wanted it to be very information-heavy, drawing inspiration from the U.S., where the energy shot market is more mature. For a European market, this would not have worked, and we would have missed an opportunity to communicate the true brand spirit. In the end, we moved the focus from an infomercial to an animation which was based on the bottle design, heroing the brand equities whilst telling the product story in an engaging, unique, and very Übershot way." It was, says Ford, "a little window into the Über world."

Taking aim at the professional sector with a key age target of 24 to 45, Übershot is sold primarily in retail stores, initially only in the UK, but now rolling out globally to Germany, Russia, and the U.S. as well as online at www.ubershot.co.uk.

PEARLFISHER, LONDON, UNITED KINGDOM
CREATIVE TEAM: Jonathan Ford, Natalie Chung, Ian Firth, Claudio Vecchio
CLIENT: Über Drinks

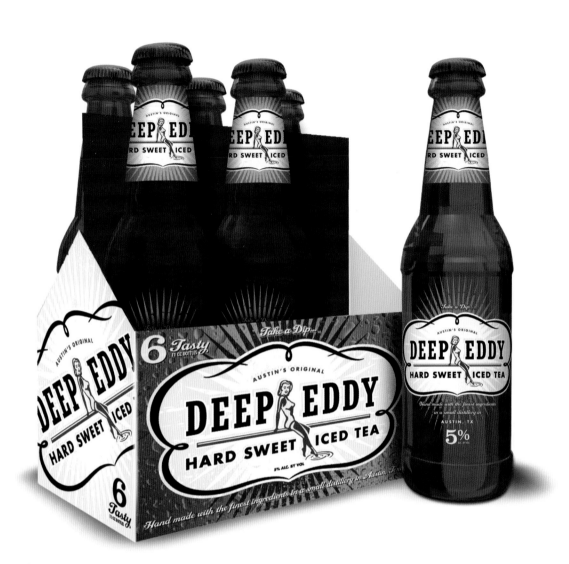

SUDDUTH DESIGN CO. AUSTIN, TX, UNITED STATES
CREATIVE TEAM: Toby Sudduth, Blue Hopkins
CLIENT: Deep Eddy Spirits

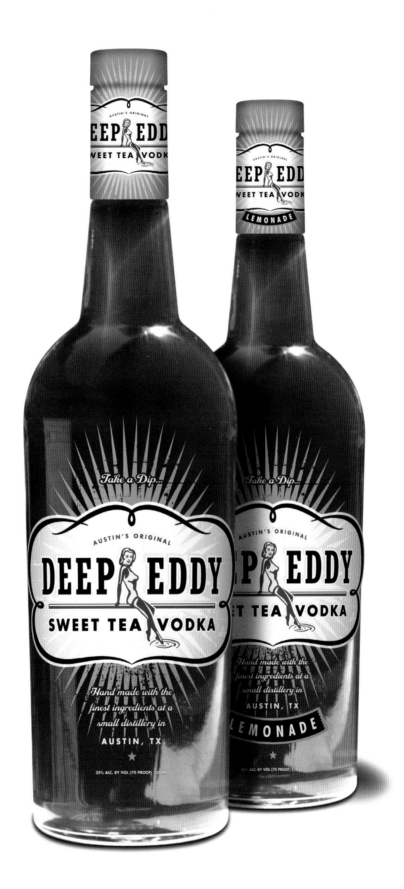

CORNERSTONE STRATEGIC BRANDING_ NEW YORK, NY, UNITED STATES
CREATIVE TEAM: Cornerstone Creative Staff
CLIENT: Nestlé Waters North America

252

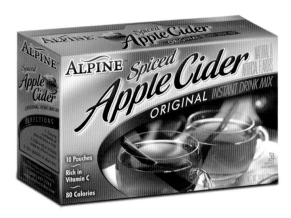

SUDDUTH DESIGN CO._ AUSTIN, TX, UNITED STATES
CREATIVE TEAM: Toby Sudduth, Richard Eskite
CLIENT: Continental Mills

MAROVINO VISUAL STRATEGY_ TORONTO, ON, CANADA
CREATIVE TEAM: Lulu Cheng, Carol Murphie, John Marovino
CLIENT: Dare Foods Ltd, Kitchener, Ontario

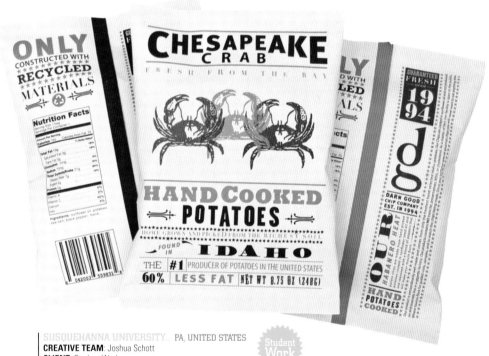

SUSQUEHANNA UNIVERSITY_ PA, UNITED STATES
CREATIVE TEAM: Joshua Schott
CLIENT: Student Work

253

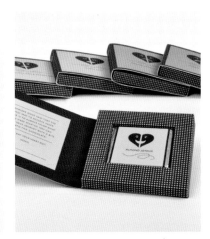

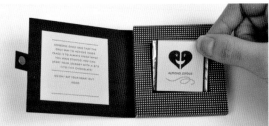

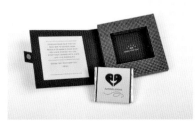

TYLER SCHOOL OF ART_ PHILADELPHIA, PA, UNITED STATES
CREATIVE TEAM: Meredith Brenner, Alice Drueding
CLIENT: Student Work

Student Work

254

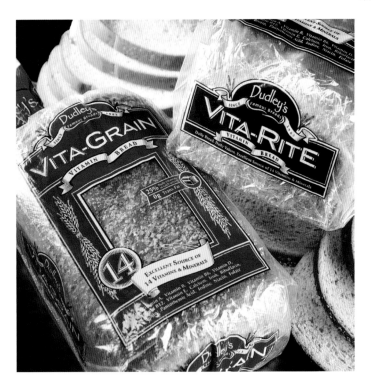

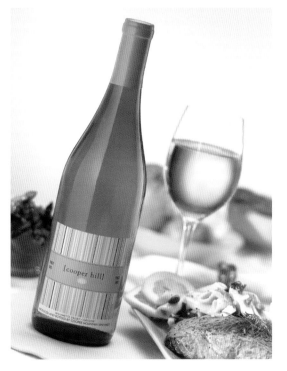

LCDA_ SAN DIEGO, CA, UNITED STATES
CREATIVE TEAM: Laura Coe Wright, Ryoichi Yotsumoto
CLIENT: Dudley's Bakery

DEFTELING DESIGN_ PORTLAND, OR, UNITED STATES
CREATIVE TEAM: Alex Wijnen
CLIENT: Cooper Mountain Vineyards

MAROVINO VISUAL STRATEGY, TORONTO, ON, CANADA
CREATIVE TEAM: Carol Murphie
CLIENT: Key West Gourmet Foods

255

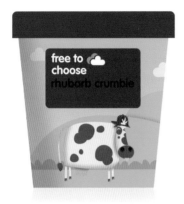

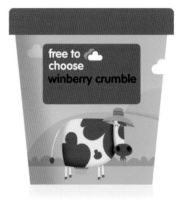

256

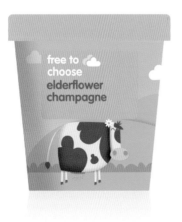

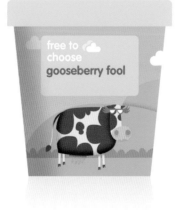

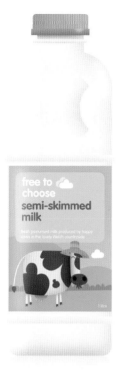

257

ELFEN, CARDIFF, UNITED KINGDOM
CREATIVE TEAM: Guto Evans, Wayne Harris
CLIENT: Free to Choose

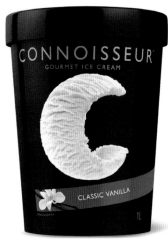
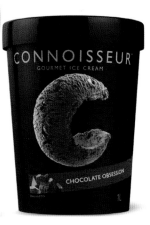

ASPREY CREATIVE_ MELBOURNE, AUSTRALIA
CREATIVE TEAM: Asprey Creative
CLIENT: Fonterra Brands

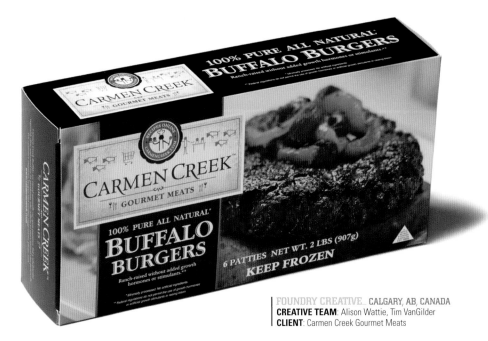

FOUNDRY CREATIVE_ CALGARY, AB, CANADA
CREATIVE TEAM: Alison Wattie, Tim VanGilder
CLIENT: Carmen Creek Gourmet Meats

HEXANINE_ CHICAGO, IL, UNITED STATES
CREATIVE TEAM: Tim Lapetino, Jim Dygas
CLIENT: Target

259

FOCUS DESIGN_ SAN RAFAEL, CA, UNITED STATES
CREATIVE TEAM: Brian Jacobson, Stephanie Orma, Kirby Veach
CLIENT: Golden West Specialty Foods

TRIDIMAGE_ BUENOS AIRES, ARGENTINA
CREATIVE TEAM: Hernán Braberman, Virginia Gines
CLIENT: Grupo Malazzo

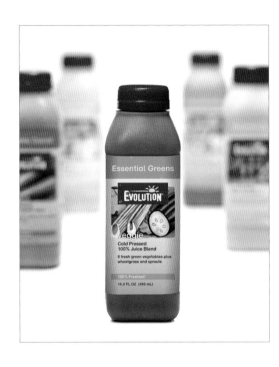

GEYRHALTER DESIGN_ SANTA MONICA, CA, UNITED STATES
CREATIVE TEAM: Fabian Geyrhalter, Kari Yu
CLIENT: Evolution Fresh

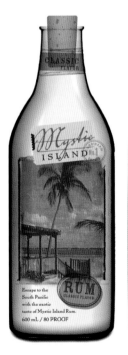
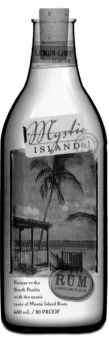
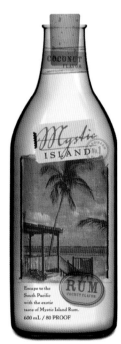

SUDDUTH DESIGN CO._ AUSTIN, TX, UNITED STATES
CREATIVE TEAM: Toby Sudduth
CLIENT: Mystic Island

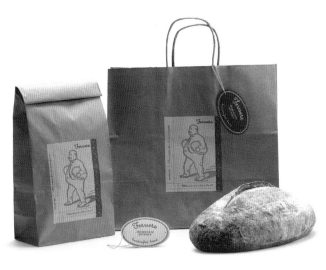

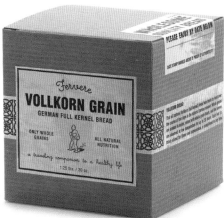

DESIGN RANCH_ KANSAS CITY, MO, UNITED STATES
CREATIVE TEAM: Michelle Sonderegger, Ingred Sidie, Michelle Martynowicz
CLIENT: Fervere

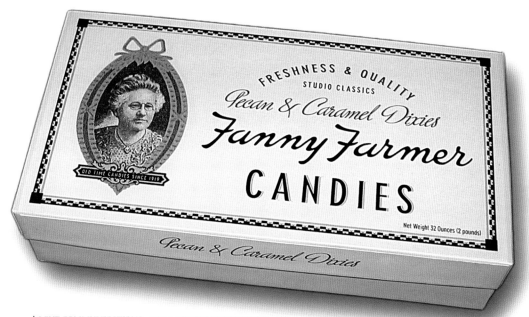

LOVE COMMUNICATIONS_ SALT LAKE CITY, UT, UNITED STATES
CREATIVE TEAM: Preston Wood
CLIENT: Dynamic Confections

261

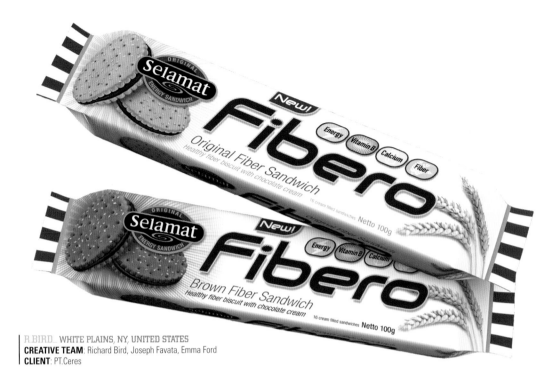

R.BIRD_ WHITE PLAINS, NY, UNITED STATES
CREATIVE TEAM: Richard Bird, Joseph Favata, Emma Ford
CLIENT: PT.Ceres

BRAUE BRAND DESIGN EXPERTS_ BREMERHAVEN, GERMANY
CREATIVE TEAM: Kai Braue, Marcel Robbers, Annika Schmidt
CLIENT: H.-J. Fiedler Meeresdelikatessen GmbH

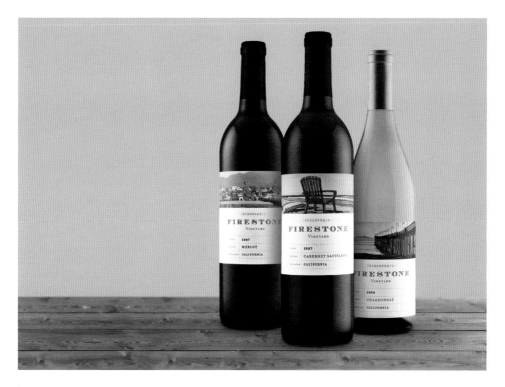

JOEY'S CORNER SAN FRANCISCO, CA, UNITED STATES
CREATIVE TEAM: Michael Osborne, Alice Koswara
CLIENT: Foley Family Wines

263

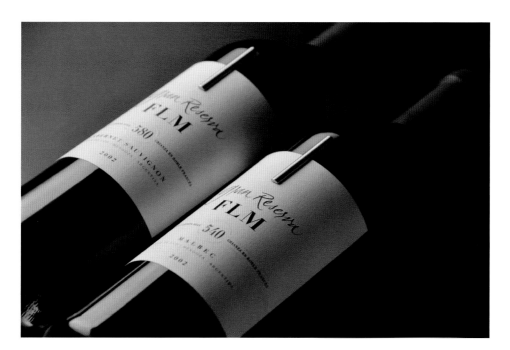

ESTUDIO IUVARO MENDOZA, ARGENTINA
CREATIVE TEAM: Cecilia Iuvaro, Silvia Keil, Celia Grezzi, Valeria Aise
CLIENT: Juan Tonconogy

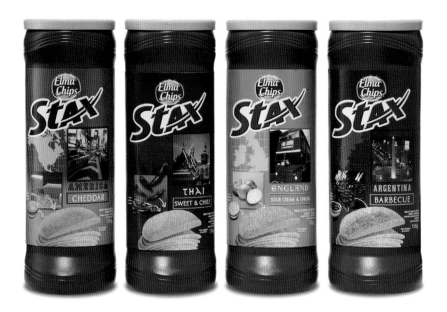

CORNERSTONE STRATEGIC BRANDING_ NEW YORK, NY, UNITED STATES
CREATIVE TEAM: Cornerstone Creative Staff
CLIENT: Elma Chips (Pepsico Do Brasil)

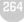

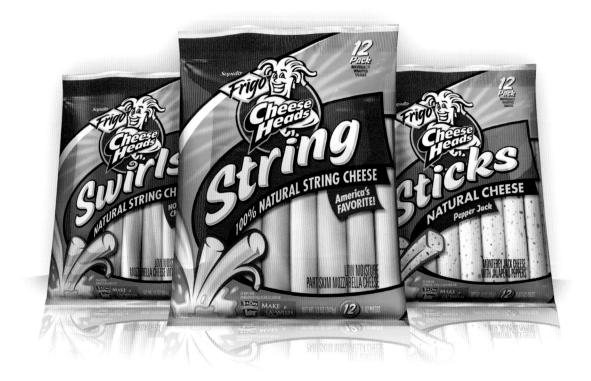

KUBLY DESIGN_ OAKLAND, CA, UNITED STATES
CREATIVE TEAM: Eric Kubly, Toby Sudduth, Filip Yip
CLIENT: Saputo

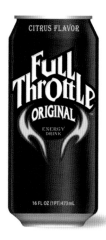

CORNERSTONE STRATEGIC BRANDING NEW YORK, NY, UNITED STATES
CREATIVE TEAM: Cornerstone Creative Staff
CLIENT: Coca-Cola North America

CORNERSTONE STRATEGIC BRANDING NEW YORK, NY, UNITED STATES
CREATIVE TEAM: Cornerstone Creative Staff
CLIENT: Unilever Bestfoods

265

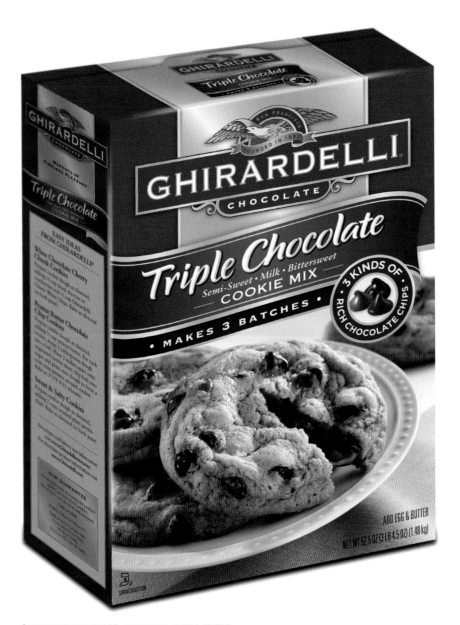

SUDDUTH DESIGN CO._ AUSTIN, TX, UNITED STATES
CREATIVE TEAM: Toby Sudduth, Mike Wepplo, Doug Evans
CLIENT: Continental Mills

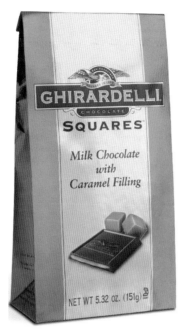

267

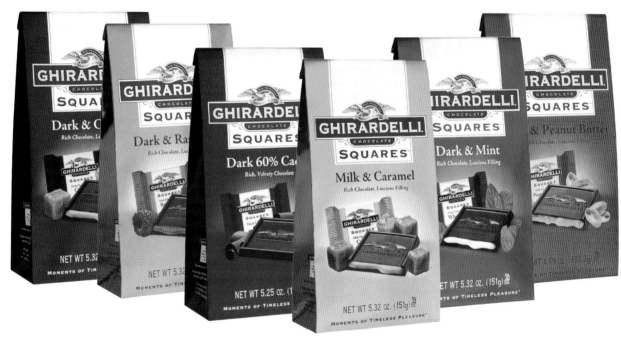

GHIRARDELLI CHOCOLATE COMPANY, SAN LEANDRO, CA, UNITED STATES
CREATIVE TEAM: Alissa Chandler, Heather Saunders, Melinda Winter, Fabrizio Parini
CLIENT: Ghirardelli Chocolate Company

An In-Depth Look

Mixed Emotions

It probably takes a college student, full of youthful energy, brimming with enthusiasm, and bubbling over with creativity, to imagine an alcoholic beverage container that will not spill, even if you turn it upside down while dancing; will not break, even if you drop it on the floor; and contains a magic potion to take you wherever you want to go emotionally. But it took José Luis García Eguiguren a week to design it.

Mixed Emotions sprang from Eguiguren's imagination onto his design board in the process of earning his Master's in Packaging Design at Elisava—Escola Superior de Disseny in Barcelona, Spain.

"The idea of this project was to sell emotions through a product. I created a cocktail in a structure that actively mixes a flavored concoction with vodka. The concoctions are different fruit blends that evoke emotions such as love, sadness, happiness, fear, and anger. The Mixed Emotions cocktail changes your attitude according to your preference. It's an entirely new concept of drinking a cocktail." The unique spiral structure Eguiguren envisioned forms two adjacent straws that allow the consumer to see how the liquids

combine as they drink. Two tiny mechanisms attach the straws to the bottom of the container, allowing air to enter and permitting the customer to take in the liquid. The cap provides an air-tight seal, thus enclosing all openings. Because of its design, the consumer can "dance, jump, go wild or do whatever they please without worrying about spilling their drink or breaking the bottle."

"Nobody has done anything like this," says Eguiguren, who explains that he wanted to break stereotypes in the category of alcoholic beverages by inventing something totally new, not only in the perception of the function of the liquor itself, but also the concept and the form of the bottle. "The bottle is unbreakable, and even if you throw the bottle to the floor, it won't spill," since the liquid must actually be drawn through the straw in order to leave the container.

"I think the mix between the idea, the design, and the industrial form conveys the whole concept. The three main elements are well integrated and unified. I also love the way the text invites the customer to have a great night experiencing different emotions." While the front panel invites the

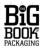

consumer to drink, the back panel depicts phrases to illustrate the type of experience the customer will encounter.

The product targets "young people who are looking for something different—people who are experimenting with new things and enjoying life." Projected vendors include restaurants, bars, discothèques, retail stores, and online websites.

"My favorite part of the project was to see that people were actually attracted by the product and the overall idea," says Eguiguren, who is now the owner and creative director at Gworkshop in Ecuador and Barcelona. "It was amazing seeing that Mixed Emotions was published on so many blogs—people all over the world were emailing me to see where they could buy the product! Unfortunately, I had to tell them that it was only a student project.

"For a student, the best experience is that people love your design and that the top professionals in the field give you positive feedback on your work. That's the best reward."

GWORKSHOP, BARCELONA, SPAIN
CREATIVE TEAM: José Luis García Eguiguren
CLIENT: Mixed Emotions

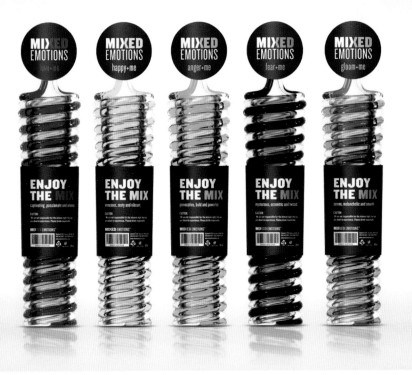

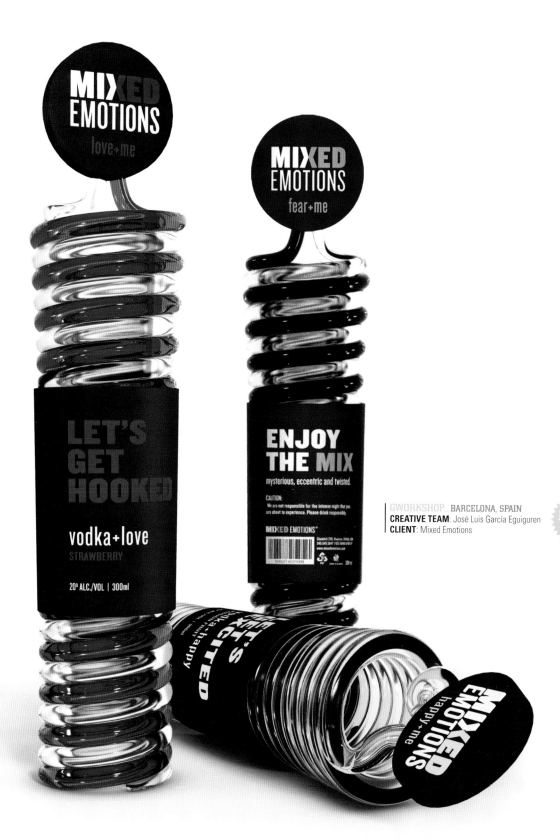

LET'S GET HOOKED

vodka+love
STRAWBERRY

20° ALC./VOL | 300ml

ENJOY THE MIX
mysterious, eccentric and twisted.

CAUTION:
We are not responsible for the intense night that you are about to experience. Please drink responsibly.

MIXED EMOTIONS®

MIXED EMOTIONS
love+me

MIXED EMOTIONS
fear+me

MIXED EMOTIONS
happy+me

GWORKSHOP, BARCELONA, SPAIN
CREATIVE TEAM: José Luis García Eguiguren
CLIENT: Mixed Emotions

Student Work

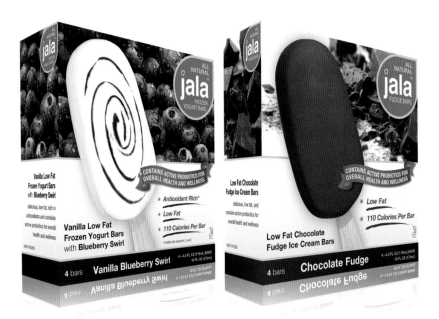

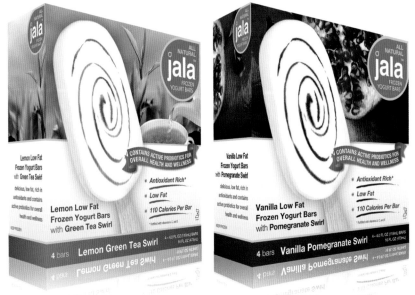

272

MAGNETIK_ NEW YORK, NY, UNITED STATES
CREATIVE TEAM: Will Kunkel, Doug Steinberg, Aaron Wilson, Cynthia Pratomo
CLIENT: Doug Steinberg

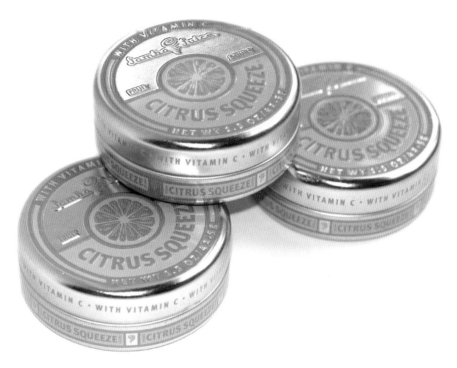

SUDDUTH DESIGN CO. AUSTIN, TX, UNITED STATES
CREATIVE TEAM: Toby Sudduth
CLIENT: Jamba Juice

273

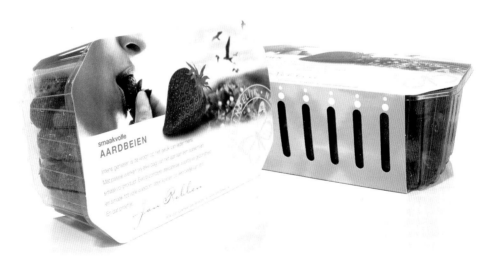

REGGS AMSTERDAM, NETHERLANDS
CREATIVE TEAM: Leonie van Dorssen
CLIENT: Reggs

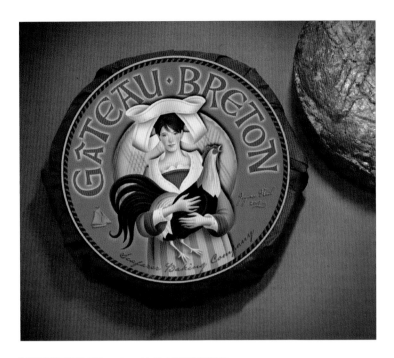

SABINGRAFIK, INC_ CARLSBAD, CA, UNITED STATES
CREATIVE TEAM: Tracy Sabin
CLIENT: Self-Promotion

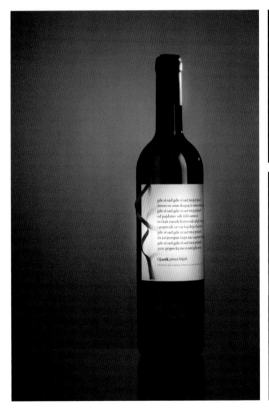

STUDIO CUCULIC_ ZAGREB, CROATIA
CREATIVE TEAM: Vanja Cuculic
CLIENT: Nikola Gjurek

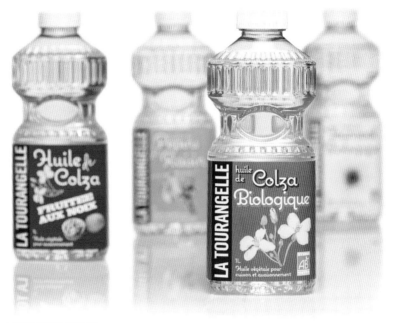

JENN DAVID DESIGN_ SAN DIEGO, CA, UNITED STATES
CREATIVE TEAM: Jenn David Connolly, Joan Bogart
CLIENT: La Tourangelle

HOYNE DESIGN_ ST. KILDA, AUSTRALIA
CREATIVE TEAM: Laine Warwick, Domenic Minieri
CLIENT: Tyrell's Wines

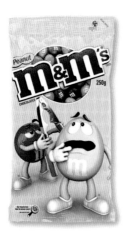
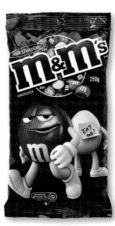
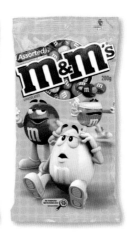
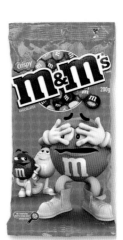

ASPREY CREATIVE_ MELBOURNE, AUSTRALIA
CREATIVE TEAM: Asprey Creative
CLIENT: Mars Snackfoods

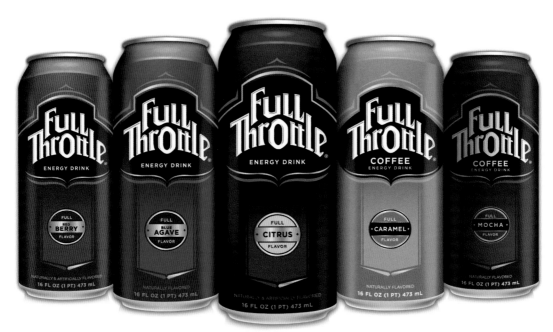

PTARMAK, INC_ AUSTIN, TX, UNITED STATES
CREATIVE TEAM: JR Crosby, Annie Mayfield, Zach Ferguson, Luke Miller
CLIENT: Fuze Beverages

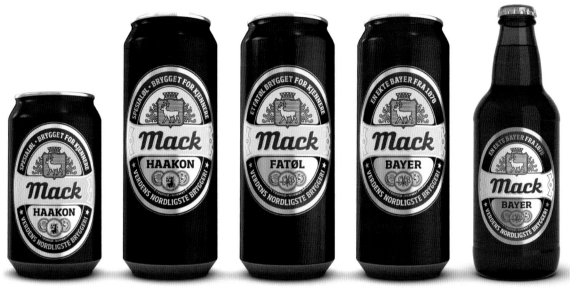

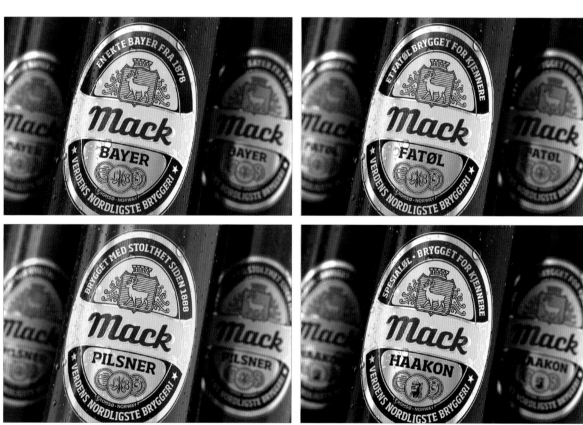

277

TANK DESIGN TROMSØ AS NORWAY
CREATIVE TEAM: Bernt Ottem, Bjoern Viggo Ottem
CLIENT: Mack Breweries, Tromsoe

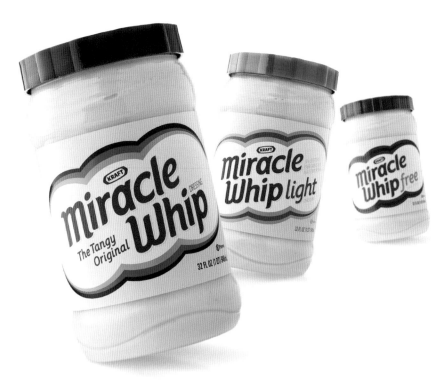

SPRING DESIGN PARTNERS, INC. NEW YORK, NY, UNITED STATES
CREATIVE TEAM: Ron Wong
CLIENT: Kraft Foods, Inc.

278

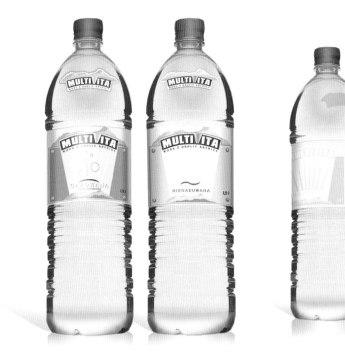

DSN WARSAW, POLAND
CREATIVE TEAM: Michal Piotrowski
CLIENT: Multivita Water

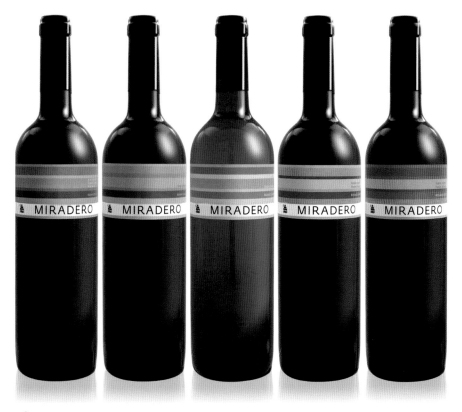

VALLADARES, DISEÑO Y COMUNICACION SANTA CRUZ DE TENERIFE, SPAIN
CREATIVE TEAM: José Jiménez Valladares
CLIENT: Bodegas Insulares Tenerife

279

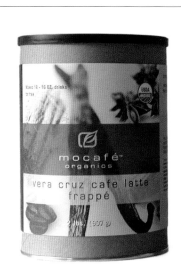 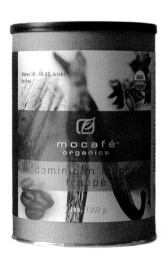 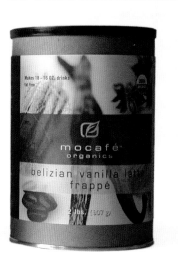

MARY HUTCHISON DESIGN LLC SEATTLE, WA, UNITED STATES
CREATIVE TEAM: Mary Chin Hutchison
CLIENT: Innovative Beverage Concepts, Inc.

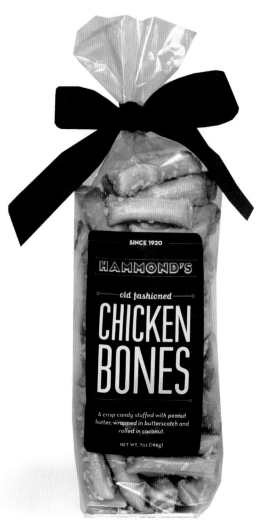

ELLEN BRUSS DESIGN_ DENVER, CO, UNITED STATES
CREATIVE TEAM: Ellen Bruss, Gemma Bayly
CLIENT: Hammond's Candies

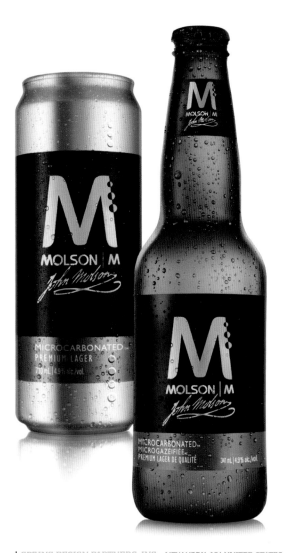

SPRING DESIGN PARTNERS, INC._ NEW YORK, NY, UNITED STATES
CREATIVE TEAM: Ron Wong
CLIENT: Molson Coors Beer

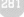

TRIDIMAGE. BUENOS AIRES, ARGENTINA
CREATIVE TEAM: Adriana Cortese, Hernán Braberman,
Virginia Gines, Gonzalo Berro
CLIENT: Danone Spain

281

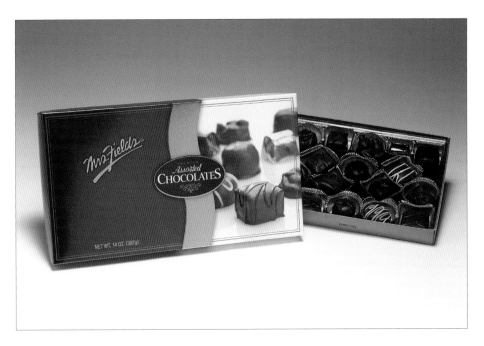

LOVE COMMUNICATIONS. SALT LAKE CITY, UT, UNITED STATES
CREATIVE TEAM: Preston Wood, Brad Smith
CLIENT: Dynamic Confections

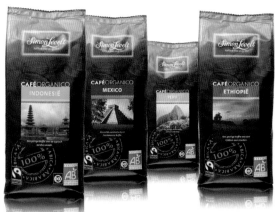

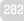

REGGS. AMSTERDAM, NETHERLANDS
CREATIVE TEAM: Leonie van Dorssen
CLIENT: Reggs

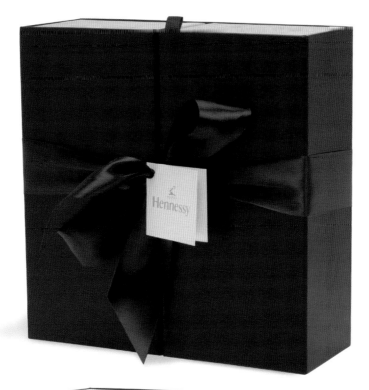

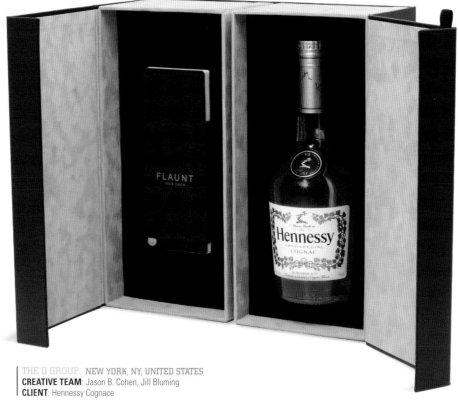

THE O GROUP_ NEW YORK, NY, UNITED STATES
CREATIVE TEAM: Jason B. Cohen, Jill Bluming
CLIENT: Hennessy Cognace

283

284

TRIDIMAGE_ BUENOS AIRES, ARGENTINA
CREATIVE TEAM: Hernán Braberman, Virginia Gines, Adriana Cortese
CLIENT: Bodega El Esteco

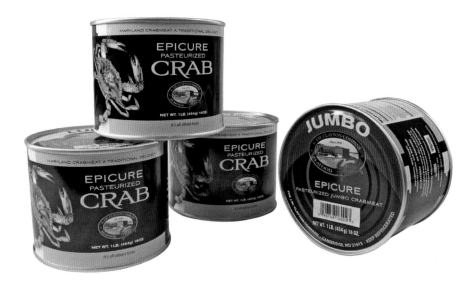

WHITNEY EDWARDS LLC_ AL, UNITED STATES
CREATIVE TEAM: Charlene Whitney Edwards, Barbara J. Christopher
CLIENT: The J.M. Clayton Company

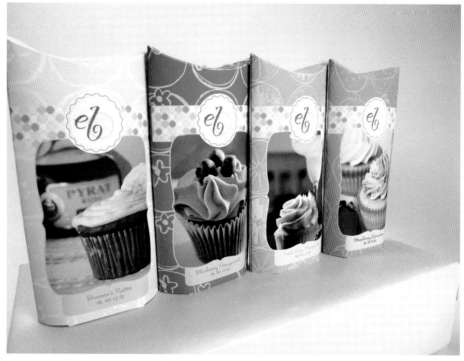

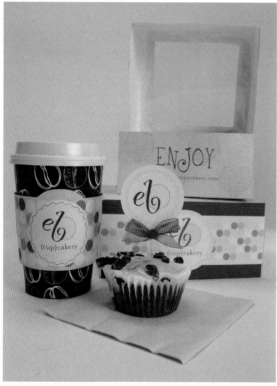

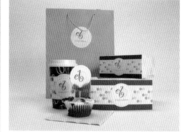

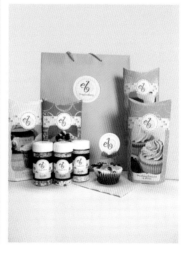

AUBURN UNIVERSITY_ AUBURN, AL, UNITED STATES
CREATIVE TEAM: Amanda Claybrook
CLIENT: Student Work

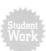

285

286

LOVE COMMUNICATIONS_ SALT LAKE CITY, UT, UNITED STATES
CREATIVE TEAM: Preston Wood, Katie Bradley, Jennifer Gudgel, Brad Smith
CLIENT: Mars Retail Group

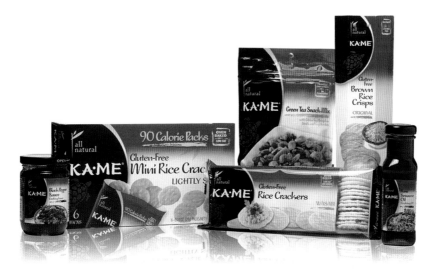

THE BIONDO GROUP_ STAMFORD, CT, UNITED STATES
CREATIVE TEAM: Charles Biondo, Gary Labra, Meg Russell, Marvin Bernfeld
CLIENT: PANOS brands

287

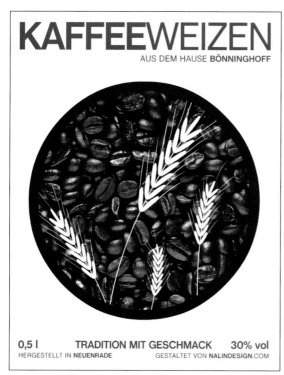

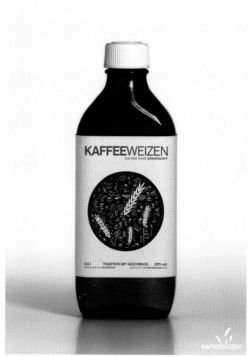

NALINDESIGN_ NEUENRADE, GERMANY
CREATIVE TEAM: Andre Weier
CLIENT: KAFFEEWEIZEN

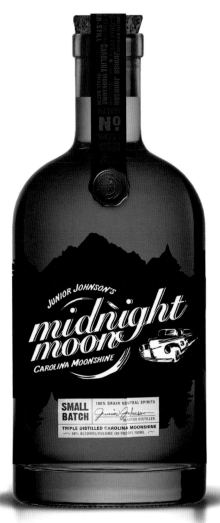

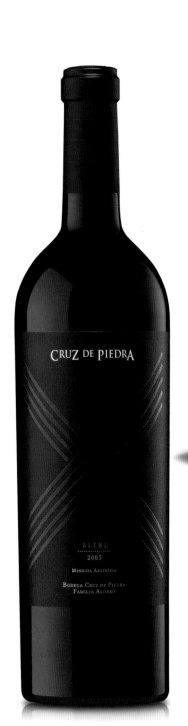

288

AIRTYPE STUDIO_ WINSTON-SALEM, NC, UNITED STATES
CREATIVE TEAM: Bryan Ledbetter, Matt Taylor
CLIENT: Piedmont Distilllers, Inc

TRIDIMAGE_ BUENOS AIRES, ARGENTINA
CREATIVE TEAM: Adriana Cortese, Hernán Braberman, Virginia Gines
CLIENT: Bodega Cruz de Piedra

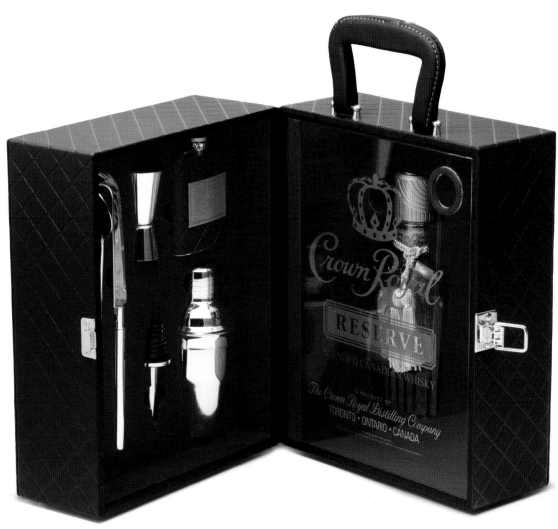

THE O GROUP_ NEW YORK, NY, UNITED STATES
CREATIVE TEAM: Jason B. Cohen, J. Kenneth Rothermich
CLIENT: Crown Royal

289

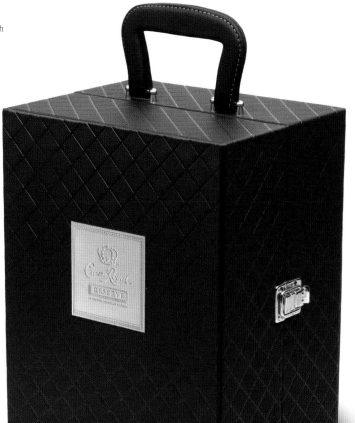

CORNERSTONE STRATEGIC BRANDING_ NEW YORK, NY, UNITED STATES
CREATIVE TEAM: Cornerstone Creative Staff
CLIENT: Nestlé USA, Inc.

291

SLOAT DESIGN GROUP, SAN RAFAEL, CA, UNITED STATES
CREATIVE TEAM: Carrie Dufour
CLIENT: Annie Chun's

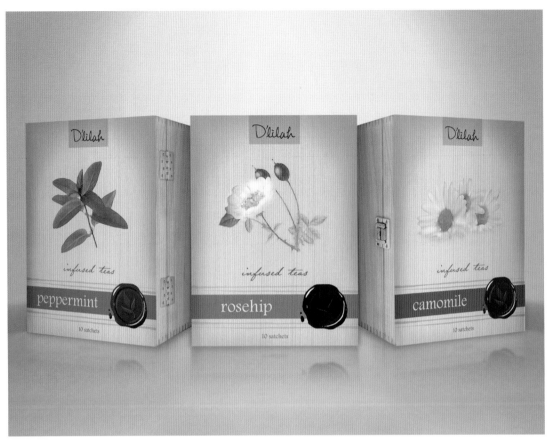

PIXIEGIRL DESIGNS_ NY, UNITED STATES
CREATIVE TEAM: Yaritsa Arenas,
CLIENT: D'lilah Herbal

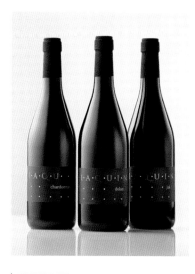

STUDIOBOTAS, SLOVENIA
CREATIVE TEAM: Boštjan Botas Kenda, Primož Fijavž, Peter Rauch, Dragan Arrigler
CLIENT: Elza Jakon

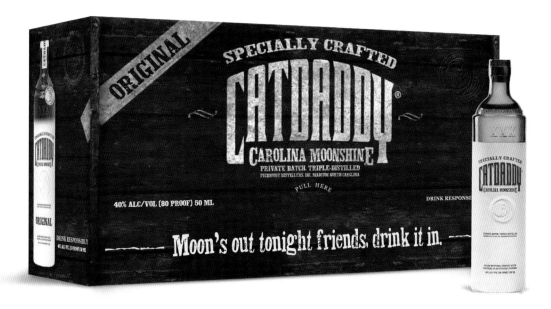

AIRTYPE STUDIO, WINSTON-SALEM, NC, UNITED STATES
CREATIVE TEAM: Bryan Ledbetter
CLIENT: Piedmont Distillers, Inc

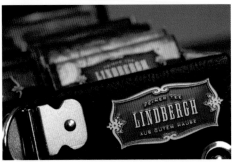

294

BRAUE BRAND DESIGN EXPERTS_ BREMERHAVEN, BREMEN, GERMANY
CREATIVE TEAM: Kai Braue, Marcel Robbers, Marianne Büsing
CLIENT: Gebrüder Wollenhaupt

KROG... LJUBLJANA, SLOVENIA
CREATIVE TEAM: Edi Berk
CLIENT: Crni kos

TRIDIMAGE... BUENOS AIRES, ARGENTINA
CREATIVE TEAM: Adriana Cortese, Hernán Braberman, Virginia Gines
CLIENT: Prodea

MARK OLIVER INC... SOLVANG, CA, UNITED STATES
CREATIVE TEAM: Mark Oliver, Patty Driskel
CLIENT: Bellwether Farms

SLOAT DESIGN GROUP_ SAN RAFAEL, CA, UNITED STATES
CREATIVE TEAM: Carrie Dufour
CLIENT: I Have a Bean

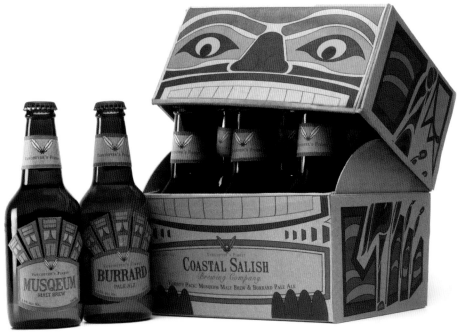

PHILADELPHIA UNIVERSITY_ PHILADELPHIA, PA, UNITED STATES
CREATIVE TEAM: Emily Zuwiala, Maribeth Kradel-Weitzel
CLIENT: Philadelphia University

Student Work

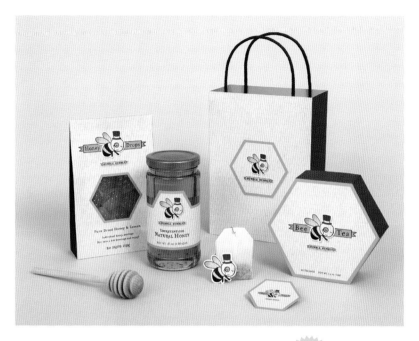

TYLER SCHOOL OF ART_ WARRINGTON, PA, UNITED STATES
CREATIVE TEAM: Jamielynn Miller
CLIENT: Student

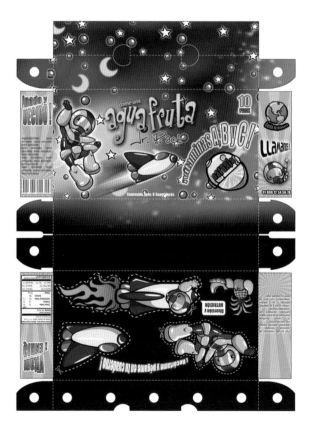

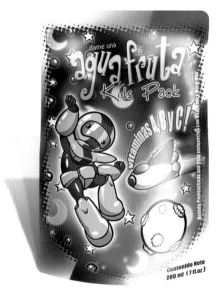

AXIOMACERO_ MONTERREY, NUEVO LEON, MEXICO
CREATIVE TEAM: Mabel Morales, Alejandro Sevilla, Francisco De La Vega
CLIENT: Toma Products

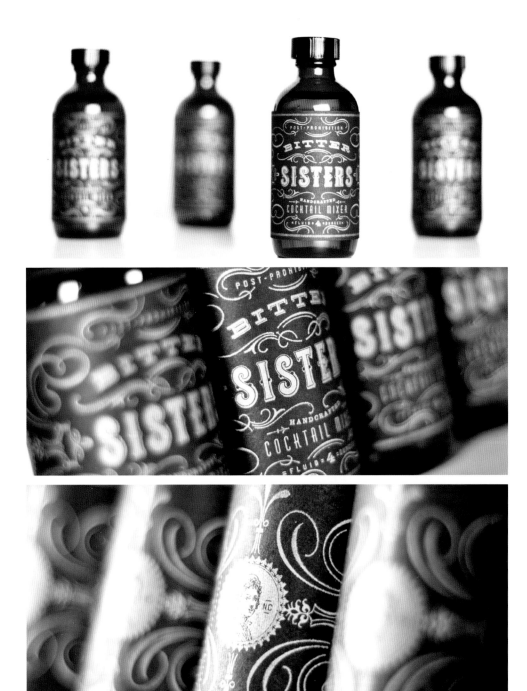

298

SHANE CRANFORD CREATIVE_ WINSTON-SALEM, NC, UNITED STATES
CREATIVE TEAM: Shane Cranford
CLIENT: Single Brothers

CREATIVE TEAM: Rodrigo Cordova, Segio Enriquez, Angel Gonzalez, Malena Gutierrez
CLIENT: Honig Mexico

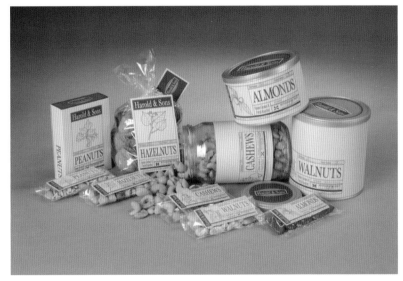

299

IOWA STATE UNIVERSITY_ AMES, IA, UNITED STATES
CREATIVE TEAM: Bethany Weber
CLIENT: Iowa State University

Student Work

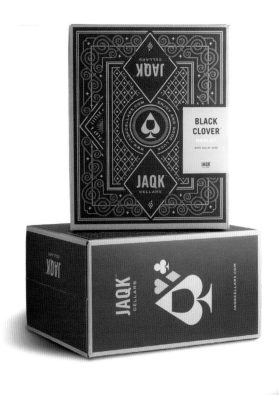

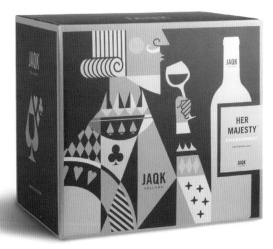

300

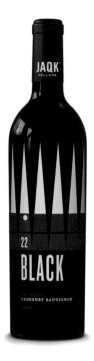
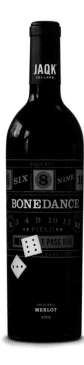
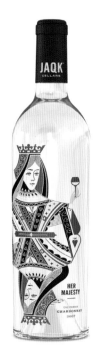
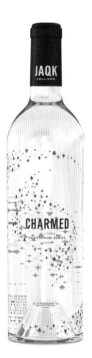

HATCH DESIGN_ SAN FRANCISCO, CA, UNITED STATES
CREATIVE TEAM: Katie Jain, Joel Templin, Eszter Clark, Ryan Meis
CLIENT: JAQK Cellars

 A3 DESIGN, LLC._ WEBSTER, NY, UNITED STATES
CREATIVE TEAM: Amanda Altman, Alan Altman, Reachal Giralico
CLIENT: Carolina Beer & Beverage

302

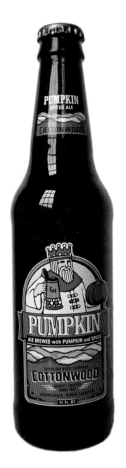
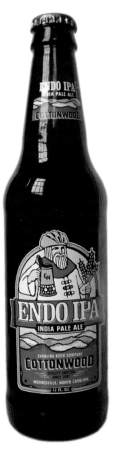
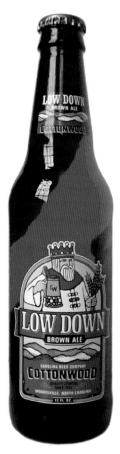

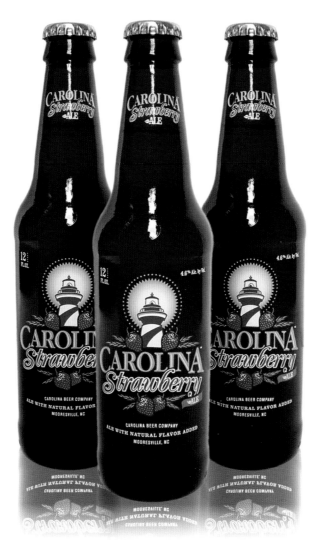

A3 DESIGN, LLC. WEBSTER, NY, UNITED STATES
CREATIVE TEAM: Amanda Altman, Alan Altman,
Reachal Giralico
CLIENT: Carolina Beer & Beverage

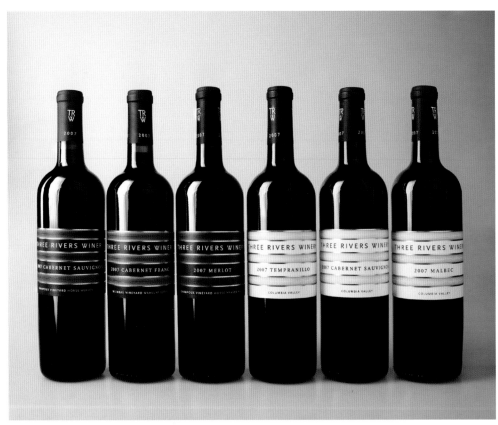

304

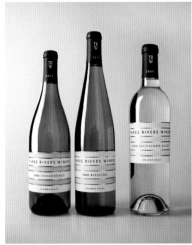

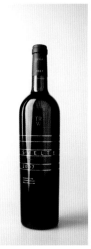

UXUS_ NETHERLANDS
CREATIVE TEAM: UXUS
CLIENT: Three Rivers

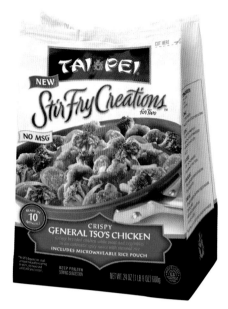

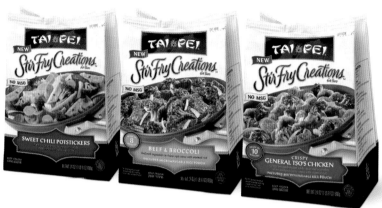

305

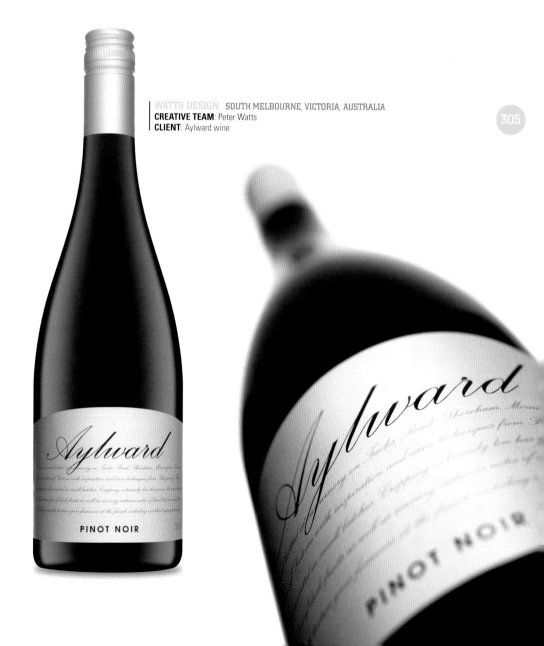

POWER UP: ALL THINGS TECHNICAL

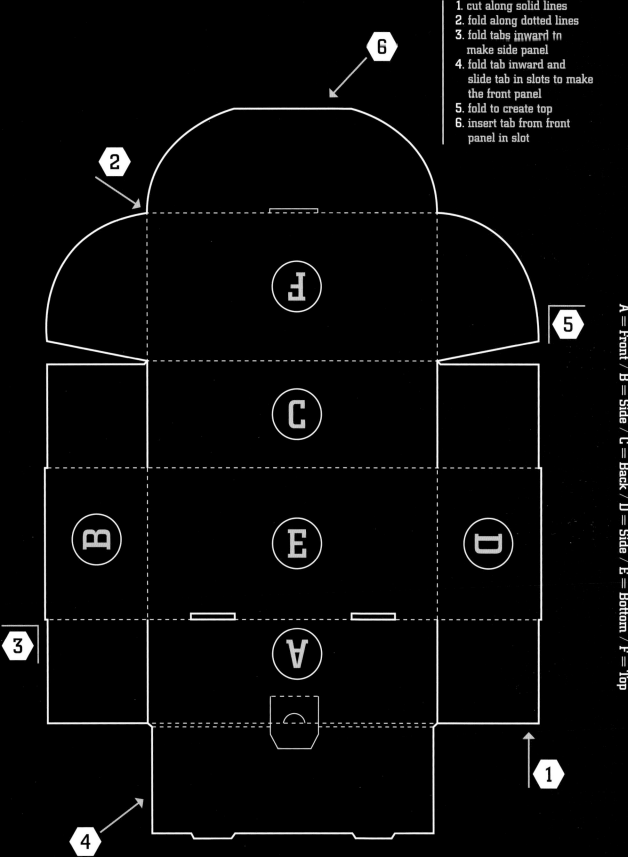

1. cut along solid lines
2. fold along dotted lines
3. fold tabs inward to make side panel
4. fold tab inward and slide tab in slots to make the front panel
5. fold to create top
6. insert tab from front panel in slot

A = Front / B = Side / C = Back / D = Side / E = Bottom / F = Top

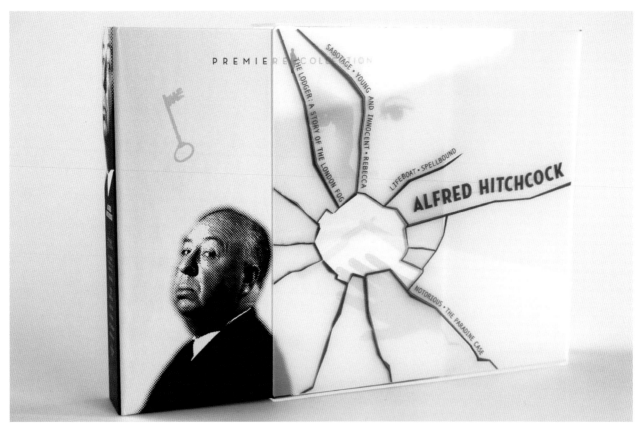

308

MENAGERIE CREATIVE_ TUSTIN, CA, UNITED STATES
CREATIVE TEAM: Cheryl Savala, Shelly Stokes, Jonah Buensuceso
CLIENT: Twentieth Century Fox Home Entertainment

BRAM STOKER'S

Dracula

DISCOVER THE FACTS BEHIND THE FICTION
VINTAGE VAMPIRE FILMS, TRAILERS & DOCUMENTARY

BEYOND BLOND DESIGN GROUP, LOS ANGELES, CA, UNITED STATES
CREATIVE TEAM: Michelle Justice
CLIENT: Delta Entertainment Corporation

305

PH.D A DESIGN OFFICE, SANTA MONICA, CA, UNITED STATES
CREATIVE TEAM: Julie Markell, Lyn Bradley, Michael Hodgson, Keith Knueven
CLIENT: Twentieth Century Fox Home Entertainment

310

UNIT DESIGN COLLECTIVE SAN FRANCISCO, CA, UNITED STATES
CREATIVE TEAM: Shardul Kiri, Ann Jordan
CLIENT: Encore Software, Inc.

MENAGERIE CREATIVE, TUSTIN, CA, UNITED STATES
CREATIVE TEAM: Cheryl Savala, Nova Indradjaja, Lyn Bradley
CLIENT: Twentieth Century Fox Home Entertainment

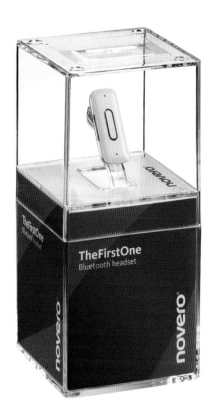

312

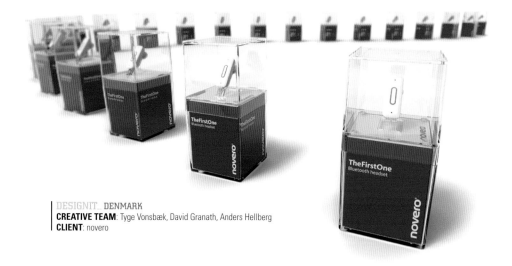

DESIGNIT_ DENMARK
CREATIVE TEAM: Tyge Vonsbæk, David Granath, Anders Hellberg
CLIENT: novero

UNIT DESIGN COLLECTIVE, SAN FRANCISCO, CA, UNITED STATES
CREATIVE TEAM: Ann Jordan, Shardul Kiri
CLIENT: Encore Software, Inc.

AXIOMACERO, MONTERREY,, NUEVO LEON, MEXICO
CREATIVE TEAM: Mabel Morales, Francisco de la Vega
CLIENT: IQ Optimo

MONDERER DESIGN, CAMBRIDGE, MA, UNITED STATES
CREATIVE TEAM: Stuart McCoy, Stewart Monderer
CLIENT: Connected Software

An In-Depth Look

The Print Shop 2.0

"*Less is more.*" This is the message the designers at UNIT design collective brought to The Print Shop 2.0 initial creative presentation, and to their client.

"The client came to us in 2008 with their existing packaging for The Print Shop 22, " says co-Creative Director Shardul Kiri. "They held the number-one market position in their product category, but they had slowly been losing that share, and they were nearly down to number two." So they were revamping the software. They wanted UNIT to develop interim packaging so they could launch The Print Shop 23, an update of version 22 with only minor software tweaks.

"Their existing packaging was overwhelming—lots of competing imagery, bullets that announced all aspects of the product and therefore sold none of them—just a lot of information," Kiri recalls. "Visual overload." The consumer couldn't dissect the competitive differences to effect a purchase decision.

"Our goals were to simplify, provide a visual hierarchy, create a strong focal point, and inspire creativity." UNIT developed a solution for The Print Shop 23—a box with hands holding design samples and creative assets representative of "creativity in the palm of your hands." When the major re-vamp was complete, the client came back to UNIT to develop the packaging for The Print Shop 2.0. The software had been greatly streamlined: the user could now create hundreds of print projects in under 5 minutes.

"Our primary message was the growth of creativity—what the user could create with this new software had grown exponentially," says Kiri's business partner and co-Creative Director Ann Jordan. Simplicity was key, and it was reflected in the new packaging solution, which featured minimal messaging and just one large image holding the focal point together. "One requirement was that we had to use design samples of things that could be created with the software. The client felt it was a top selling point because the design opportunities surpassed the competition's. So we came up with a flower with design samples blooming out of the center like petals." Getting the center of the flower just right took some doing—the client wanted it be realistic. "Perfecting the center of the flower was our primary creative challenge."

As a unified visual story carried through the complete line, UNIT maintained the product's existing color coding — red for Standard, blue for Deluxe, yellow for Professional. "We took their original color story and made the palettes more vibrant, approachable, and friendly," explains Jordan.

"Since the revamp was such a dramatic shift, we felt it was important to signify that in their logo," she continues. "They felt their logo was very recognizable in the industry, so we made a subtle change—rather than a dot over the 'i' in Print Shop, we created an iconic leaf shape to signify growth, and we used the shape throughout the packaging to reinforce the brand as a whole." There are leaves on the outside and leaves on the interior in a vine-like structure to guide the user through the simplified content structure.

The product's user base was mostly women 50 and over. While careful not to alienate their existing user base, the client recognized a younger, tech-

▥ The Print Shop 23 initial creative presentation

savvy market interested in design and was determined to market the product to this audience as a cost effective alternative to the Adobe Creative Suite.

The results were telling. Their client is now the exclusive desktop publishing software provider for both Target and Walmart stores. The product launched in March 2010. "That month was the single highest sales for the The Print Shop line in the 5 1/2 years since our client has owned the brand—200% over average monthly sales," says Kiri. "In prior release of The Print Shop 23, we had placed everything on a white box that really stood out on shelf, which resulted in a 400% sales increase. We stayed with the white box with 2.0."

"One of our goals as a design firm is to develop environmentally conscious solutions," Kiri adds. "This client had always included a thick user manual with their product, but with this version, they decided to eliminate the paper manual. Now all that information, and more, is available online, including a blog website that is constantly updated with tutorials, sample projects, and user input. We were especially pleased with that and how it enhanced the visual concept."

▥ Before

the **print**shop D E L U X E VERSION **23**

▥ After

the **print**shop® DELUXE **2.0**

UNIT DESIGN COLLECTIVE SAN FRANCISCO, CA, UNITED STATES
CREATIVE TEAM: Shardul Kiri, Ann Jordan, Michelle Yee, David Serrano, Erin Delorefice
CLIENT: Encore Software, Inc.

◾ Before

◾ The Print Shop 23 initial creative presentation

Final Selection

UNIT DESIGN COLLECTIVE. SAN FRANCISCO, CA, UNITED STATES
CREATIVE TEAM: Shardul Kiri, Ann Jordan, Erin Delorefice
CLIENT: Encore Software, Inc.

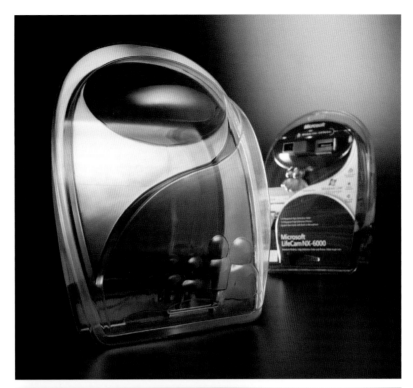

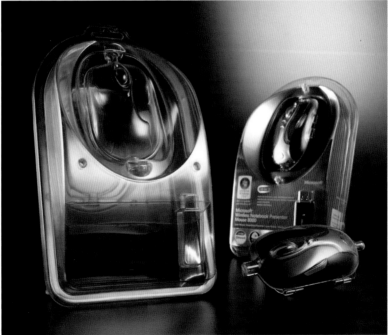

LCDA_ SAN DIEGO, CA, UNITED STATES
CREATIVE TEAM: Laura Coe Wright, Ryoichi Yotsumoto
CLIENT: Microsoft Corporation

HOYNE DESIGN, ST KILDA, AUSTRALIA
CREATIVE TEAM: Dan Johnson, Domenic Minieri, Anthony Teoh
CLIENT: Dick Smith

BRAND ENGINE, SAUSALITO, CA, UNITED STATES
CREATIVE TEAM: Will Burke, Bob Hullinger, Meegan Peery, Bill Kerr
CLIENT:Hewlett-Packard

319

320

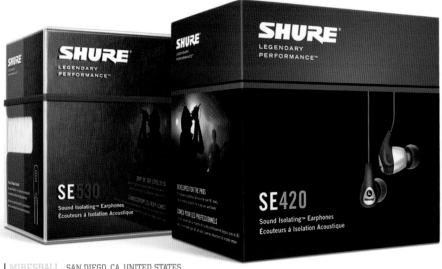

MIRESBALL SAN DIEGO, CA, UNITED STATES
CREATIVE TEAM: John Ball, Dylan Jones, Holly Houk
CLIENT: Shure

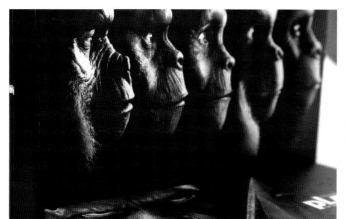

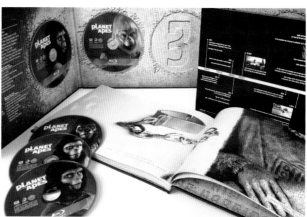

MENAGERIE CREATIVE, TUSTIN, CA, UNITED STATES
CREATIVE TEAM: Cheryl Savala, Dino Espinosa
CLIENT: Twentieth Century Fox Home Entertainment

322

MENAGERIE CREATIVE_ TUSTIN, CA, UNITED STATES
CREATIVE TEAM: Cheryl Savala, Nofabiana Indradjaja, Dino Espinosa, Tony Hsu
CLIENT: Twentieth Century Fox Home Entertainment

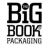

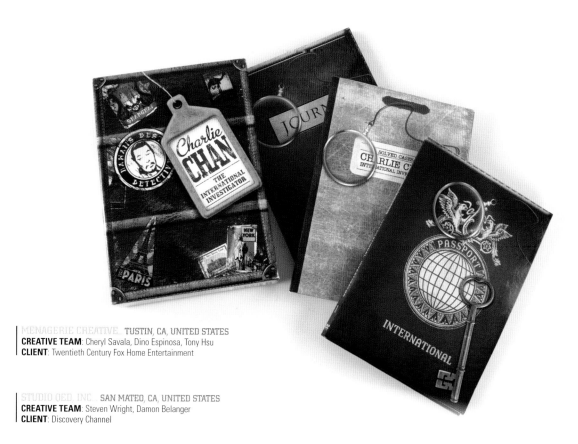

MENAGERIE CREATIVE, TUSTIN, CA, UNITED STATES
CREATIVE TEAM: Cheryl Savala, Dino Espinosa, Tony Hsu
CLIENT: Twentieth Century Fox Home Entertainment

STUDIO QED, INC. SAN MATEO, CA, UNITED STATES
CREATIVE TEAM: Steven Wright, Damon Belanger
CLIENT: Discovery Channel

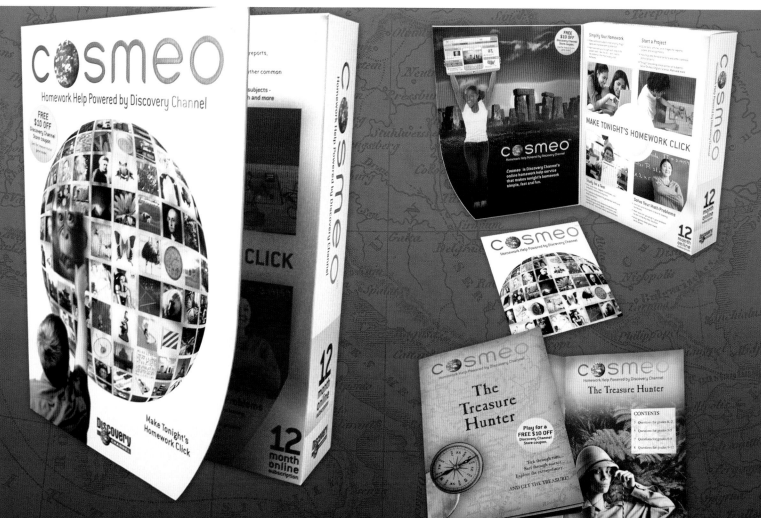

324

MENAGERIE CREATIVE TUSTIN, CA, UNITED STATES
CREATIVE TEAM: Cheryl Savala, Nova Indradjaja, Jonah Buensuceso
CLIENT: Twentieth Century Fox Home Entertainment

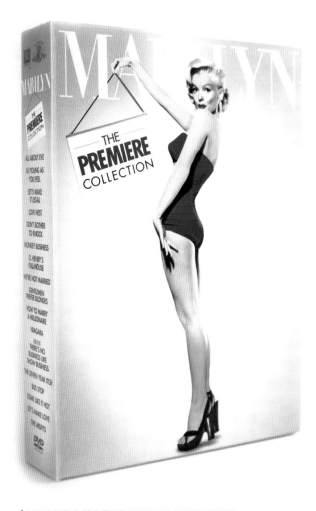

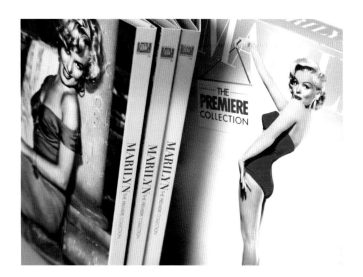

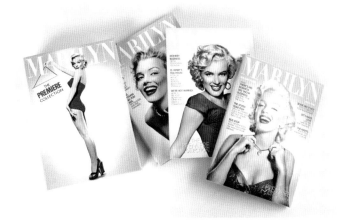

MENAGERIE CREATIVE, TUSTIN, CA, UNITED STATES
CREATIVE TEAM: Cheryl Savala, Michelle Manley, Lilian Wong
CLIENT: Twentieth Century Fox Home Entertainment

PLAZM_ PORTLAND, OR, UNITED STATES
CREATIVE TEAM: Joshua Berger
| **CLIENT**: Soleilmoon Recordings

SAINT DWAYNE DESIGN_ CHARLOTTE, NC, UNITED STATES
CREATIVE TEAM: Dwayne Cogdilll, C.B. Canga
| **CLIENT**: ITR

MENAGERIE CREATIVE TUSTIN, CA, UNITED STATES
CREATIVE TEAM: Cheryl Savala, Michelle Manley, Tony Hsu
CLIENT: Twentieth Century Fox Home Entertainment

MENAGERIE CREATIVE TUSTIN, CA, UNITED STATES
CREATIVE TEAM: Cheryl Savala, Michelle Manley
CLIENT: Twentieth Century Fox Home Entertainment

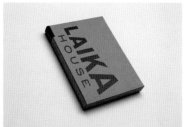

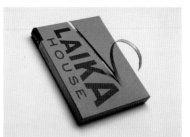

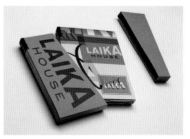

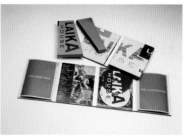

328

PLAZM_ PORTLAND, OR, UNITED STATES
CREATIVE TEAM: Joshua Berger, Todd Houlette
CLIENT: LAIKA

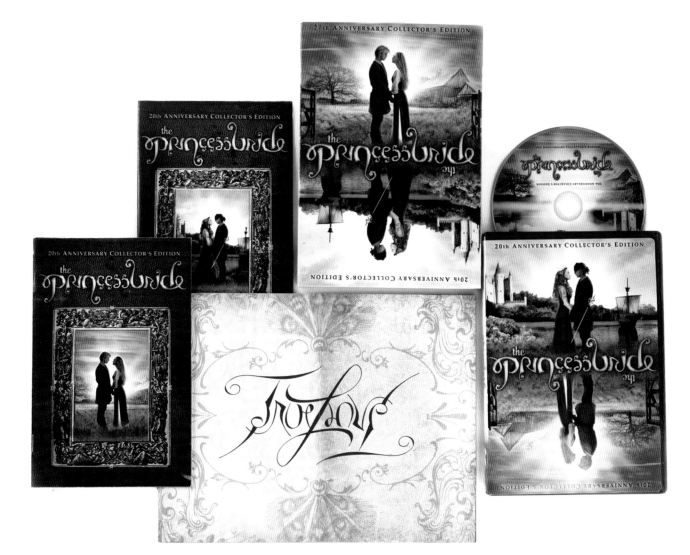

MENAGERIE CREATIVE. TUSTIN, CA, UNITED STATES
CREATIVE TEAM: Cheryl Savala, Shelly Stokes, Dino Espinosa, Doug Sirois
CLIENT: Twentieth Century Fox Home Entertainment

331

PH.D A DESIGN OFFICE SANTA MONICA, CA, UNITED STATES
CREATIVE TEAM: Parinaz Nabus, Michael Hodgson, Alice Joo
CLIENT: Sony

STUDIO QED, INC. SAN MATEO, CA, UNITED STATES
CREATIVE TEAM: Steven Wright
CLIENT: XSEED Games

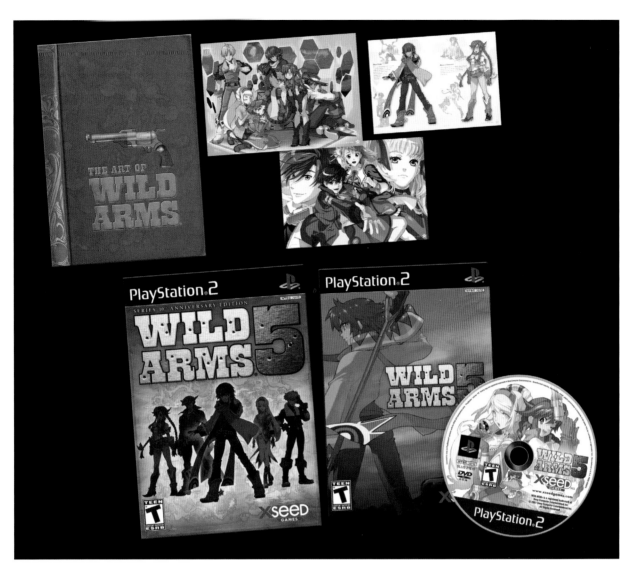

STUDIO QED, INC., SAN MATEO, CA, UNITED STATES
CREATIVE TEAM: Steven Wright
CLIENT: XSEED Games

THERE'S MORE!: MISCELLANEOUS

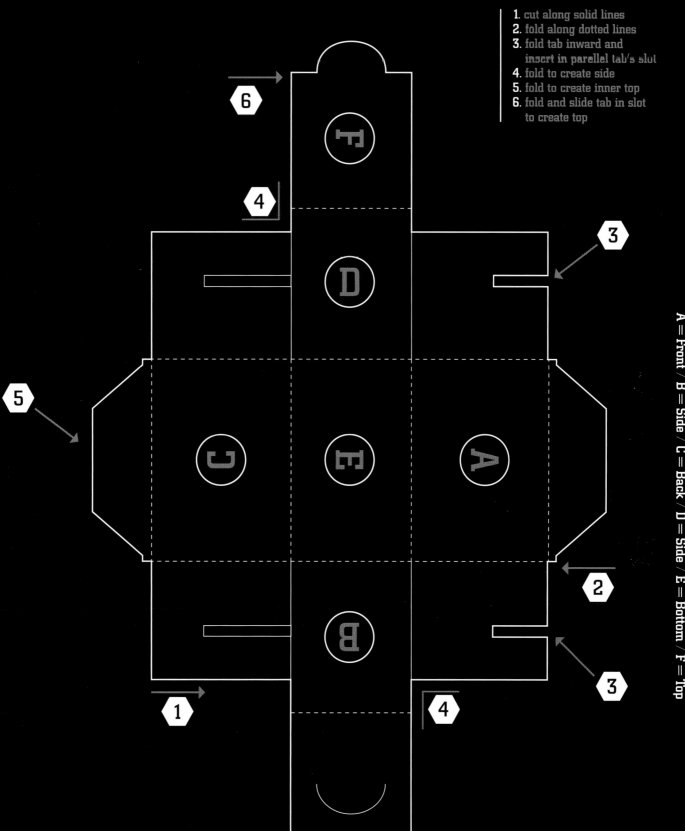

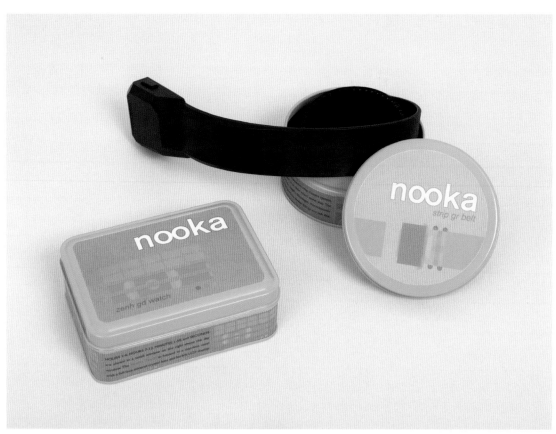

TYLER SCHOOL OF ART_ WARRINGTON, PA, UNITED STATES
CREATIVE TEAM: Jamielynn Miller
CLIENT: University Tyler School of Art, Temple University

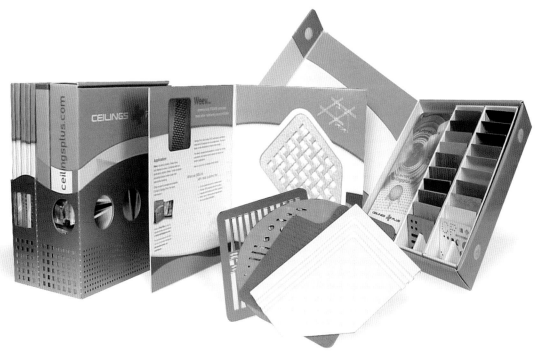

THE SHERWOOD GROUP_ VALENCIA, CA, UNITED STATES
CREATIVE TEAM: Will Sherwood, Betty Mallorca
CLIENT: Ceilings Plus

FACEOUT STUDIO_ BEND, OR, UNITED STATES
CREATIVE TEAM: Nate Salciccioli, Eleen Cheung
CLIENT: WW Norton

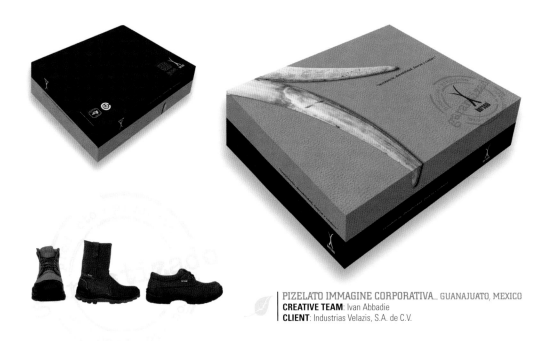

PIZELATO IMMAGINE CORPORATIVA_ GUANAJUATO, MEXICO
CREATIVE TEAM: Ivan Abbadie
CLIENT: Industrias Velazis, S.A. de C.V.

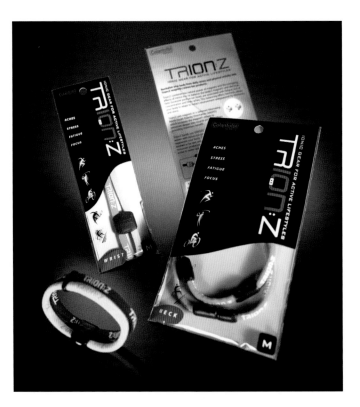

LCDA_ SAN DIEGO, CA, UNITED STATES
CREATIVE TEAM: Laura Coe Wright, Ryoichi Yotsumoto
CLIENT: Sonartec

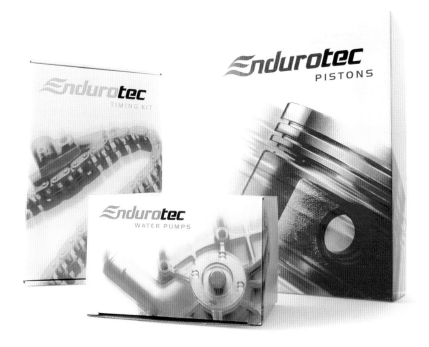

APREY CREATIVE_ MELBOURNE, AUSTRALIA
CREATIVE TEAM: Aprey Creative
CLIENT: Precision International

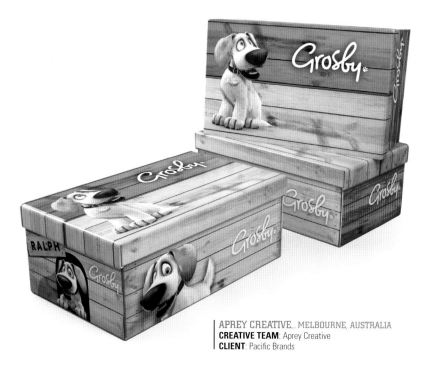

APREY CREATIVE_ MELBOURNE, AUSTRALIA
CREATIVE TEAM: Aprey Creative
CLIENT: Pacific Brands

SPLASH PRODUCTIONS, PTE LTD_ SINGAPORE
CREATIVE TEAM: Stanley Yap, Natalie Low
CLIENT: Splash Productions Pte Ltd

MILLER MEIERS DESIGN FOR COMMUNICATION_
LAWRENCE, KS, UNITED STATES
CREATIVE TEAM: Bob Meiers, Dan Rood
CLIENT: Livinity Inc.

FACEOUT STUDIO_ BEND, OR, UNITED STATES
CREATIVE TEAM: Nate Salciccioli, Connie Gabbert, Diane Lugar
CLIENT: Grand Central Publishing

339

HACHEJOTA_ GUADALAJARA, MEXICO
CREATIVE TEAM: Arturo Jimenez, Aramis Herrera
CLIENT: ZAR

FOUNDRY CREATIVE_ CALGARY, AB, CANADA
CREATIVE TEAM: Zahra Al-Harazi, Louise Uhrenholt
CLIENT: Rob Young

DREXEL UNIVERSITY, ANTOINETTE WESTPHAL COLLEGE OF MEDIA ARTS & DESIGN_
PHILADELPHIA, PA, UNITED STATES
CREATIVE TEAM: Joey Krietemeyer, Sandy Stewart
CLIENT: Secrets of Misdirection and Illusion

Student Work

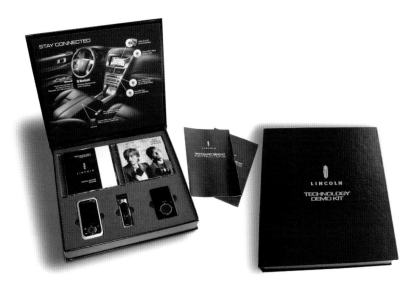

JACKSON-DAWSON COMMUNICATIONS_ DEARBORN, MI, UNITED STATES
CREATIVE TEAM: Jenny Lynn, Max Akemann, Craig Johnson, Jamie Buckler
CLIENT: Ford Motor Company

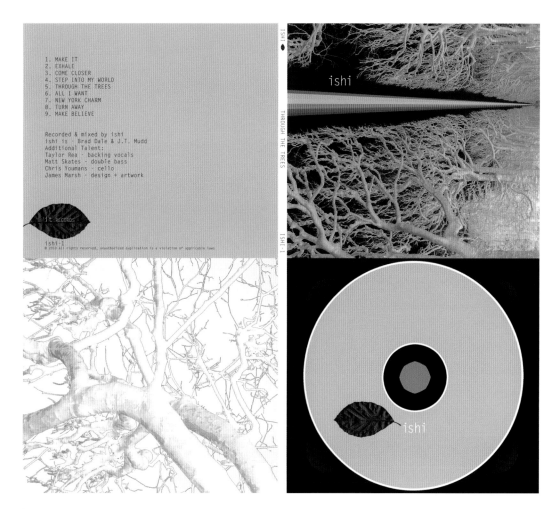

JAMES MARSH DESIGN_ KENT, UNITED KINGDOM
CREATIVE TEAM: James Marsh
CLIENT: Ishi

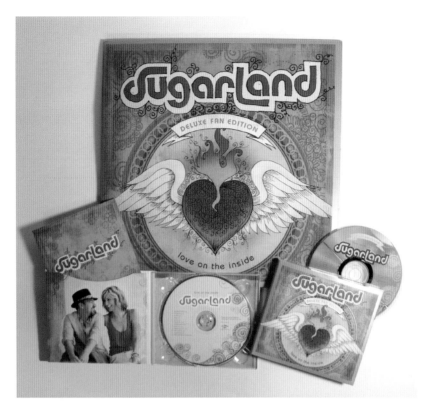

ANDERSON DESIGN GROUP_ NASHVILLE, TN, UNITED STATES
CREATIVE TEAM: Joel Anderson, Amy Olert, Emily Keafer
CLIENT: Mercury Records

342

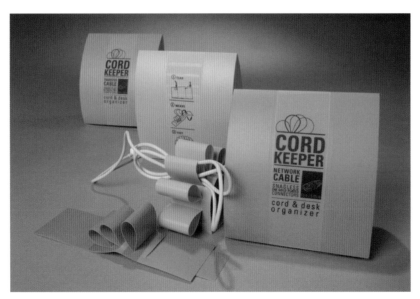

 IOWA STATE UNIVERSITY_ AMES, IA, UNITED STATES
CREATIVE TEAM: Leah Hanus
CLIENT: Iowa State University

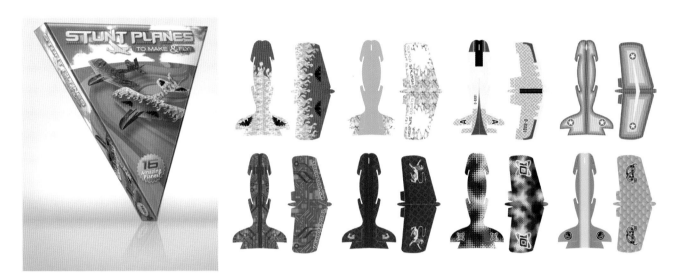

TRILION STUDIOS_ LAWRENCE, KS, UNITED STATES
CREATIVE TEAM: Brian White
CLIENT: Dolphin Impex

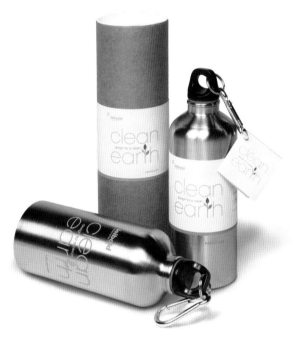

LEIBOLD ASSOCIATES, INC._ NEENAH, WI, UNITED STATES
CREATIVE TEAM: Mark Vanden Berg, Ryan Wienandt
CLIENT: Leibold Associates, Inc.

FACEOUT STUDIO_ BEND, OR, UNITED STATES
CREATIVE TEAM: Charles Brock, Karen Nelson
CLIENT: Sterling Publishing Company

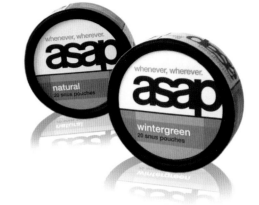

A3 DESIGN, LLC_ WEBSTER, NY, UNITED STATES
CREATIVE TEAM: Amanda Altman, Alan Altman, Reachal Giralico
CLIENT: Cheyenne International

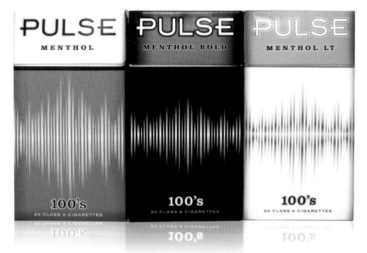

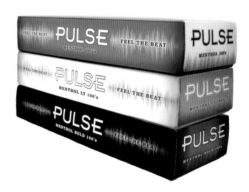

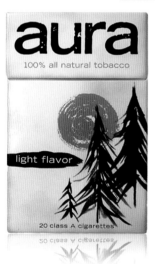

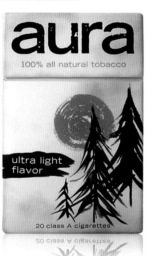

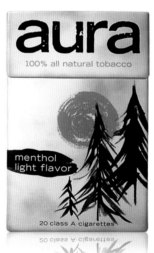

344

LEIBOLD ASSOCIATES, INC._ NEENAH, WI, UNITED STATES
CREATIVE TEAM: Therese Joanis, Jason Konz, Greg Madson, Kris Peterson
CLIENT: R. Sabee Company, LLC

DIOGRAFIC_ LISBON, PORTUGAL
CREATIVE TEAM: Diografic
CLIENT: Gentleman

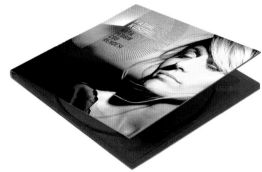

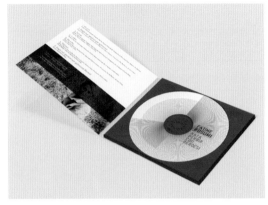

MASSIVE STUDIOS_ BOZEMAN, MT, UNITED STATES
CREATIVE TEAM: Benjamin Bennett, Steve Bretson, Spencer Williams
CLIENT: West Paw Design

PROJECTGRAPHICS.EU_ PRISHTINA, KOSOVA, ALBANIA
CREATIVE TEAM: Agon Ceta, Jetmir Idrizi
CLIENT: Fatime Kosumi

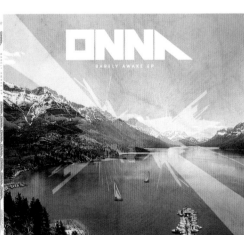

AIRTYPE STUDIO_ WINSTON-SALEM, NC, UNITED STATES
CREATIVE TEAM: Bryan Ledbetter
CLIENT: ONNA

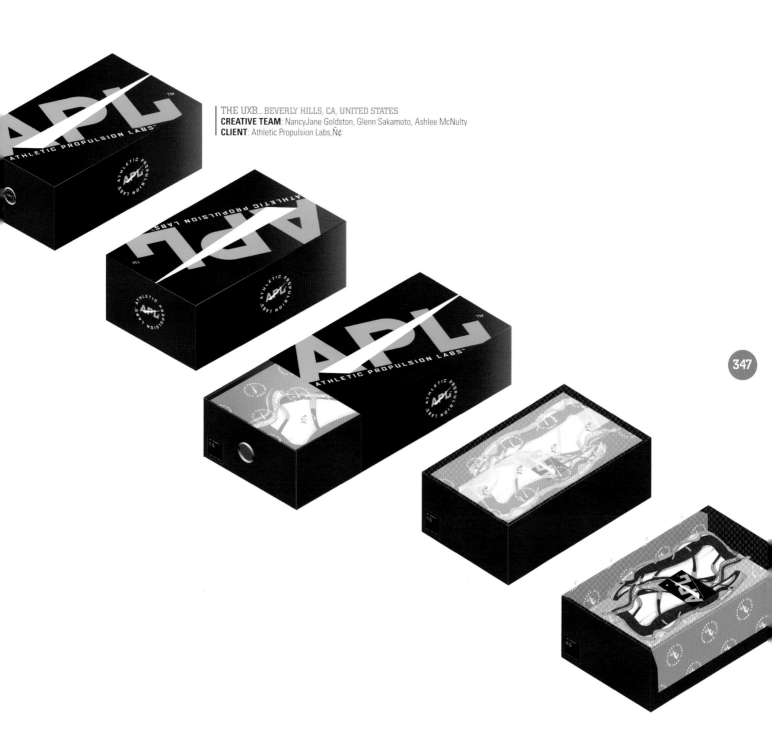

THE UXB_ BEVERLY HILLS, CA, UNITED STATES
CREATIVE TEAM: NancyJane Goldston, Glenn Sakamoto, Ashlee McNulty
CLIENT: Athletic Propulsion Labs,Ñ¢

347

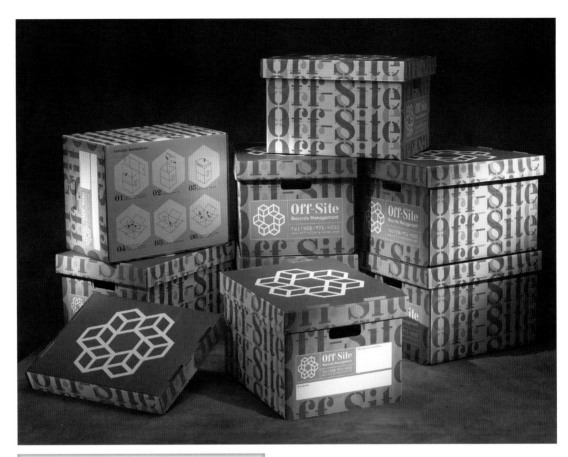

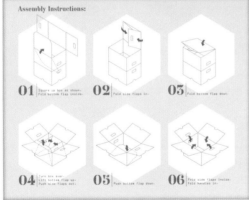

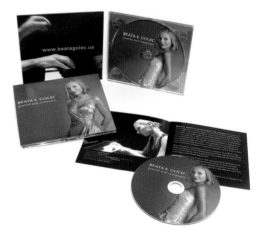

GEE + CHUNG DESIGN_ SAN FRANCISCO, CA, UNITED STATES
CREATIVE TEAM: Earl Gee
CLIENT: Off-Site Records Management

THINKHAUS_ OMAHA, NE, UNITED STATES
CREATIVE TEAM: Jill Kepler-Wagner, John W. Retallack, Blackdog Records, Beata E. Golec
CLIENT: Beata E. Golec and Blackdog Records

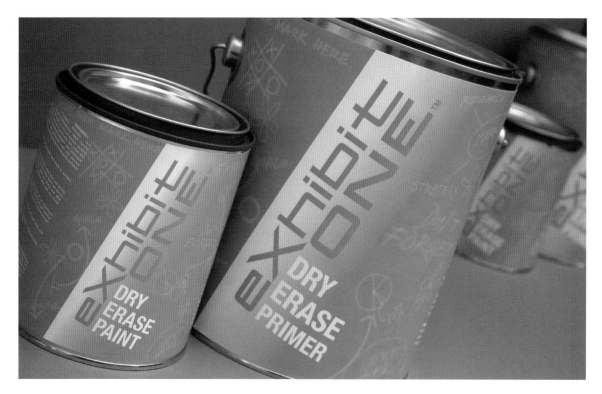

SKY DESIGN_ ATLANTA, GA, UNITED STATES
CREATIVE TEAM: W. Todd Vaught, Carrie Wallace Brown, Tiffany Chen
CLIENT: AWI Textiles, Inc.

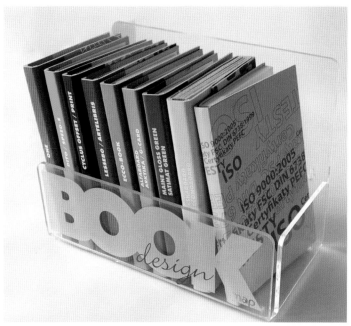

JURCZYKDESIGN_ POLAND
CREATIVE TEAM: Izabela Jurczyk
CLIENT: Map Poland

350

| CHRISTOPHER MARTIN | CREATIVE DESIGN_ WESTERVILLE, OH, UNITED STATES
CREATIVE TEAM: Christopher Martin
CLIENT: SAA

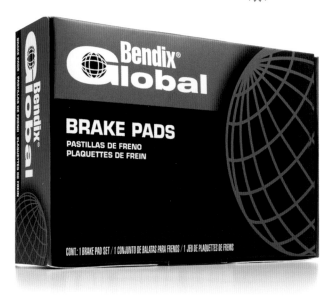

| TFI ENVISION, INC._ NORWALK, CT, UNITED STATES
CREATIVE TEAM: Elizabeth P. Ball, Mary Ellen Butkus, Mary Justin Wright
CLIENT: Honeywell Consumer Products Group

FACEOUT STUDIO_ BEND, OR, UNITED STATES
CREATIVE TEAM: Jason Gabbert, Richard Ljoenes
CLIENT: Harper Collins

AXIOMACERO_ MONTERREY, NUEVO LEON, MEXICO
CREATIVE TEAM: Mabel Morales, Idida Urbiola
CLIENT: Yesera Monterrey

351

ANDREA CUTLER DESIGN_ MARINA DEL RAY, CA, UNITED STATES
CREATIVE TEAM: Andrea Cutler, Stewart Silverstein
CLIENT: Fetch Creative / Wonk

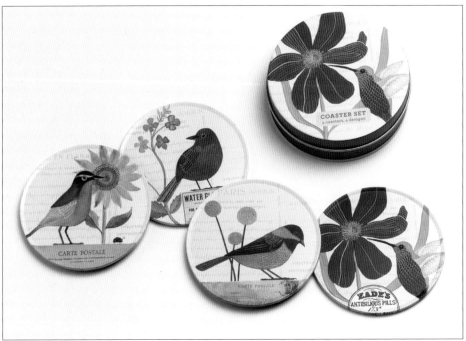

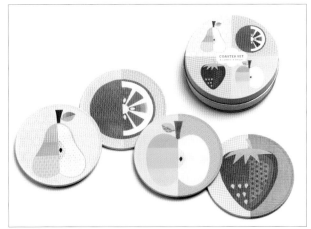

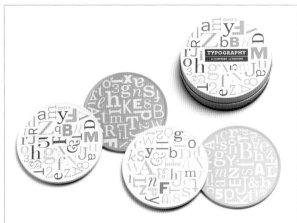

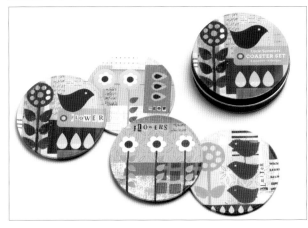

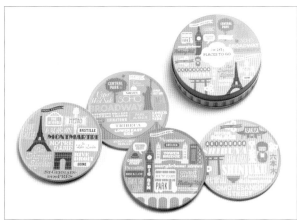

GALISON_ NYC, NY, UNITED STATES
CREATIVE TEAM: Juanita Dharmazi, Heather Schellhase, Julia Hecomovich, Shelby Spears
CLIENT: Galison In House Products

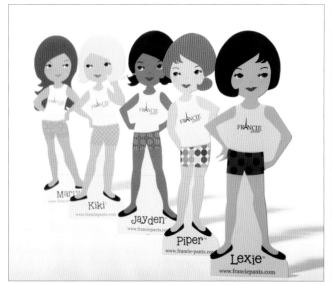

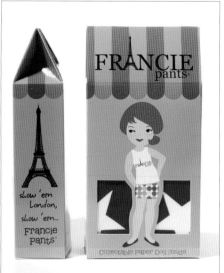

SITESQUARED, LLC_ BLACKLICK, OH, UNITED STATES
CREATIVE TEAM: Shanna Cote
CLIENT: Francie Pants

ZINNOBERGRUEN GMBH_ DUESSELDORF, NRW, GERMANY
CREATIVE TEAM: Baerbel Muhlack, Tobias Schwarzer
CLIENT: m-real Zanders gmbh

MINE_ SAN FRANCISCO, CA, UNITED STATES
CREATIVE TEAM: Christopher Simmons, Tim Belonax
CLIENT: InsideTrack

KEN-TSAI LEE DESIGN STUDIO_ TAIPEI, TAIWAN, PROVINCE OF CHINA
CREATIVE TEAM: Ken-tsai Lee
CLIENT: Havest Ads Co., Ltd

356

PROJECTGRAPHICS.EU_ PRISHTINA, KOSOVA, ALBANIA
CREATIVE TEAM: Agon Ceta
CLIENT: Self-Promotion

APREY CREATIVE_ MELBOURNE, AUSTRALIA
CREATIVE TEAM: Aprey Creative
CLIENT: Drieyes

357

VISUAL LURE_ CASEYVILLE, IL, UNITED STATES
CREATIVE TEAM: Justen Hong
CLIENT: Intercon Chemical

MATADOG DESIGN_ ATHENS, GREECE
CREATIVE TEAM: Kioroglou Andreas
CLIENT: Verdes Innovations

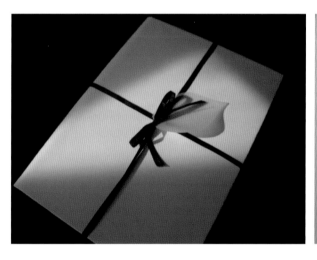

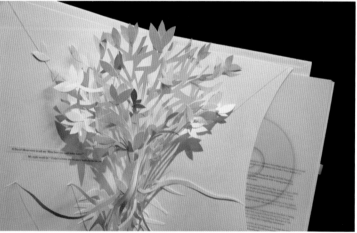

CHANGZHI ART & DESIGN_ SINGAPORE
CREATIVE TEAM: Changzhi Lee
CLIENT: CZA&D

ALYSSA HAMILTON_ PENNSYLVANIA, UNITED STATES
CREATIVE TEAM: Alyssa Hamilton
CLIENT: Student Work

Student Work

359

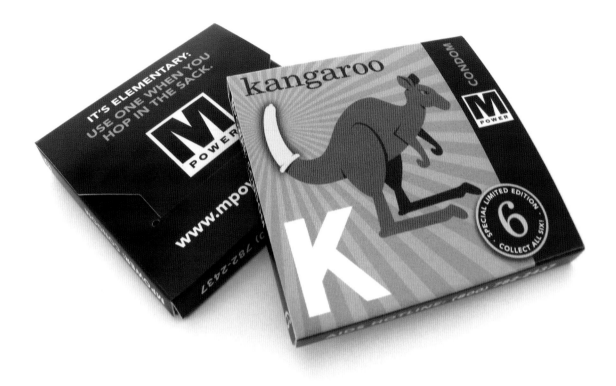

An In-Depth Look

MPower Condom Wrappers

"I don't know if other design firms think this way, but having someone walk in the door with a design-us-a-box-that-a-condom-goes-in project is pretty high on the list of things we're always hoping for," says Drew Davies, founder of Oxide Design Co. in Omaha, Nebraska. "Kinda cool."

Mpower, a division of the Nebraska AIDS Project (the state's primary AIDS/HIV education and prevention nonprofit) distributes free condoms at bars and clubs in the area, primarily targeting gay and bisexual males. When Mpower first approached Oxide Design, they had a problem.

"They approached us because they were putting all these condoms out there for free, and every last one of them would still be there at the end of the night," Davies says. "And that doesn't make any sense. You can give anything away for free, and people take it.

"Basically, it came down to that fact that nobody wanted to be *that guy* who gets his condoms out of a fishbowl at a night club. The social stigma was making the program ineffective. Plus, they had these 'AIDS PROJECT AIDS PROJECT AIDS PROJECT' kind of wrappers, which made it scary.

"We said, okay—what's the easiest way to make it un-scary, or to add some kind of hip cachet that makes it cool to reach into the fishbowl instead of being 'that guy'? Why don't we make the whole thing sort of tongue-in-cheek silly, take all the scariness out of it?

"It all came together because we were thinking, this is so simple: Use these—protect yourself—end of discussion. It's elementary." Elementary = kindergarten = alphabet = primer = problem solved.

"I'm drawn toward simple graphics, the straightforwardness of elementary school primers: c—camel—picture of a camel—*done*. It's that easy. We turned it on its head a bit, but I like that it's so recognizable in the marketplace," says Davies.

Inspiration struck again when Oxide Design decided instead of just one wrapper, why not design 6 and make it a hip, cool, I'm-gonna-collect-the-whole-set thing, like trading cards. "We pitched the idea of building a numbered set of six and making them collectible. They actually say something cheesy on them, like 'Collect all 6!' And that's how we ended up with this primer-alphabet set of animals."

> "...nobody wanted to be *that guy* who gets his condoms out of a fishbowl at a night club."

It was the only concept they presented to the client. "If we feel we've really solved the problem well, we try not to fabricate a bunch of other concepts that aren't all that meaningful. We got to this one and stopped." Happily, the client was "remarkably open-minded. It sailed through in a way it might not have with a large corporation.

"One of the things we feel pretty strongly about at Oxide is not just

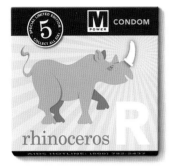

OXIDE DESIGN CO.— OMAHA, NE, UNITED STATES
CREATIVE TEAM: Drew Davies
CLIENT: Nebraska AIDS Project

addressing a social problem like this, but making sure there's a cohesive thought process to solving a problem."

Some aspects of the project were non-negotiable. For instance, the paper stock and die-cutting were already established by the client, so revamping the packaging structure was not an option. "In this case," says Davies, "I think it helped focus the process by narrowing the parameters."

Ultimately, they tied all the pieces together via taglines on the back of each pack. They knew they wanted something just as simple, straightforward, and unscary as the elementary-school primer design, and they sat down with a director of education at NAP, who was also a copywriter, to create it.

"You can imagine the fairly entertaining process of coming up with these tongue-in-cheek, off-the-wall, really bad double-entrendres," says Davies. "Not every day in design is a really fun day, but that was a really fun day."

They convinced the client to release the designs in sets of two. NAP staged social events where they released one set at a time, instead of just dropping all six of them unceremoniously into a fishbowl at the nightclubs. Did it work?

The good news: "They started disappearing in droves. The Nebraska AIDS Project was getting calls from these clubs, asking them to fill the fishbowls back up because they were always empty. We'd run into people who would say, 'Oh, yeah, I collected all 6 of them, and I've still got the whole set. They're in the china cabinet in my dining room.'" Right next to the Vera Wang.

"That's when we knew we were making an impact," says Davies.

The bad news: Out of funding, the Nebraska AIDS Project has dropped the program. "You can't get these anymore. Although they're probably on eBay," Davies observes. "The response to this was solid. We are now looking into ways we can partner with a national AIDS not-for-profit and merchandise these designs into t-shirts and posters and generate revenue for them."

OXIDE DESIGN CO._ OMAHA, NE, UNITED STATES
CREATIVE TEAM: Drew Davies
CLIENT: Nebraska AIDS Project

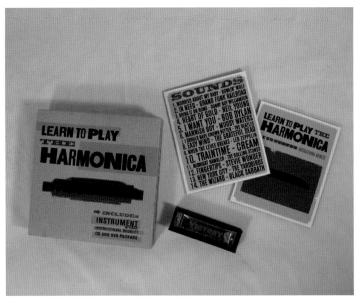
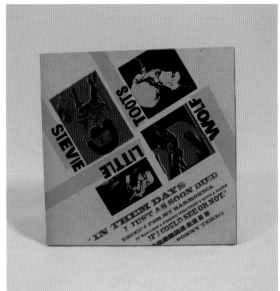

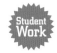

DREXEL UNIVERSITY, ANTOINETTE WESTPHAL COLLEGE OF MEDIA ARTS & DESIGN_
PHILADELPHIA, PA, UNITED STATES
CREATIVE TEAM: Michael Valentine, Jody Graff
CLIENT: Learn to Play the Harmonica

Student Work

364

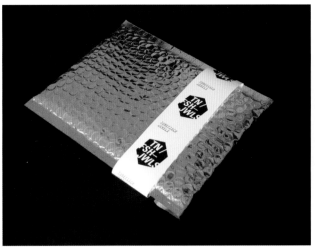

ALEXANDER EGGER_ VIENNA
CREATIVE TEAM: Alexander Egger
CLIENT: TN/FSH

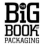

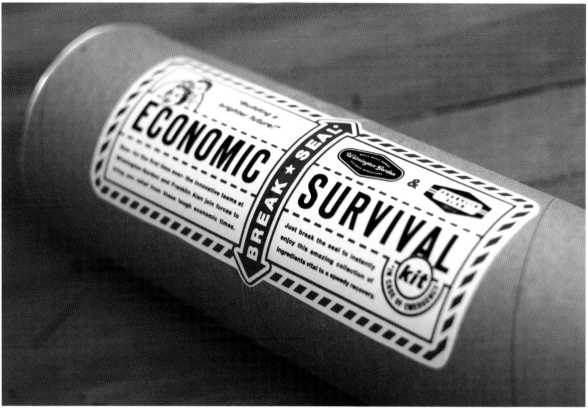

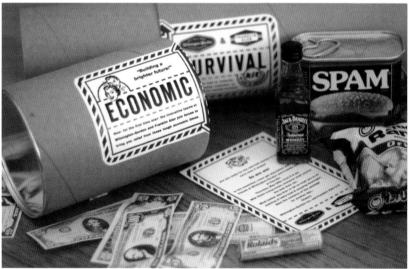

SUDDUTH DESIGN CO._ AUSTIN, TX, UNITED STATES
CREATIVE TEAM: Toby Sudduth
CLIENT: Wilmington-Gordon & Franklin Alan

RAIDY PRINTING GROUP S.A.L._ BEIRUT, LEBANON
CREATIVE TEAM: Mariejoe Raidy, Roger Moukarzel, Kamel Barakat
CLIENT: Behind the Green Door

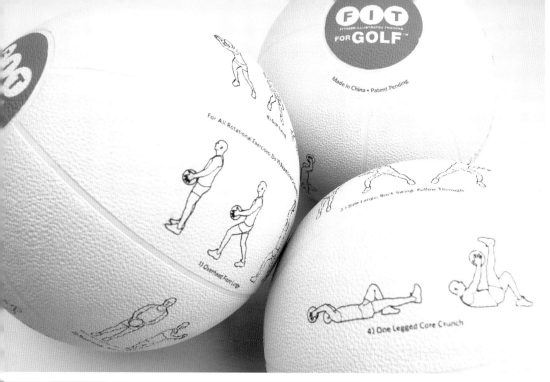

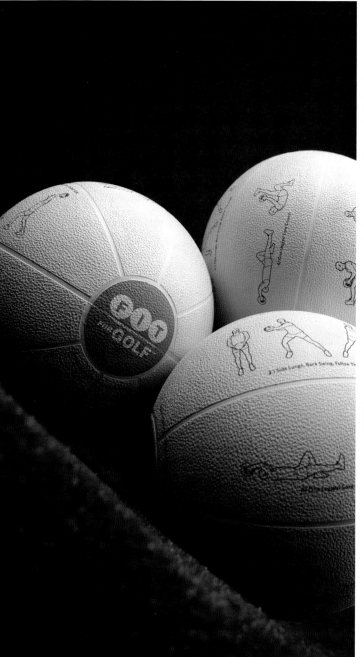

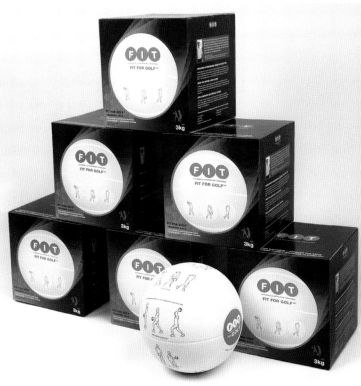

THINKHOUSE - WHERE GREAT IDEAS LIVE... HUNTINGTON, NY, UNITED STATES
CREATIVE TEAM: Adam Bank
CLIENT: Fit For Golf

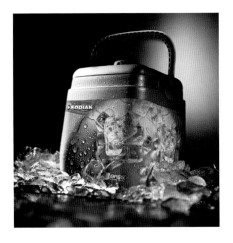

LCDA_ SAN DIEGO, CA, UNITED STATES
CREATIVE TEAM: Laura Coe Wright, Tracy Castle
CLIENT: Breg

JENN DAVID DESIGN_ SAN DIEGO, CA, UNITED STATES
CREATIVE TEAM: Jenn David Connolly, Nannette Hoogslag
CLIENT: The Relaxation Company

368

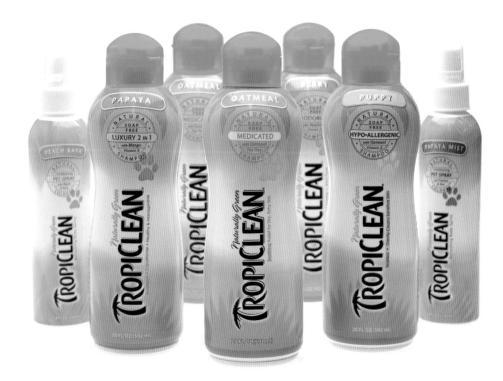

STUDIO ONE ELEVEN - A DIVISION OF BERLIN PACKAGING_ CHICAGO, IL, UNITED STATES
CREATIVE TEAM: Studio One Eleven
CLIENT: Cosmos Corporation

FACEOUT STUDIO_ BEND, OR, UNITED STATES
CREATIVE TEAM: Charles Brock, Lisa Fyfe
CLIENT: Henry Holt and Company

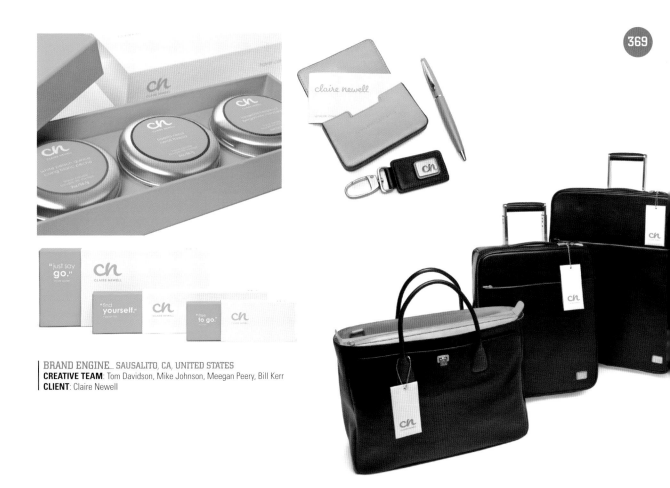

369

BRAND ENGINE_ SAUSALITO, CA, UNITED STATES
CREATIVE TEAM: Tom Davidson, Mike Johnson, Meegan Peery, Bill Kerr
CLIENT: Claire Newell

TODD CHILDERS GRAPHIC DESIGN_ BOWLING GREEN, OH, UNITED STATES
CREATIVE TEAM: Todd Childers, Katerina Ruedi Ray
CLIENT: Bowling Green State University School of Art

THE GRAFIOSI_ NEW DELHI, DELHI, INDIA
CREATIVE TEAM: Pushkar Thakur
CLIENT: Them Clones

THE MECHANISM_ NEW YORK, NY, UNITED STATES
CREATIVE TEAM: Dave Fletcher, Kasim Sulton, Sharon Terry
CLIENT: Kasim Sulton

AIRTYPE STUDIO_ WINSTON-SALEM, NC, UNITED STATES
CREATIVE TEAM: Bryan Ledbetter
CLIENT: Jerry Chapman

BEFORE IDENTITY REDESIGN

AFTER IDENTITY REDESIGN

372

R.BIRD_ WHITE PLAINS, NY, UNITED STATES
CREATIVE TEAM: Richard Bird, Joseph Favata
CLIENT: Whirlpool Corporation

STUDIO **STUBBORN SIDEBURN**_ SEATTLE, WA, UNITED STATES
CREATIVE TEAM: Junichi Tsuneoka
CLIENT: STUDIO STUBBORN SIDEBURN

373

LCDA_ SAN DIEGO, CA, UNITED STATES
CREATIVE TEAM: Laura Coe Wright, Tracy Castle
CLIENT: UK International

TFI ENVISION, INC._ NORWALK, CT, UNITED STATES
CREATIVE TEAM: Elizabeth P. Ball
CLIENT: NorEast Air LLC

374

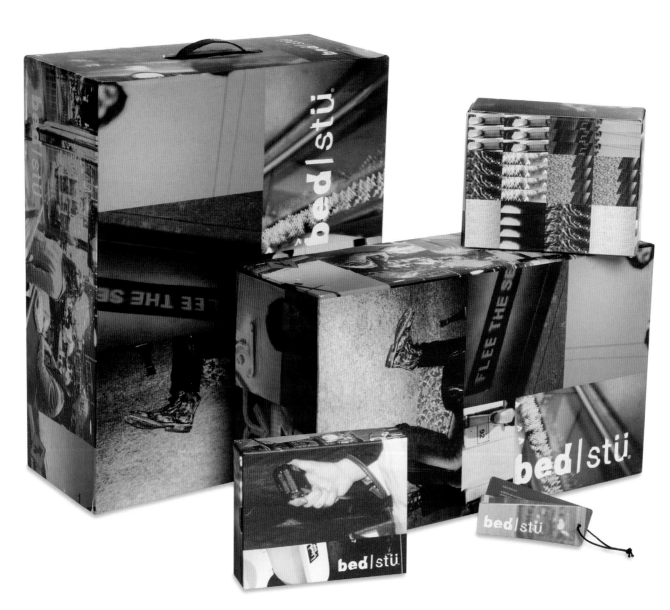

AUSTIN WALSH PHOTOGRAPHY AND DESIGN RANCH_ KANSAS CITY, MO, UNITED STATES
CREATIVE TEAM: Michelle Sondergger, Ingred Sidie, Brynn Johnson, Austin Walsh
CLIENT: Bed Stu

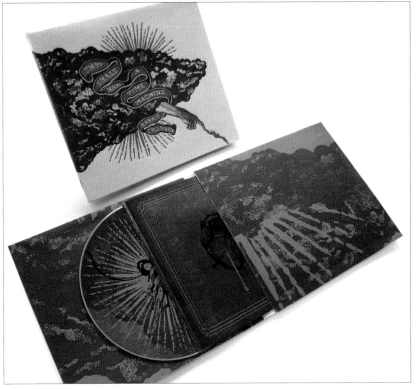

375

BRIAN DANAHER/MADE FOR ENDING_ ST. PAUL, MN, UNITED STATES
CREATIVE TEAM: Brian Danaher
CLIENT: Clutter Bear Record

INDEX

INDEX